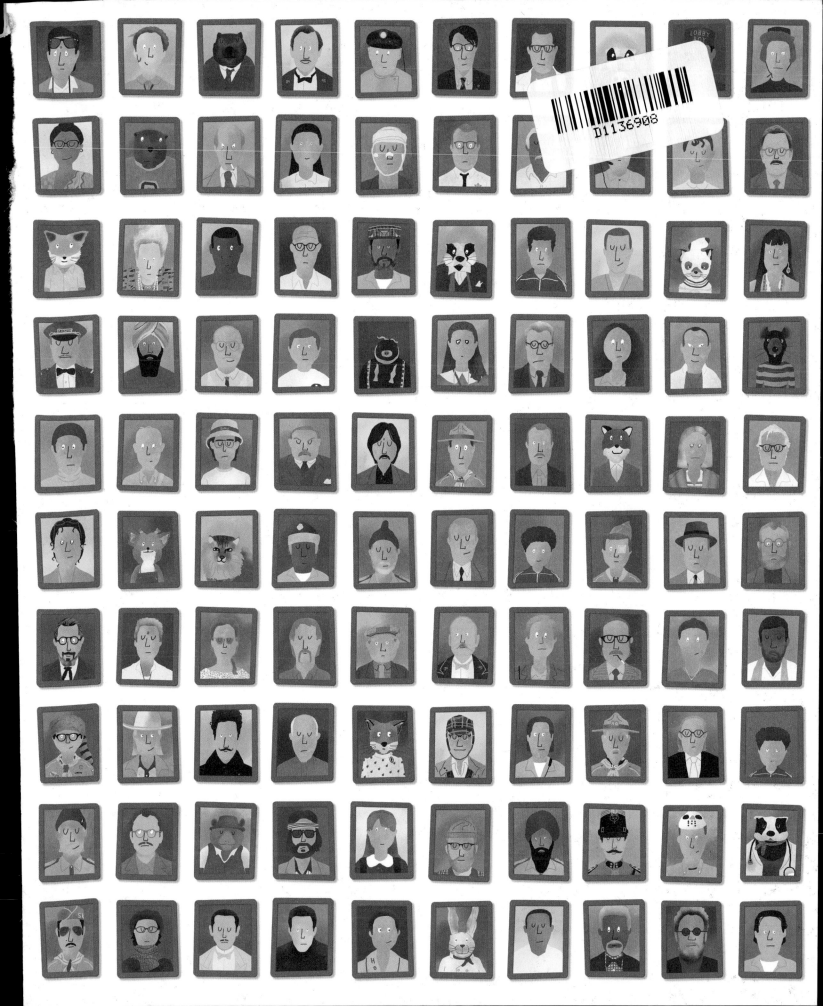

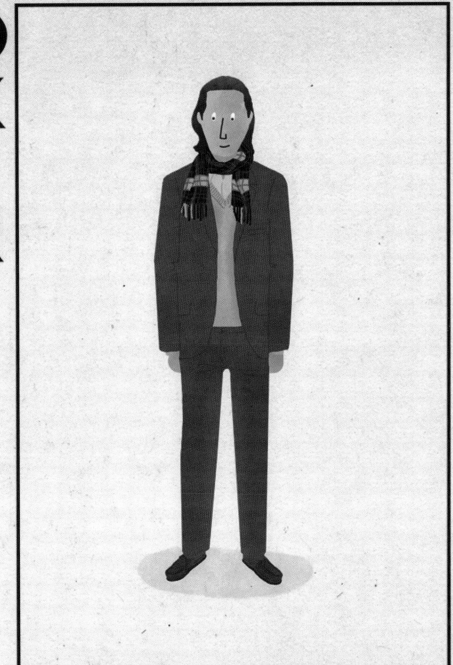

THE
WES
ANDERSON
COLLECTION

BAD DADS

ART
INSPIRED BY THE
FILMS
OF
WES
ANDERSON

BY
SPOKE
ART GALLERY
FOREWORD BY WES ANDERSON
INTRODUCTION BY MATT ZOLLER SEITZ
PREFACE BY KEN HARMAN

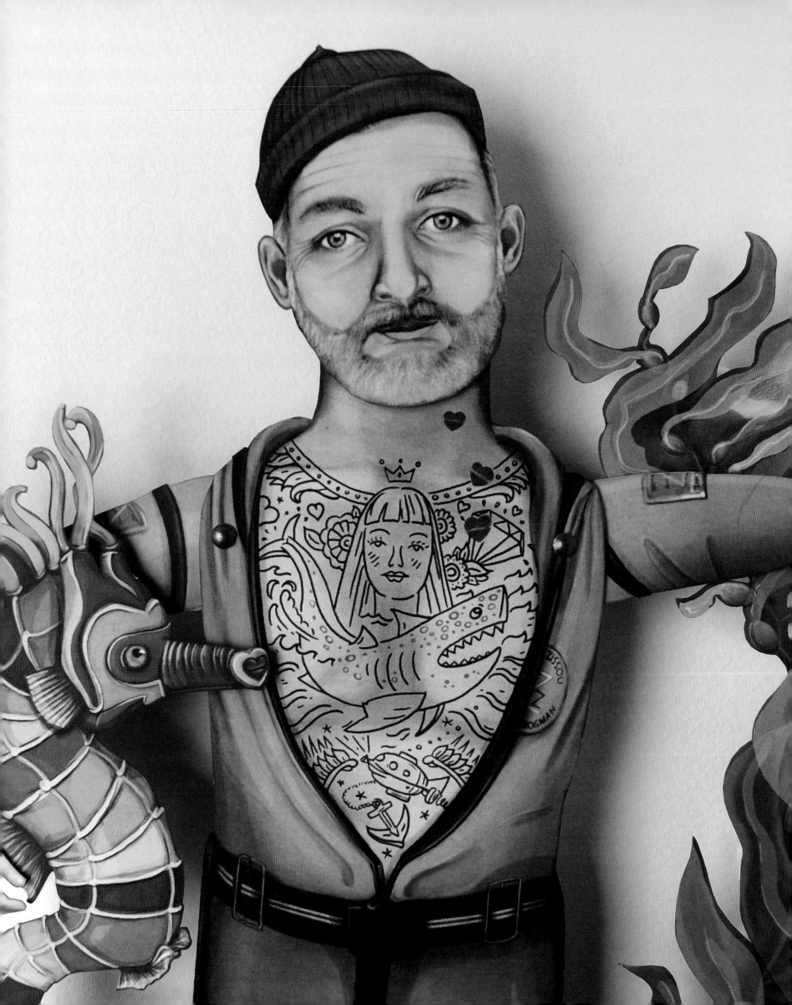

MY FATHER WAS THE FIRST person to mention to me, several years ago, that some people in California were putting on an art show with pictures based on characters in my movies—and that it was going to be called *Bad Dads*.

He did not like the title at all. (He has always been more of a good dad, and it rubs him the wrong way when people confuse him with some of our fictional characters. He monitors with Google Alert.) He did, however, like the pictures. For me, it is extremely encouraging to know that somebody-or-other somewhere is interested enough to make something-or-other new of their own inspired by something-or-other old of *my* own—that was in itself inspired by all sorts of other something-or-others somebody else invented before that. In fact, I have, on more than one occasion, turned to an artist represented/ discovered in this series of exhibitions to make pictures for use in my own ongoing movies. (Rich Pellegrino, in particular, made a sort of a Schiele-esque watercolor for *The Grand Budapest Hotel* which is known as *Two Lesbians Masturbating*, and I think we can say he got that one just right.) Jason Schwartzman and I paid a visit to the last *Bad Dads* show when it made its appearance in New York. By the time you get yourself out of the cutting room on a movie, you usually have a strong desire not to be exposed to the material ever again for the rest of your life. But, it turns out, after a decade or two, it can be a nice feeling to revisit the old characters. Jason and I moved from picture to picture with our hands in our pockets, nodding and murmuring. I guess we were kind of walking down memory lane. I cannot take credit for much of anything on these pages, and I do not even know if it is actually legal to publish this book? It probably violates if not my own personal copyrights then almost certainly those of a number of multinational entertainment conglomerates. But, for whatever it is worth, I approve, and I hope you will, too.

Wes Anderson
January 2016
New York, NY

Crankbunny
Steve Zissou
Hand-cut paper
doll (detail)
12 × 16"

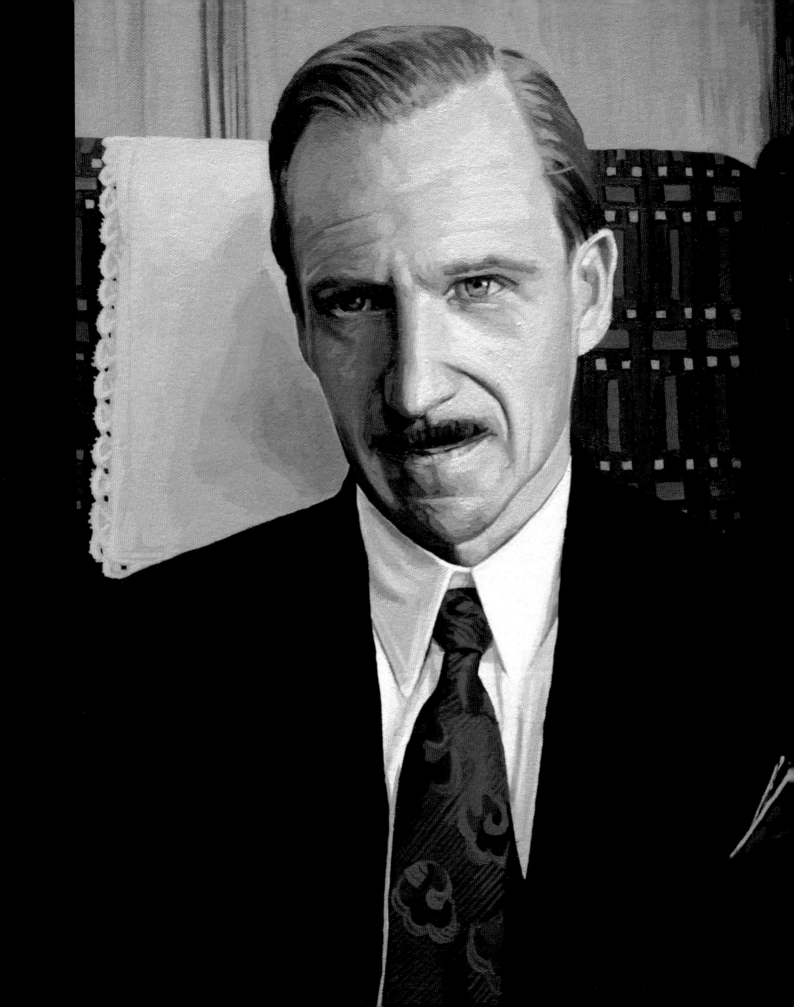

OVER THE PAST SEVERAL years, every time I've gone into a bookstore or movie theater while touring to promote my books about the films of Wes Anderson, I've noticed the same two amazing things, and I have come to believe they are related.

First, while I'm scribbling my signature on the title page of a book, a fan of Wes's work will bring up a recurring motif or subtle in-joke or buried bit of marginalia related to his work—some marvelous insight that I had missed, despite having seen all of his features more than twenty times each, and despite having made fourteen video essays and written tens of thousands of words about his evolution as an artist. This is a testament to the richness of Wes's films: They're perfect for rewatching and revisting. You find that you keep coming back for more, and it seems you always find something new—and you're far from alone. A passionate community of fans is constantly refining the collective database of observations, in everything from academic papers and magazine articles to Tweets and Tumblr posts.

The second thing is the display of tattoos. A lot of Wes Anderson fans have tattoos derived from his films. No two people have exactly the same one. Even people who have taken the trouble to ink, say, the submersible from *The Life Aquatic* or the falcon from *The Royal Tenenbaums* have placed it on a different spot on their bodies or have it rendered in a unique style: black and white, color, realistic, stylized. Some design the tattoos themselves. A few hold the needle. What better way to declare, *This art is a part of me*?

The works collected in *Bad Dads* present a third amazing thing, perhaps a fusion of the first two. Originated by a series of exhibitions at Ken Harman's Spoke Art Gallery in San Francisco, the artwork in this book is by Wes Anderson superfans who also happen to be gifted artists. Like scholarship on Wes's films and the tattoos I see at book events, no two artworks are alike in style, tone, material, or effect. The best pieces have as many layers as Max Dalton's cutaway views of Wes Anderson structures—the Tenenbaum house, the *Belafonte*, Rushmore Academy, and so on—that adorn my books.

The diversity of approaches here is remarkable, as is the preponderance of art that does not reveal its cleverness or depth until you've stared at it long enough to realize that the artist is not merely a technically gifted draftsperson, fabricator, painter, or what have you, but perhaps is also a journalist, scholar, diarist, or critic as well.

The art in this book expresses that sense, intrinsic to all of Wes's films, of an eternal child hidden inside each grownup, plus a related obsession with nostalgia and returning to a naïve state. It also suggests different ways of looking at Wes's characters: as icons, as symbols, as products, as dream figures, as toys that the imagination can play with or that a cruel universe can collect, sell off, or discard.

Bad Dads is a treasure trove of images as inexhaustible as the films that inspired it, and, fortunately for the needle-averse, you can carry it with you in handy book form.

Matt Zoller Seitz is the TV critic for New York Magazine, *the editor-in-chief of RogerEbert.com, and the author of the* New York Times *bestsellers* The Wes Anderson Collection *(Abrams, 2013) and* The Wes Anderson Collection: The Grand Budapest Hotel *(Abrams, 2015).*

INTRODUCTION

Rebecca Mason Adams
Gustave
Acrylic on canvas
12 × 16"

CREATIVE PEOPLE ARE,
more often than not,
drawn to others of the
same ilk.

There is a magnetism to creative energy that brings together like-minded people and ignites into them collaboration, competition, and conversation. It is through this synthesis when artistic movements begin, where revolutions are born, and how changes to our society's cultural fabric are tailored.

It's hard to pinpoint exactly what it is about Wes Anderson's films, but over the course of the last twenty years, they have become something of a touchstone for the creative community. Visual artists in particular have a wealth of inspiration to pull from: the set designs, costumes, cinematography, colors—tools and tropes akin to the individual globs on a painter's palette, and just as powerful when combined in the right proportions and applied in just the right way.

The importance of these visual aesthetics, combined with Anderson's trademark catchy soundtracks, smart writing, lovable yet flawed characters, and a superb sense of storytelling, blend together like the ingredients in a Mendl's Courtesan au Chocolat . . . and just as that fictional pastry brought together both the members of the Zubrowkan aristocracy and the prisoners of Checkpoint 19, so too do Wes Anderson's films bring together artists, creatives, designers, and art lovers the world over.

PRE FACE

Even the characters in Anderson's films tend to be like-minded groups of people, united by a similar passion or for reasons beyond their control. They represent the misunderstood loners fighting for their love (Sam and Suzy), the dysfunctional families forced to reunite (the Tenenbaums and the Whitman brothers), the schoolyard outcasts (the Max Fischer Players), and the cast-off antiheroes (Team Zissou). "Klaus used to be a bus driver. Wolodarsky was a high school substitute teacher. We're a pack of strays, don't you get it?!"

In 2010, I produced an art exhibit in San Francisco dedicated to Anderson's films. The show was (and still is) titled *Bad Dads*, a tongue-in-cheek recognition of the recurring fathers or father figures found throughout Anderson's films—most of whom are characters one loves to hate (and many of whom are played by Bill Murray).

For the inaugural exhibit, we invited around one hundred of our favorite visual artists and friends to participate. Painters, sculptors, illustrators, designers, craft makers, and screen printers came together to create all-new, original works inspired by Anderson's films. We gave them full carte blanche, and the exhibit opened on Halloween night with a pop-up exhibit and costume party in San Francisco.

The show was such a success and so well received that I soon found myself quitting my day job and signing a lease for a brick-and-mortar gallery space in San Francisco's Tenderloin neighborhood. My gallery, Spoke Art, now produces more than twenty-four exhibitions a year, ranging from fine art solos to large, pop culture–themed group shows.

In 2015, we decided to bring the exhibit to our home away from home: the Chelsea art district in New York City. Though we do at least a couple exhibits in New York every year, and though our flagship *Bad Dads* show was already a tremendous success back in SF, we were completely unprepared for the response our show would receive for its sixth annual incarnation.

Veronica Fish
Suzy on New Penzance
Gouache, pencil on paper
12 × 16"

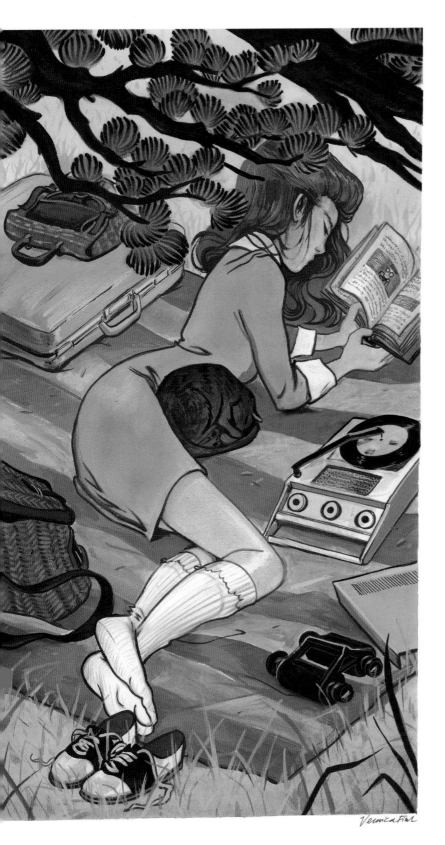

By the time our doors opened to the NYC humidity on August 7, we had been flooded with more than sixty thousand RSVPs, hundreds of phone calls and emails, and had hour-long lines of costumed fans waiting patiently around the block. Our two-day art show quickly became a five-day art show, and we even extended the exhibit's viewing times from six hours a day to twelve, all in an attempt to get as many fans as possible into our midsize Chelsea rental gallery space.

Being in a gallery immersed floor to ceiling with amazing and inspired art is always an awe-inducing experience. Being in that same room but also surrounded by hundreds of strangers dressed up as their favorite Tenenbaum, Fox, or Zissou member is an enlightening experience, an awareness of a shared cultural subconsciousness.

Found throughout this book are the works of more than one hundred artists from around the world—from New Mexico to New Penzance, from Rhode Island to Rushmore—each of whom has created original paintings, illustrations, designs, and sculptures inspired by the characters, scenes, and themes found throughout Anderson's worlds.

Our artists, much like our fans, come from all walks of life. From formally trained art-school grads who submitted formal portfolios to self-taught illustrators we found on Tumblr, this selection of works represents a diverse cross section of the many creatives from all over the world brought together by their appreciation and love of Anderson's films, and the artistic inspirations that have come from those films. Hopefully it inspires you, too.

Ken Harman is a curator and gallerist based in the San Francisco Bay Area. He is the owner and director of Hashimoto Contemporary and Spoke Art galleries and is the former online editor for Hi-Fructose *magazine. He lives in Oakland, California, with his girlfriend and their two cats.*

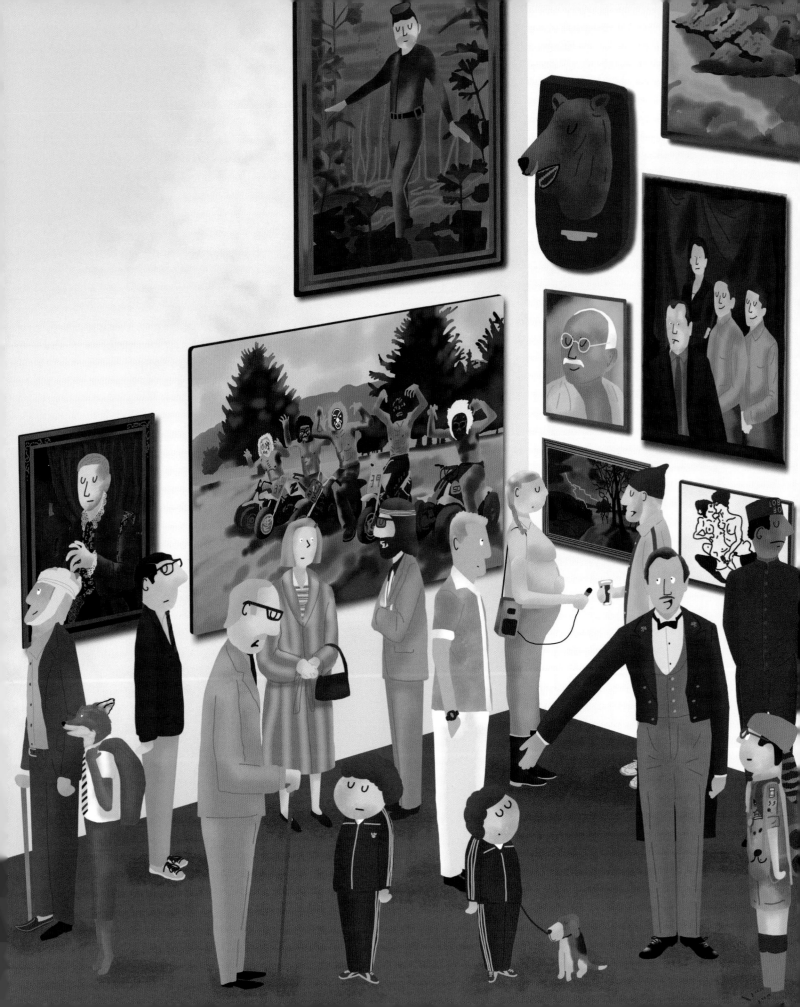

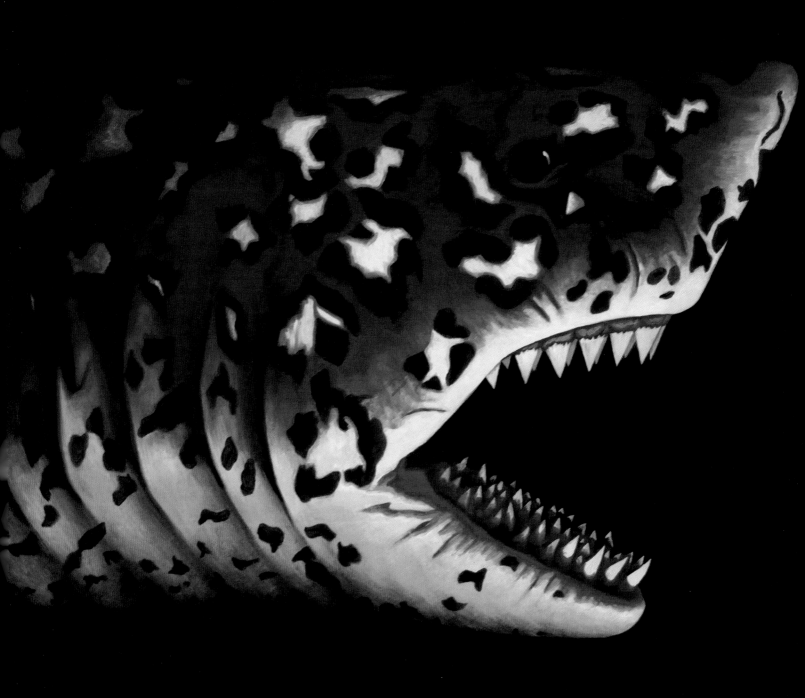

Steven Foundling
For Esteban
Oil on board
35 × 15"

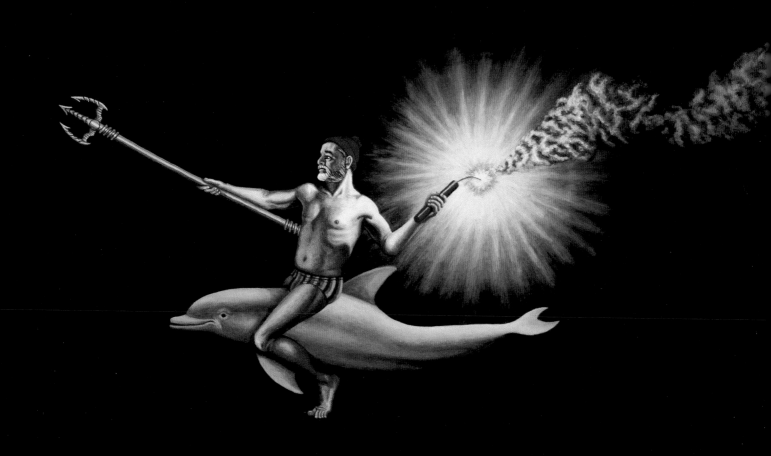

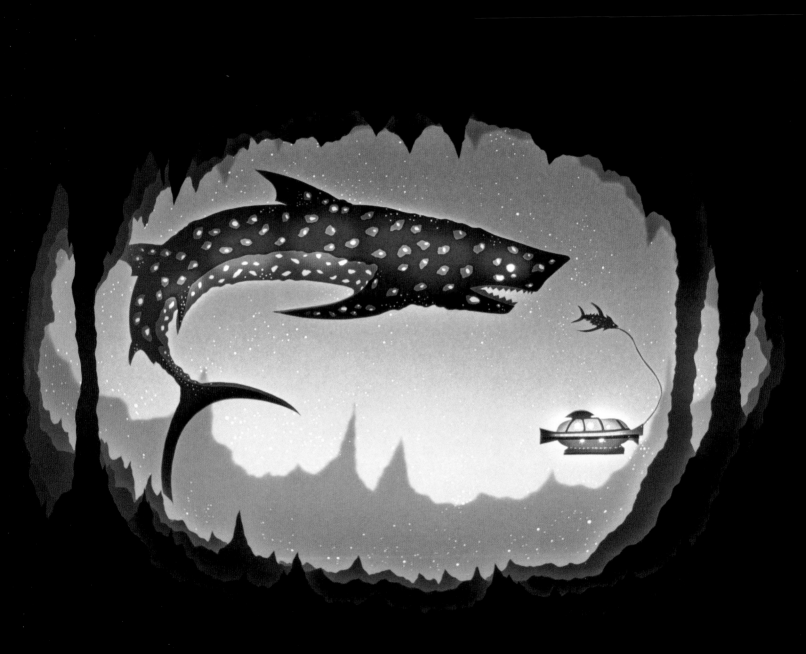

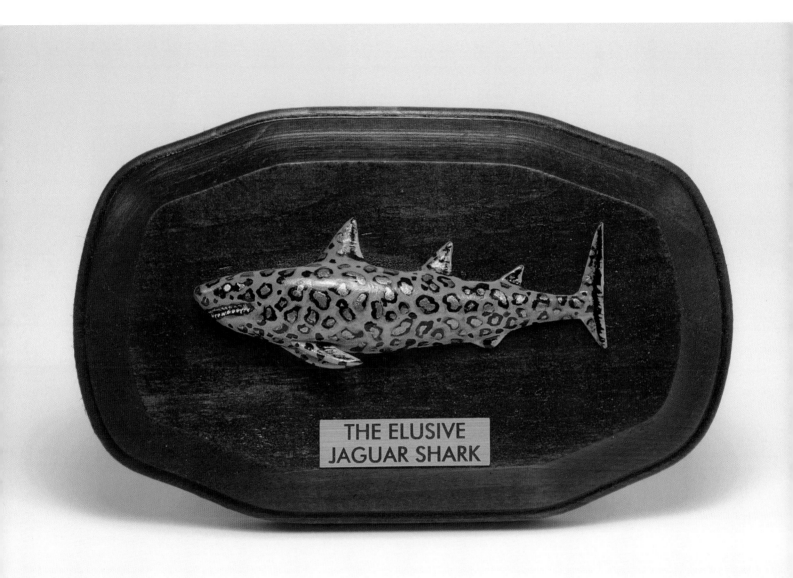

THE ELUSIVE
JAGUAR SHARK

←

Hari & Deepti
*I Wonder If It
Remembers Me . . .*
Hand-cut archival paper
sculpture in a light box
11 × 14"

➡

Geoff Trapp
The Elusive Jaguar Shark
Mixed media
5 × 3"

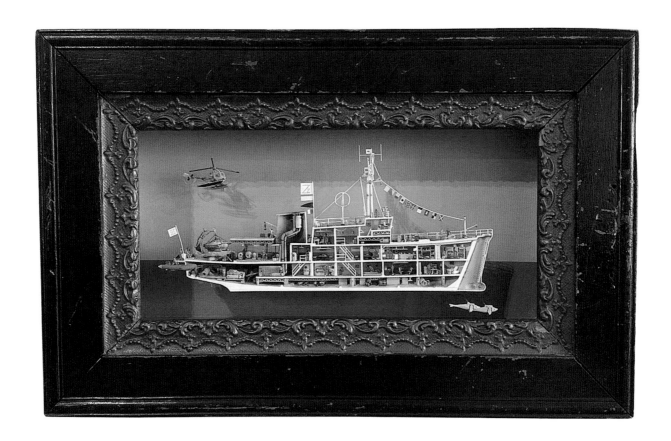

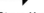

Vic DeLeon
*The Life Aquatic
with Steve Zissou*
1:160-scale miniature
sculpture with figures;
polystyrene, resin,
urethane, polymer clay,
wood, and acrylic;
antique wood frame
16 × 4 × 6"

Steve Yamane
Belafonte
Plastic and resin model
14 × 7 × 3.5"

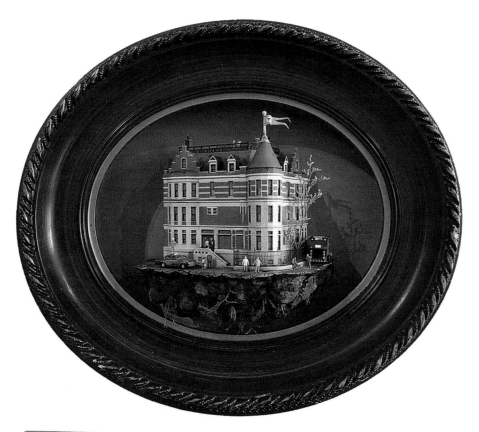

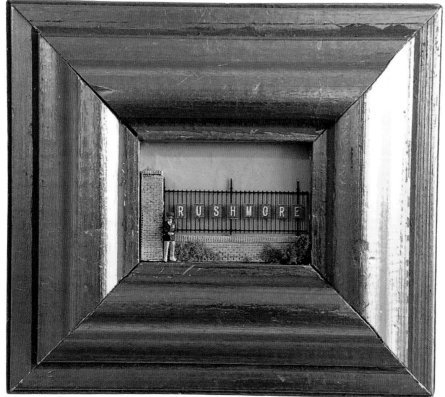

Vic DeLeon

The Royal Tenenbaums
1:160-scale miniature
sculpture with figures;
polystyrene, resin,
urethane, polymer clay,
wood, and acrylic;
antique wood frame
15 × 12 × 4"

Rushmore
1:160-scale miniature
sculpture with figures;
polystyrene, resin,
urethane, polymer clay,
wood, and acrylic;
antique wood frame
4 × 3.5"

Nicole Gustafsson
Rough Year
Gouache and ink on
cradled wood panel
9 × 12"

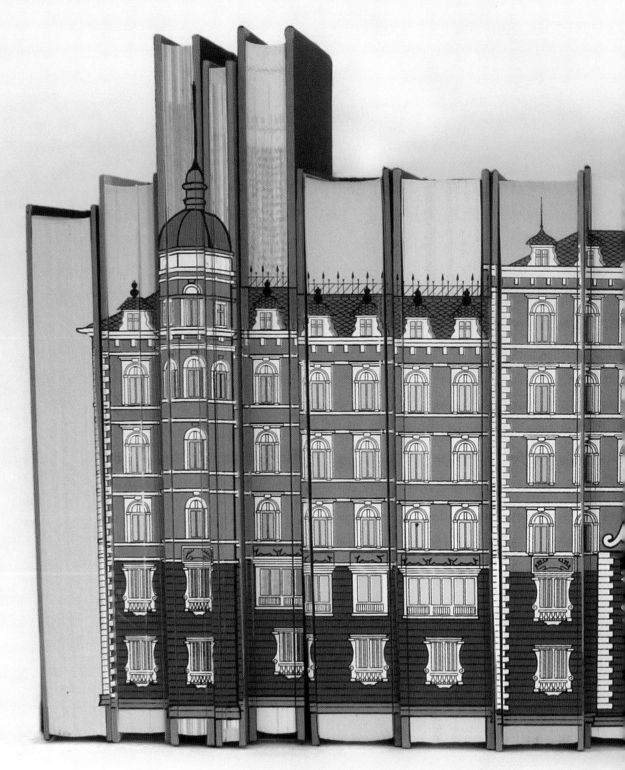

Daniel Speight
Grand Budapest Hotel
Screen print on reclaimed books
23 × 12 × 18"

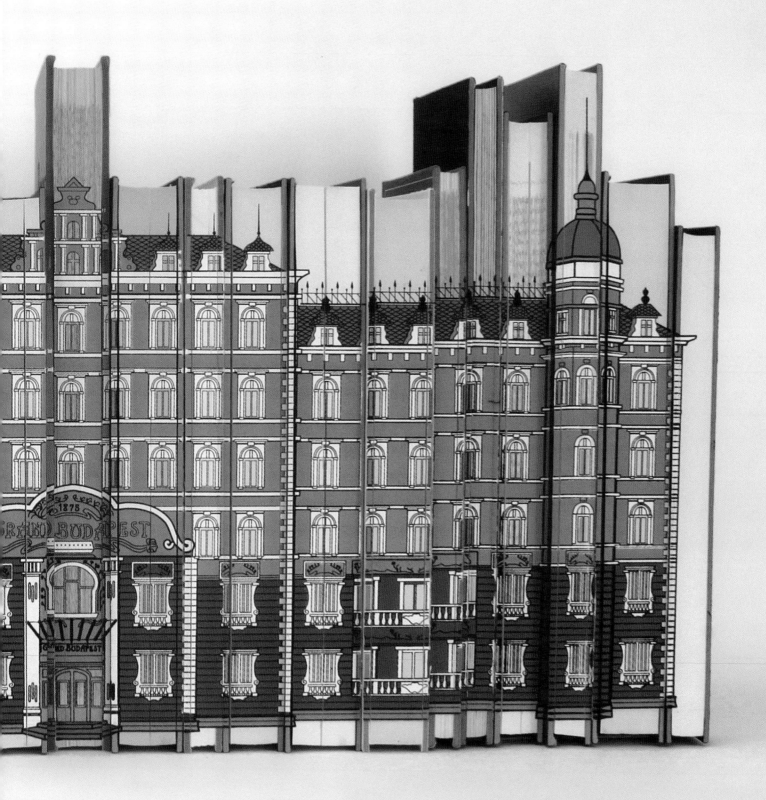

nakedness tonight

the iceman cometh

three plays

wildcat

OLD CUSTER

accounting for everything

EROTIC TRANSFERE

family of geniuses

STATIC ELECTRICITY

dudley's world

DANIELLE RIZZO

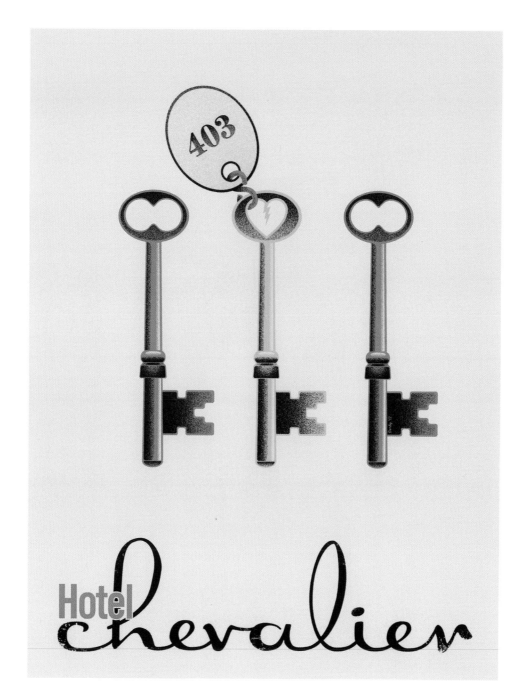

Danielle Rizzolo
*The Architecture
of the House on
Archer Avenue*
Oil and gold on board
13 × 15"

Scott Derby
Room 403
Screen print
18 × 24"

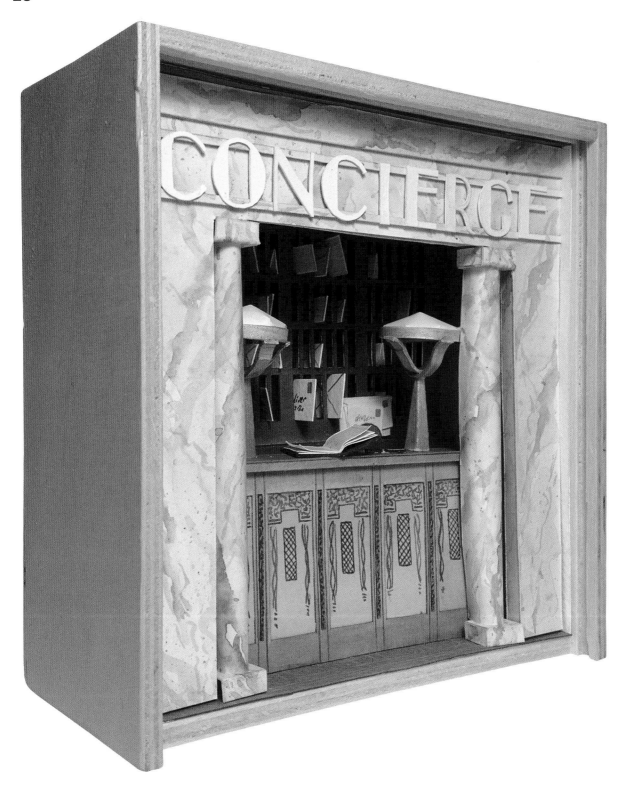

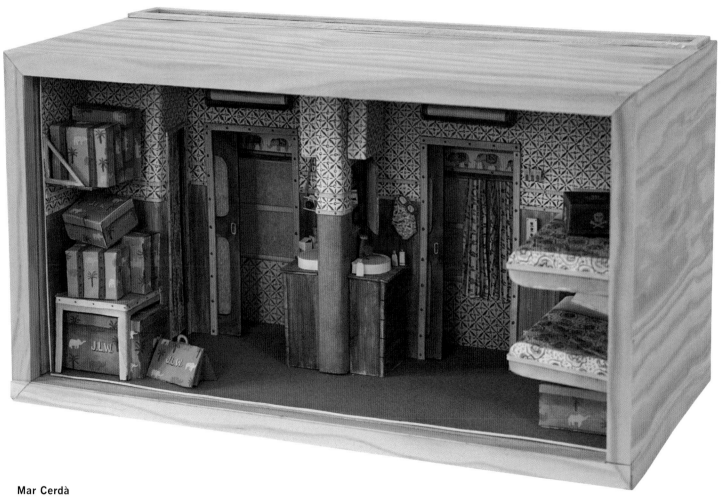

Mar Cerdà

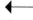

Concierge
Paper-cut and watercolor
miniature model
6 × 6 × 2.75"

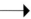

*The Darjeeling
Limited*
Paper and watercolor
diorama
13.5 × 7.57 × 7.28"

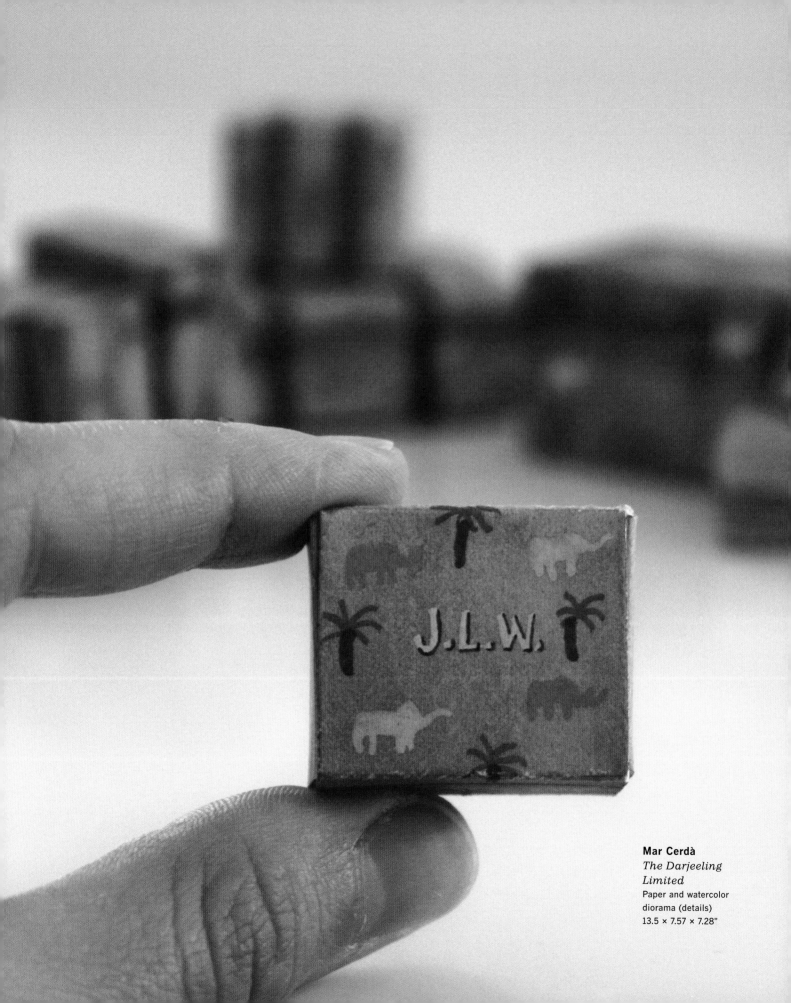

Mar Cerdà
The Darjeeling Limited
Paper and watercolor diorama (details)
13.5 × 7.57 × 7.28"

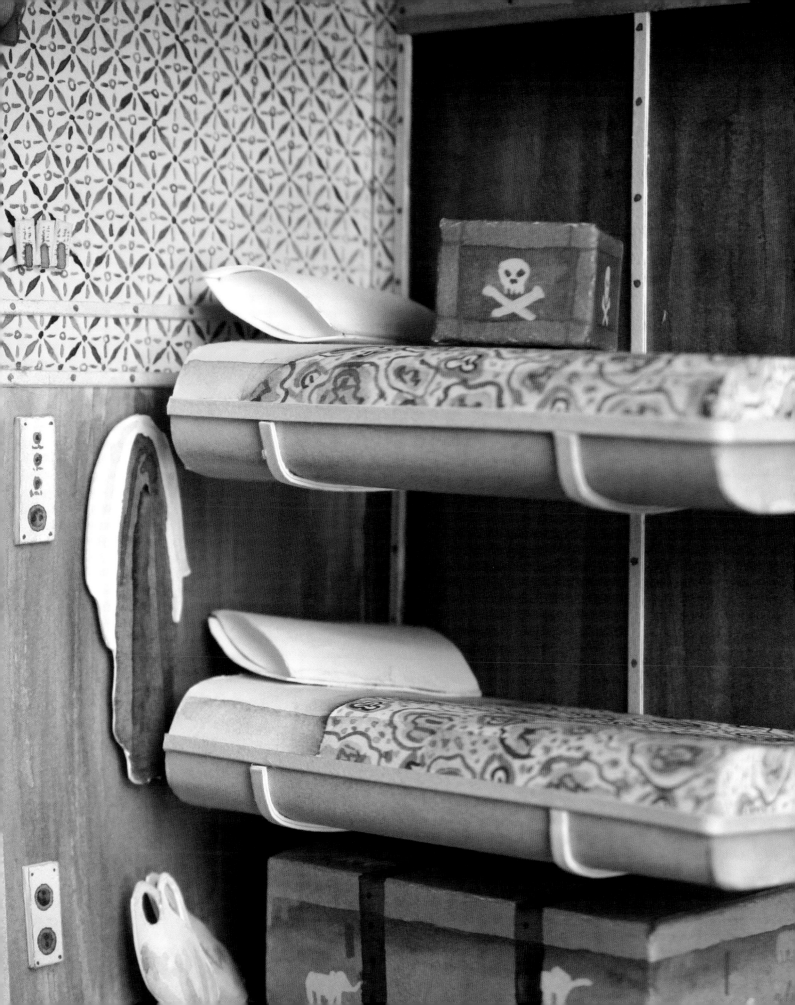

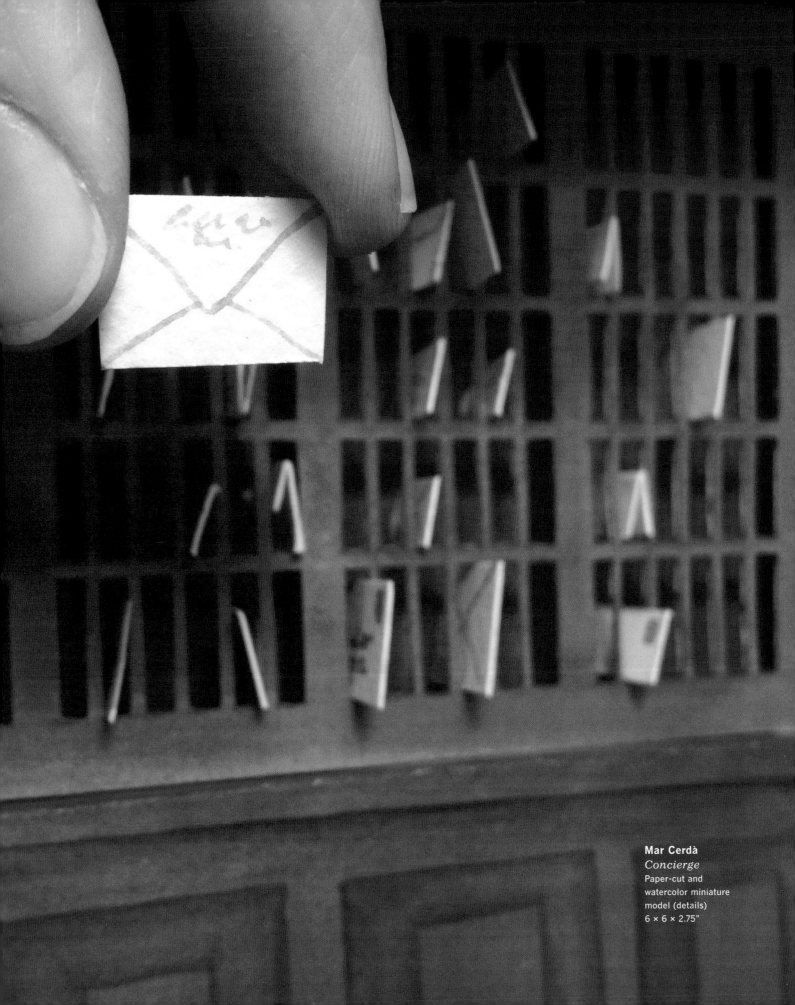

Mar Cerdà
Concierge
Paper-cut and
watercolor miniature
model (details)
6 × 6 × 2.75"

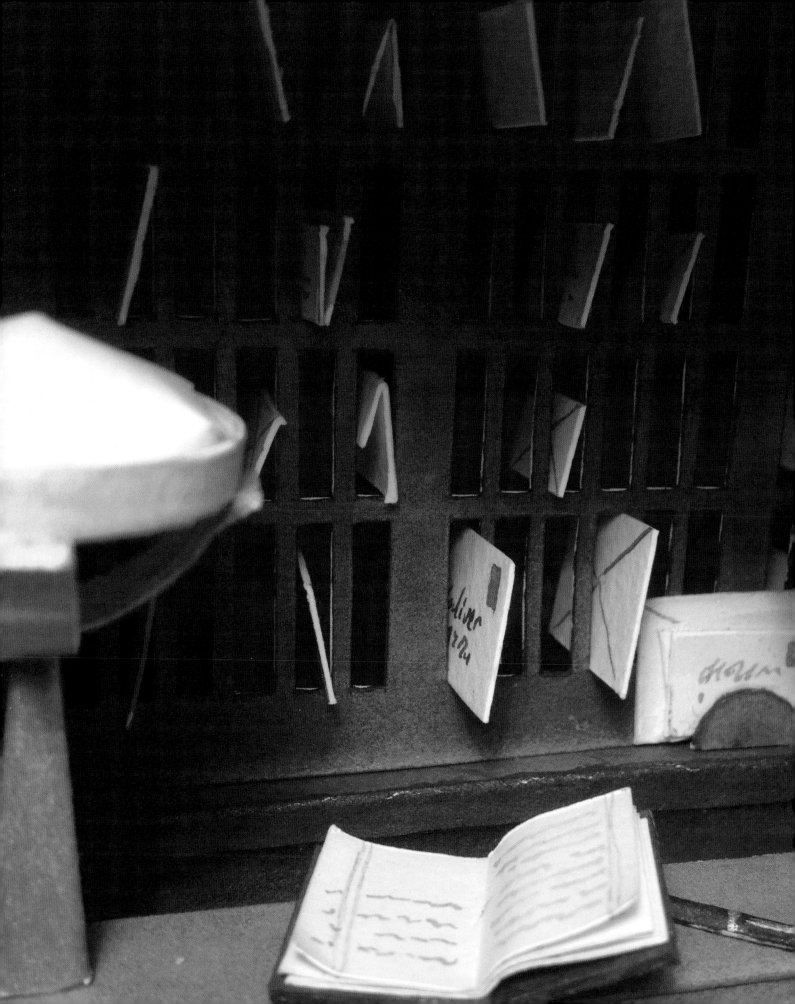

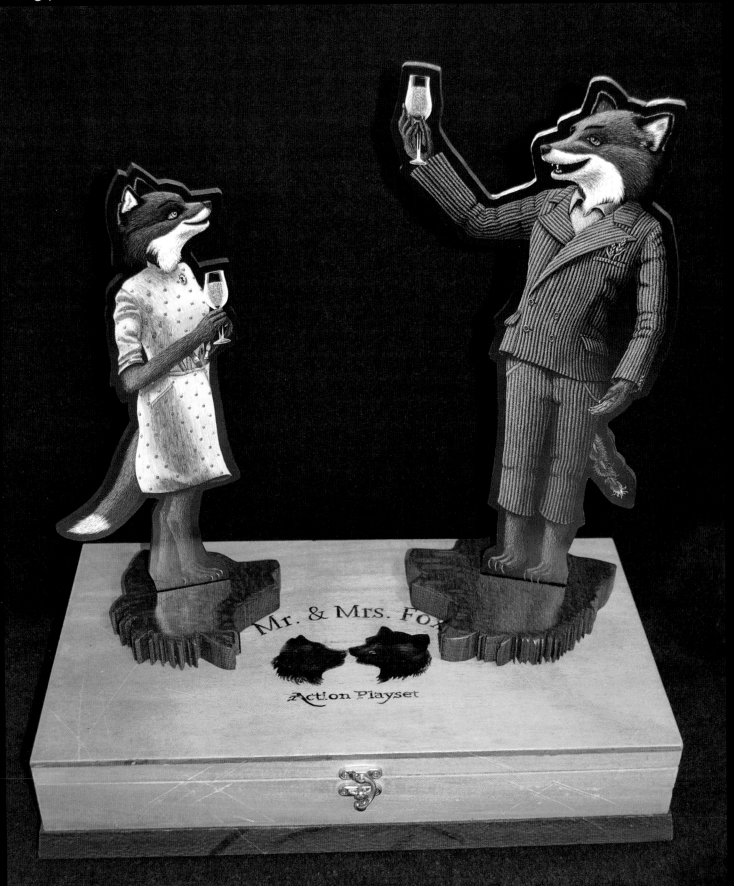

**Craig "Tapecat"
McCudden**
*Mr. and Mrs. Fox
Action Figure Playset*
Hand-painted scratchboard
on various fine woods
Dimensions variable

→

Julian Callos
Sam
Mixed media
13" tall

Codeczombie
*Steve Zissou's
Adventure in Resin*
Hand-painted resin figurine,
acrylic
2 × 7.5"

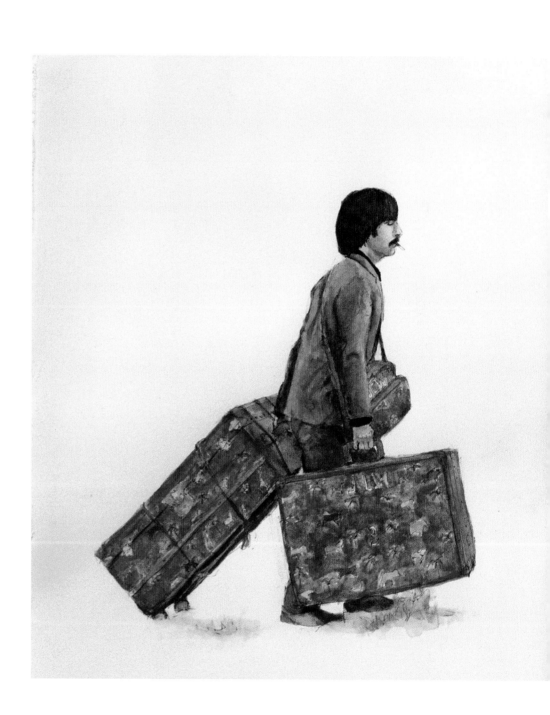

Christine Aria Hostetler
Baggage Brothers
Watercolor and pen and ink
on Arches watercolor paper
22 × 10"

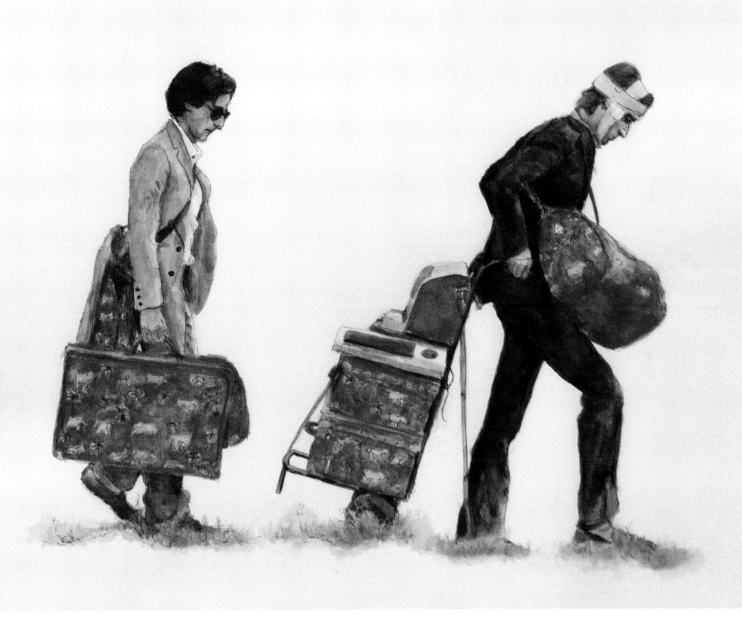

40

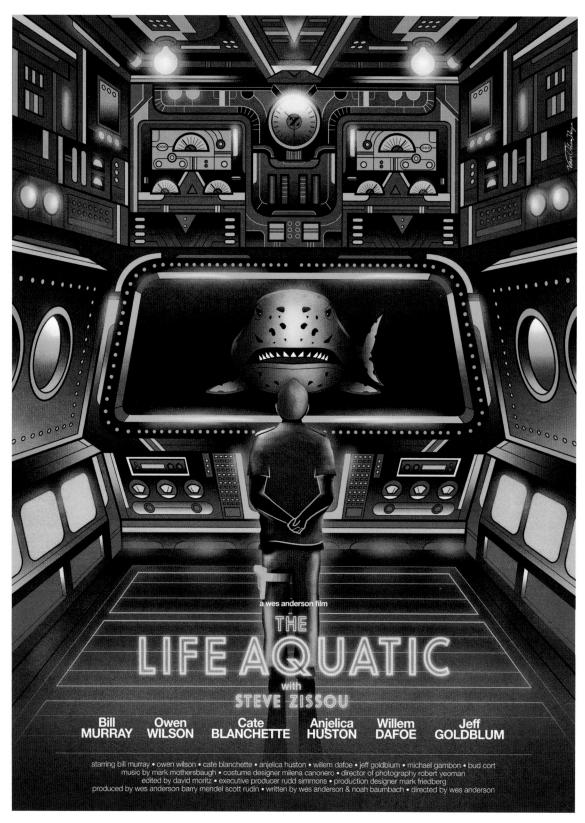

Van Orton Design

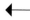

*The Life Aquatic
with Steve Zissou*
Fine art giclée print
18 × 24"

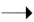

*The Grand
Budapest Hotel*
Fine art giclée print
18 × 24"

a wes anderson film

the grand budapest hotel

ralph fiennes f.murray abraham adrien brody willem dafoe jude law

starring ralph fiennes • f.murray abraham • edward norton • mathieu amalric • saoirse ronan • adrien brody • willem dafoe • léa seydoux
jeff goldblum • jason schwartzman • jude law • tilda swinton • harvey keitel • tom wilkinson • bill murray • owen wilson
music by alexandre desplat • director of photography robert yeoman a.s.c. • story by wes anderson & hugo guinness • directed by wes anderson

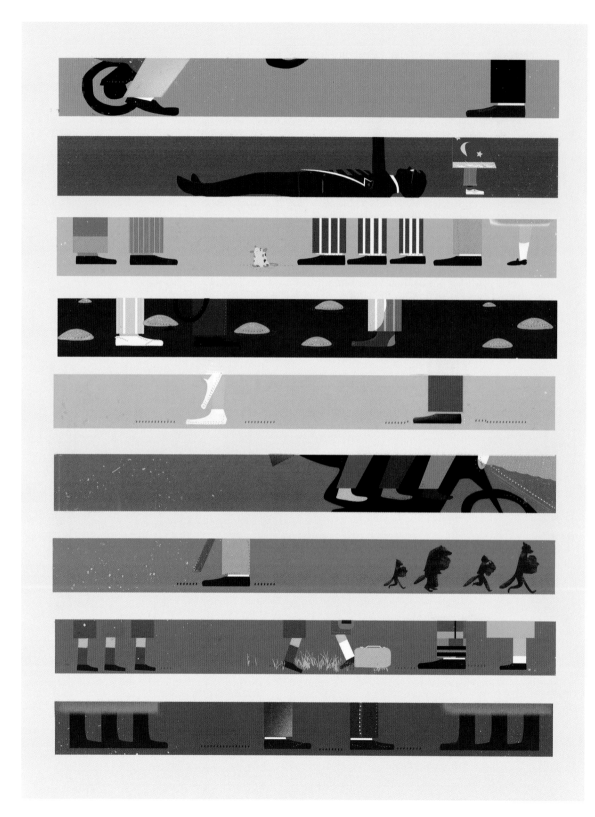

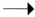

Fernando Reza
Feet on the
Ground
Fine art giclée print
18 × 24"

→

Doug LaRocca
F Is for Fantastic
Screen print
10.5 × 13.5"

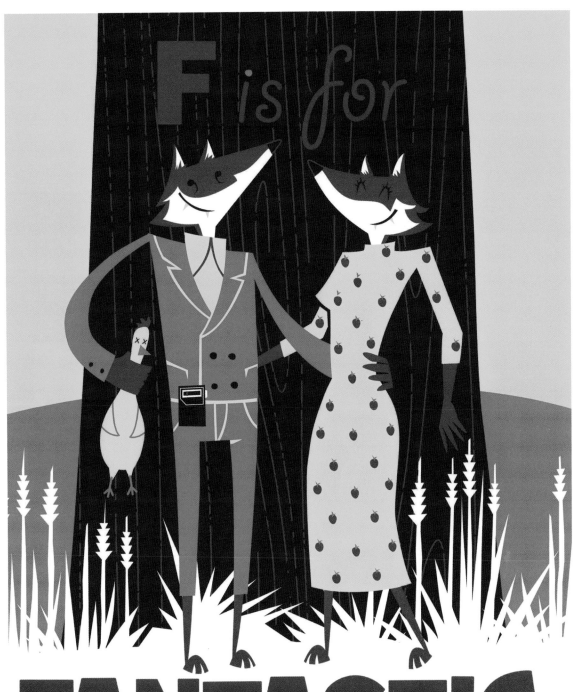

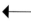

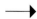

Van Orton Design
*The Royal
Tenenbaums*
Fine art giclée print
18 × 24"

Tara Krebs
*How Interesting,
How Bizarre*
Oil on Masonite
8 × 10"

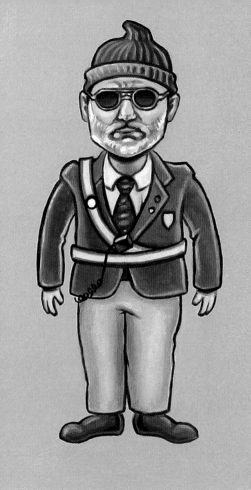

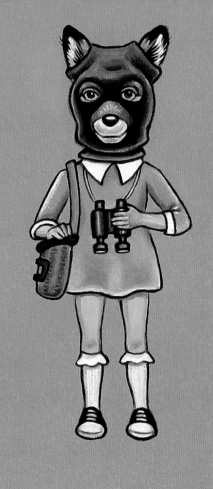

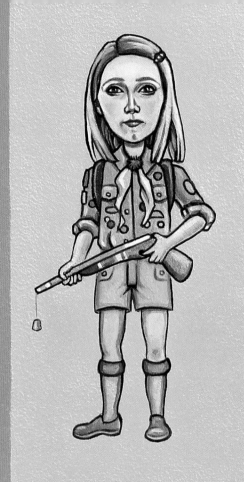

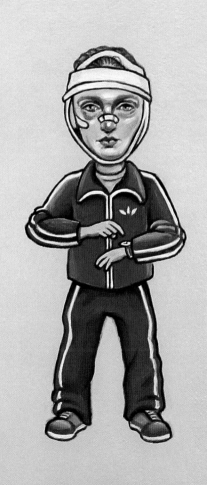

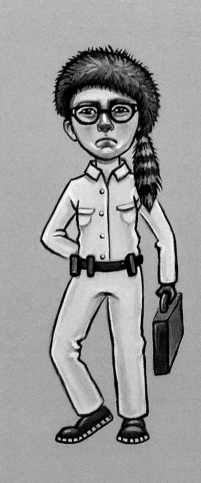

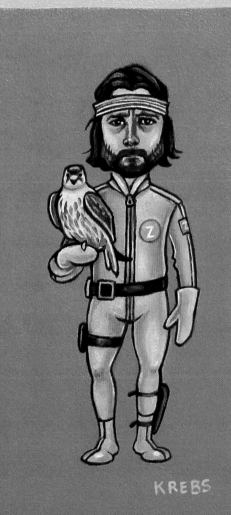

KREBS

46

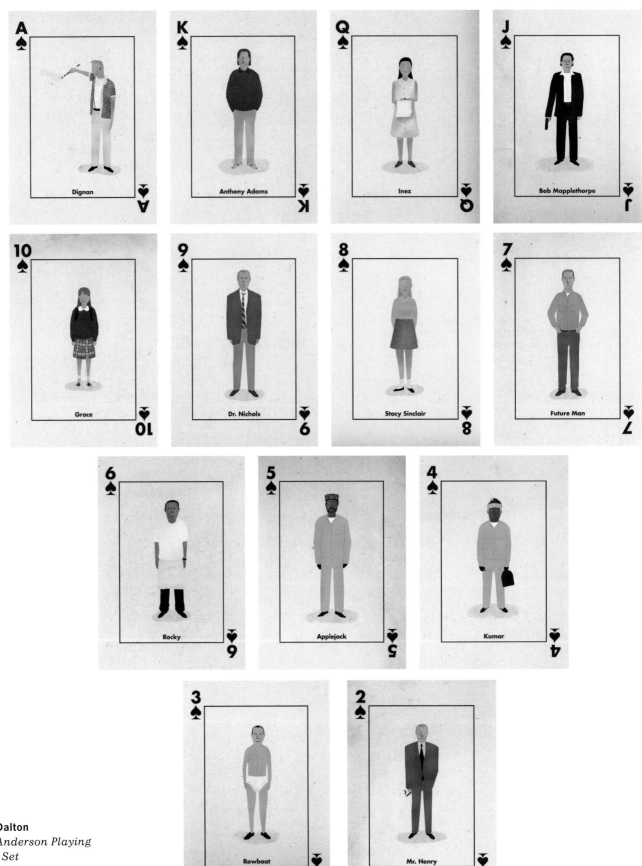

Max Dalton
Wes Anderson Playing Card Set
Custom printed playing cards
2.5 × 3.5" (each)

47

Jane Winslett-Richardson

Oseary Drakoulias

Bill Ubell

Esteban du Plantier

Intern

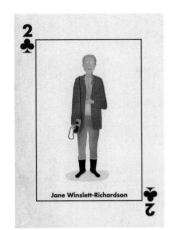

Vladimir Wolodarsky

Alistair Hennessey

Cody

Pelé dos Santos

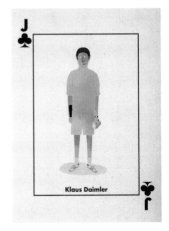

Klaus Daimler

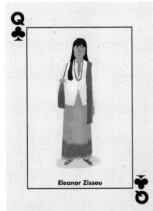

Eleanor Zissou

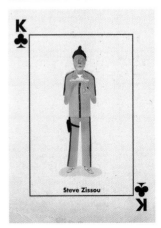

Steve Zissou

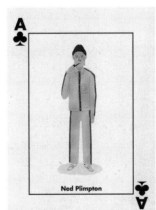

Ned Plimpton

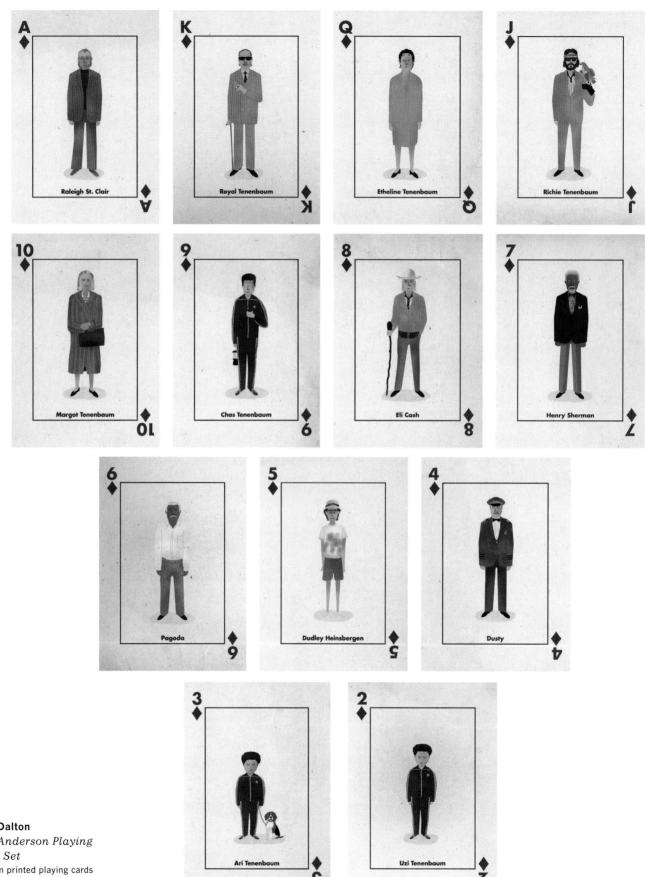

Max Dalton
Wes Anderson Playing Card Set
Custom printed playing cards
2.5 × 3.5" (each)

49

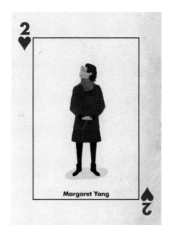

Margaret Yang

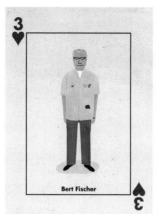

Bert Fischer

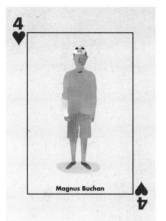

Magnus Buchan

Mr. Littlejeans

Ronny and Donny

Dr. Peter Flynn

Coach Beck

Mrs. Blume

Dr. Nelson Guggenheim

Dirk Calloway

Rosemary Cross

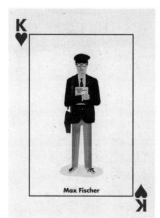

Max Fischer

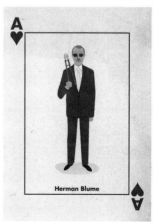

Herman Blume

Matt Chase
The Whole Family
Fine art giclée print
(details)
12 × 18"

Chelsea O'Byrne
Khaki Crusade
Gouache and graphite on
paper
20 × 16"

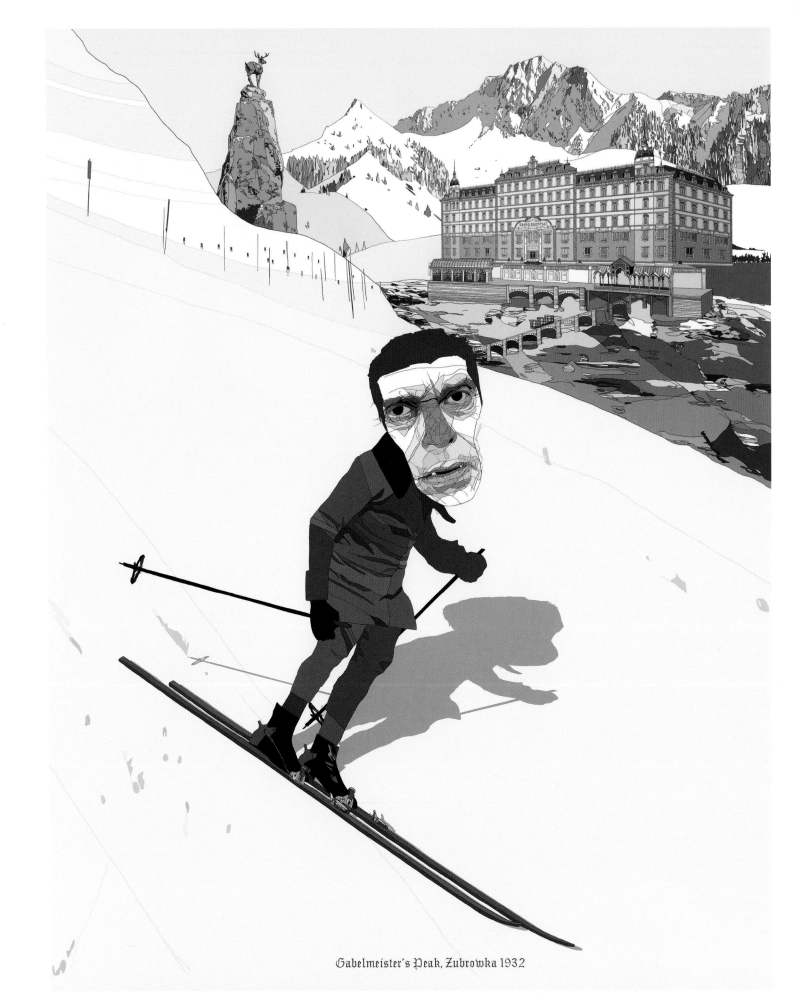

Gabelmeister's Peak, Zubrowka 1932

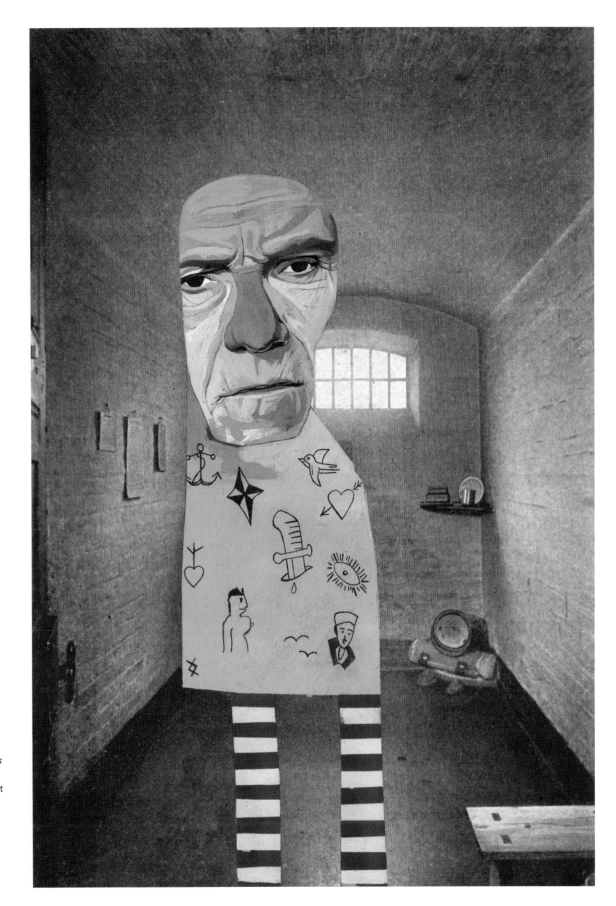

Conor Langton

←

*Gabelmeister's
Peak*
Fine art giclée print
16 × 20"

→

Ludwig
Acrylic portrait on
giclée print
13 × 17.5"

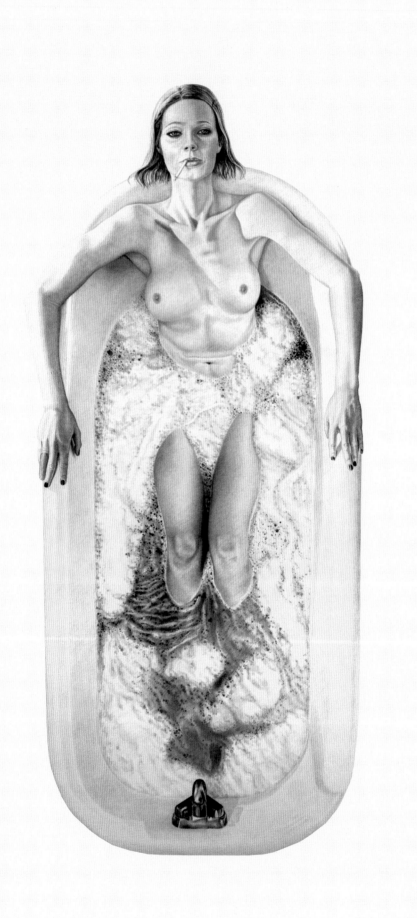

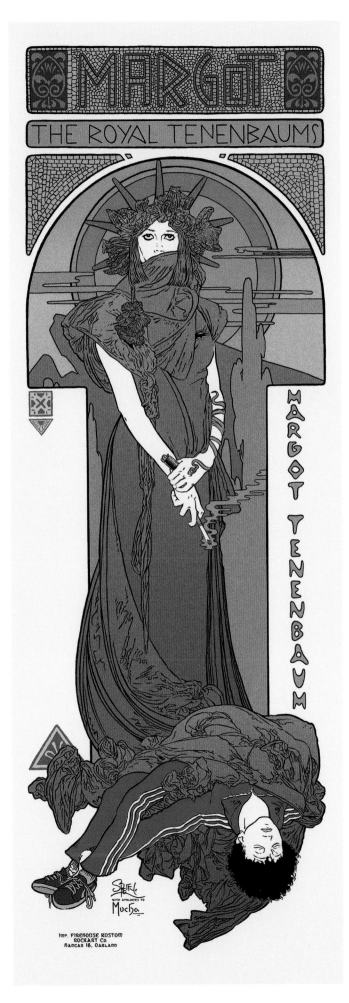

Joel Daniel Phillips
Margot
Charcoal and graphite
on paper
42 × 90"

Chuck Sperry
Margot
Screen print
22 × 62"

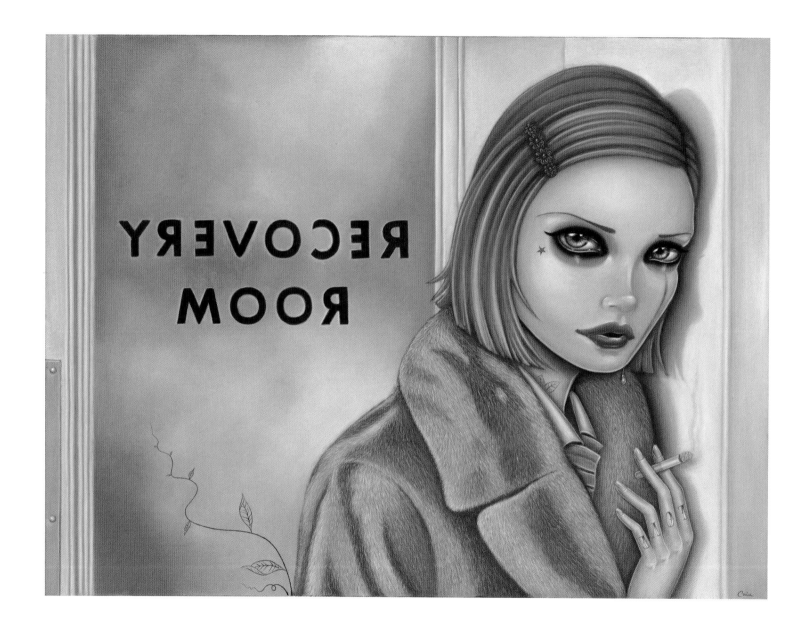

←
Caia Koopman
Recovery Room
Acrylic on panel
20 × 16"

→
Audrey Pongracz
Rat
Oil on canvas
11 × 14"

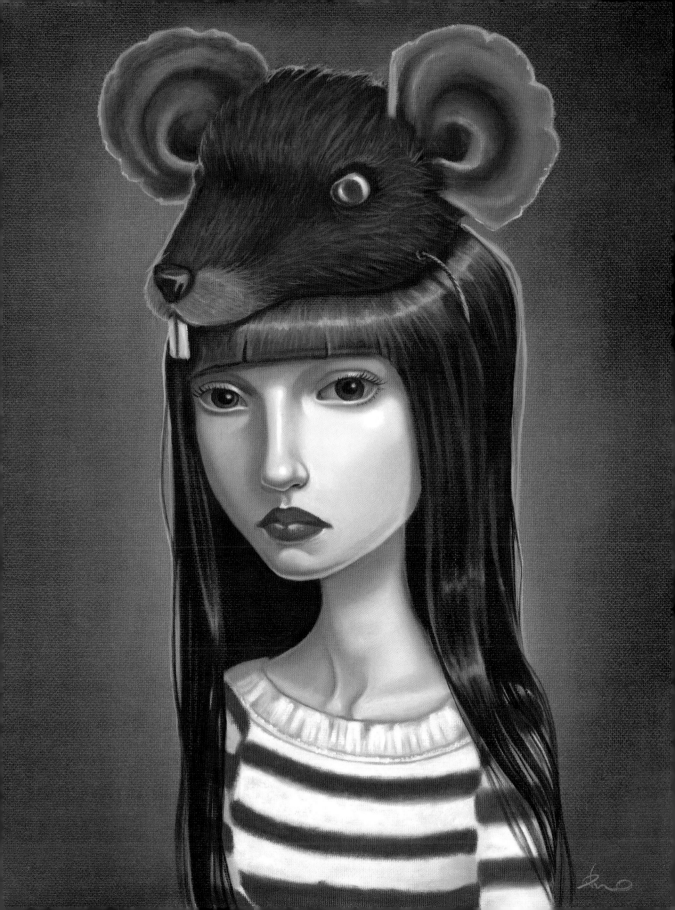

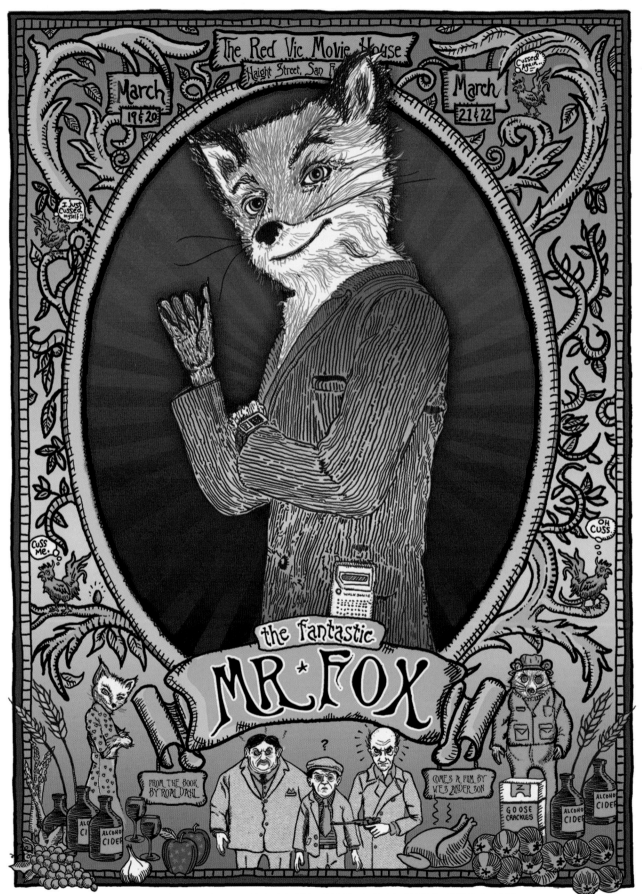

POSTER BY ZOLTRON 2010 FOR THE RED VIC MOVIE HOUSE, HAIGHT STREET, SF. - PRINTED AT HANGAR 18 IN OAKLAND. CA. RV30-12

Zoltron
Fantastic Mr. Fox
Five-color hand-pulled
silk-screen print

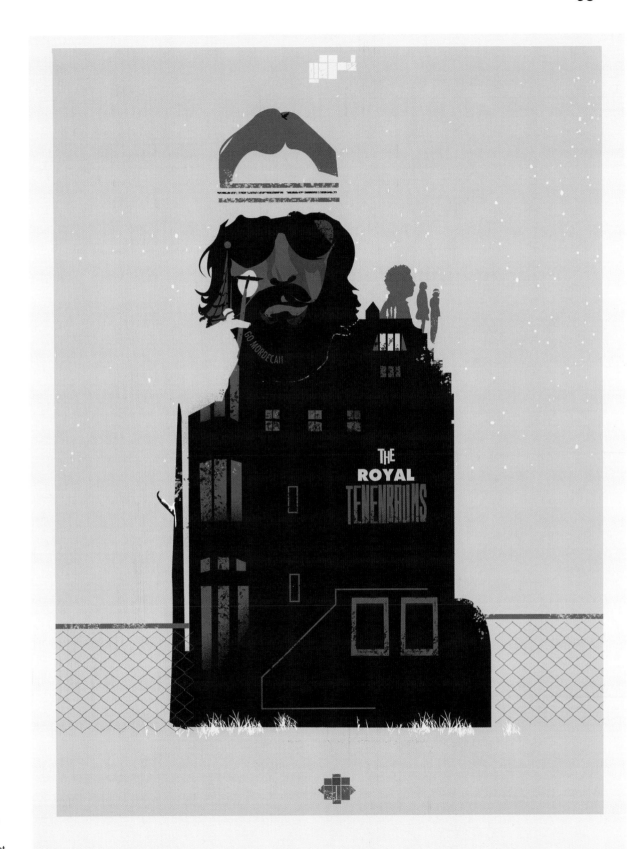

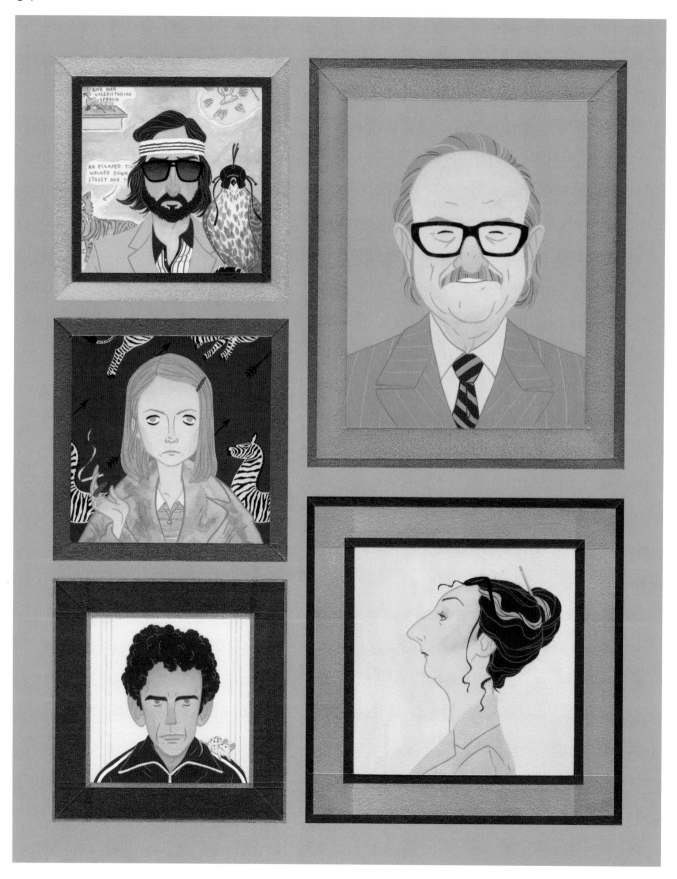

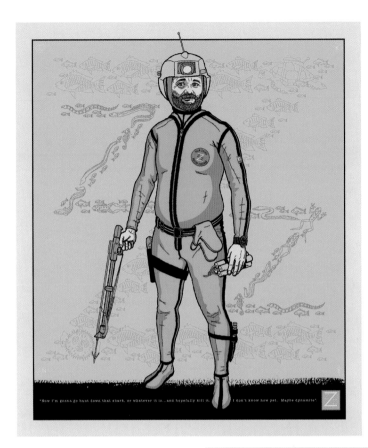

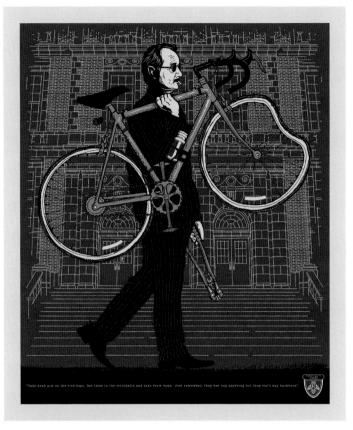

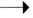

Julian Callos
The Royal Tenenbaums
Acrylic, gouache, and iridescent paint on paper mounted on panels
14 × 18" (variable)

Todd Slater
Zissou,
They Can't Buy Backbone,
The Royal Tenenbaums
Screen prints
18 × 24" (each)

66

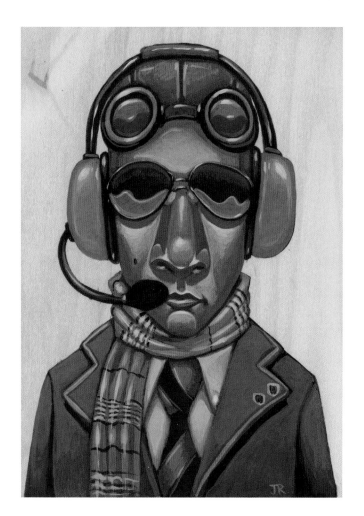

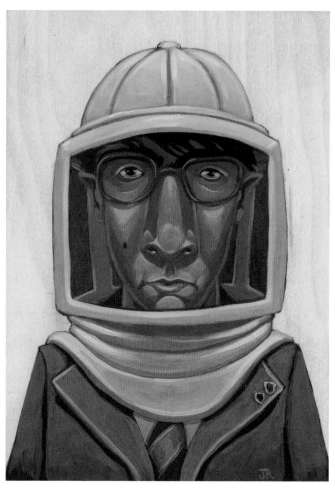

Jesse Riggle

←

Piper Cub Club
Acrylic on maple
5 × 7"

←

*Rushmore
Beekeepers*
Acrylic on maple
5 × 7"

→

Yankee Racers
Acrylic on maple
5 × 7"

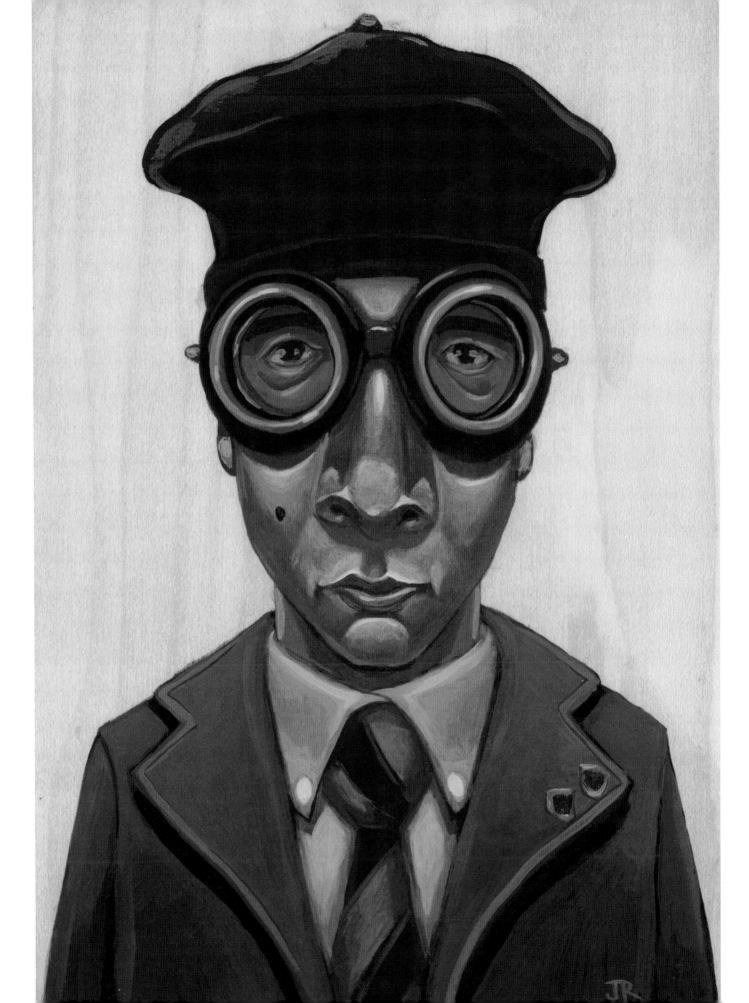

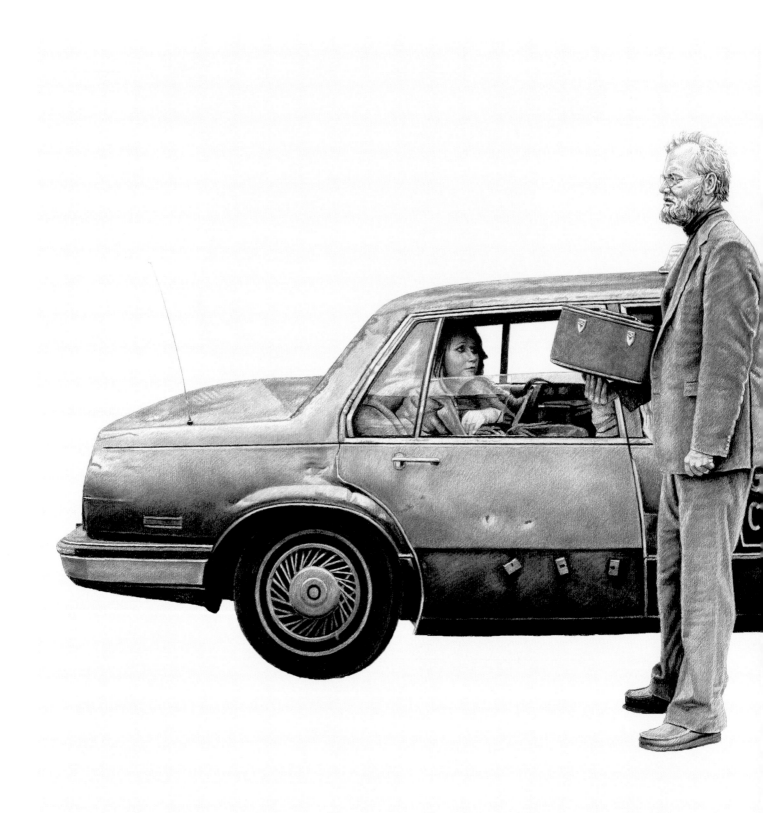

Joel Daniel Phillips
You Don't Love Me Anymore, Do You?
Graphite and charcoal on paper
30 × 16"

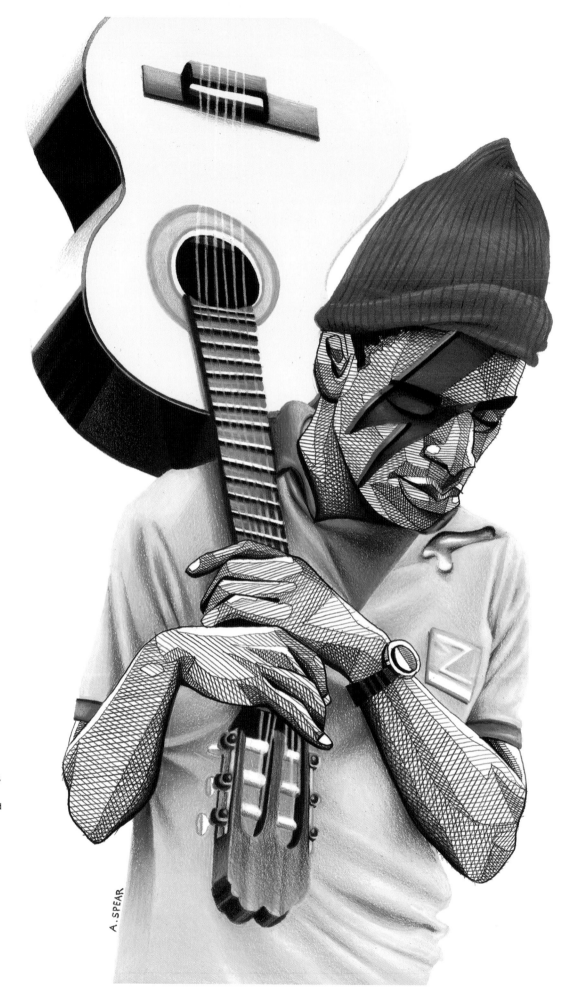

←

Andrew Spear
Aladdin Sue-Sain Zissou
Colored pencil, pen and ink on paper
11 × 17"

→

Bruce White
Steve Zissou
Acrylic on black velvet
14 × 18"

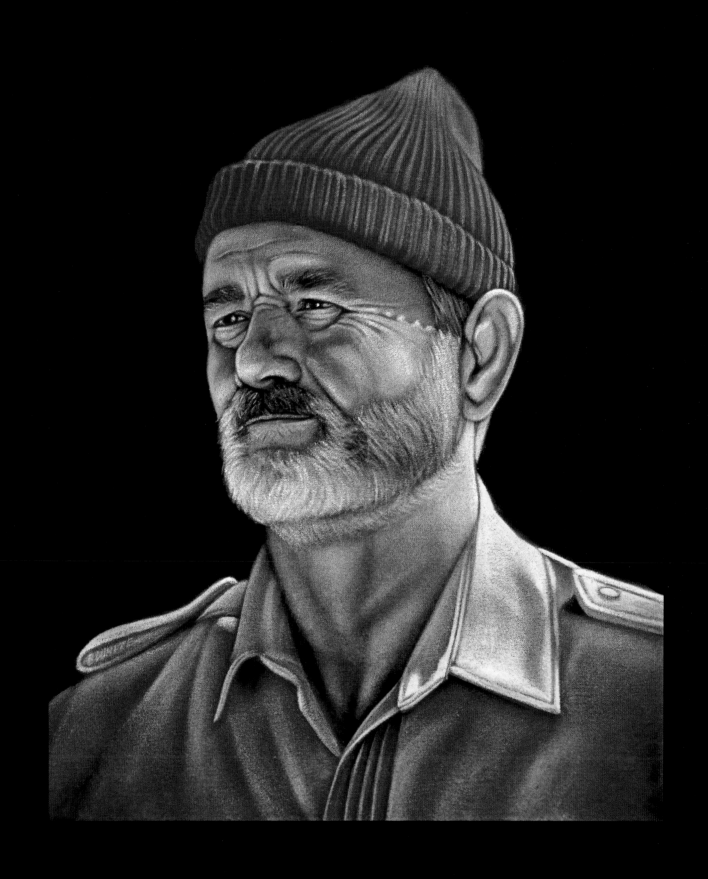

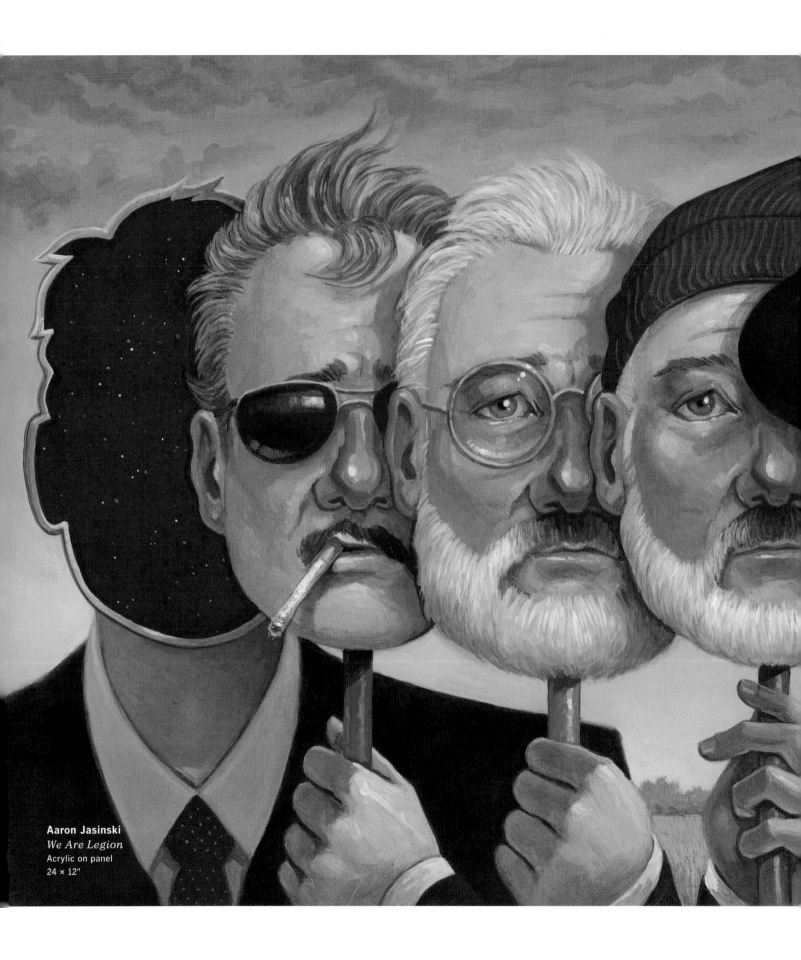

Aaron Jasinski
We Are Legion
Acrylic on panel
24 × 12"

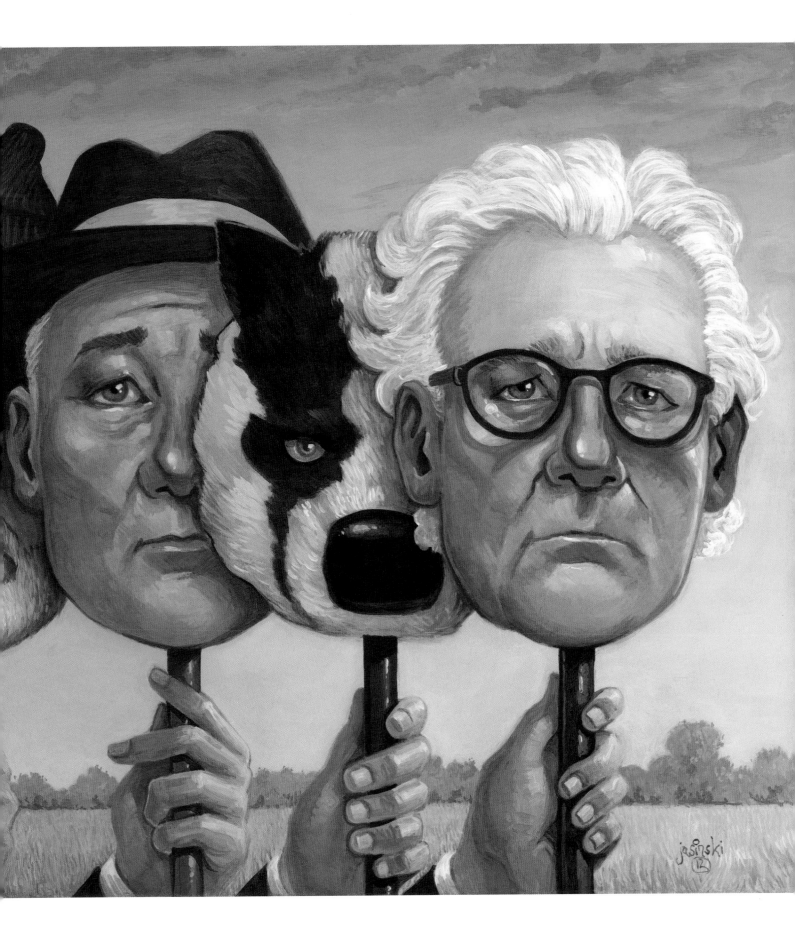

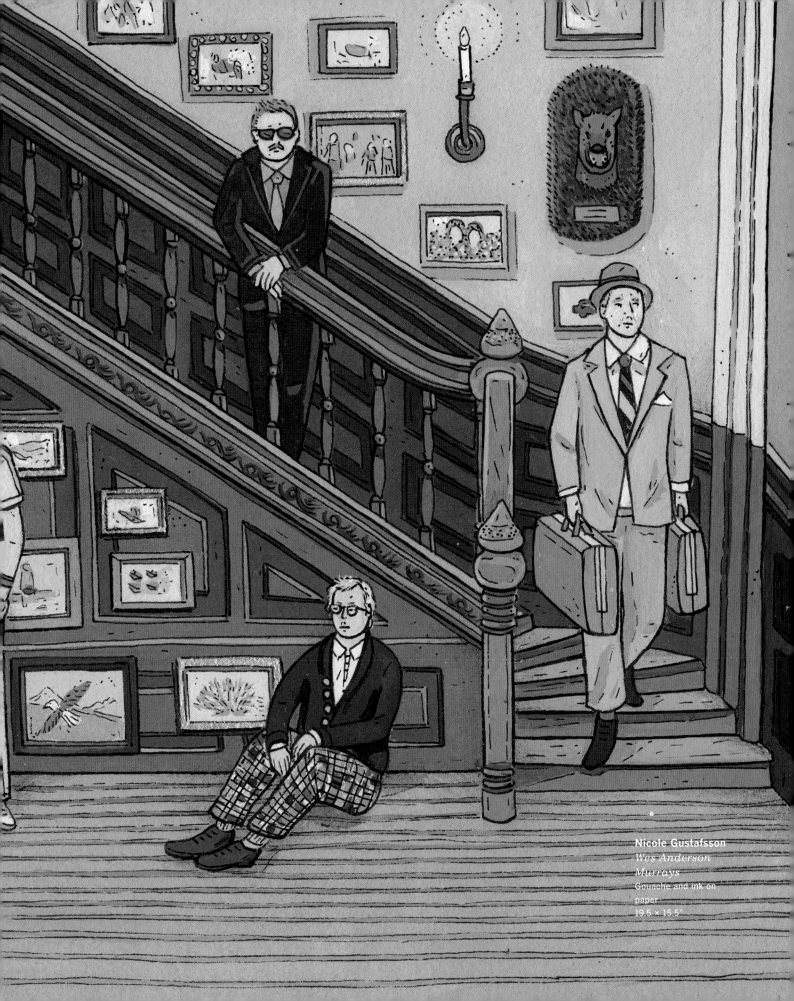

Nicole Gustafsson
*Wes Anderson
Murrays*
Gouache and ink on
paper
19.5 × 15.5"

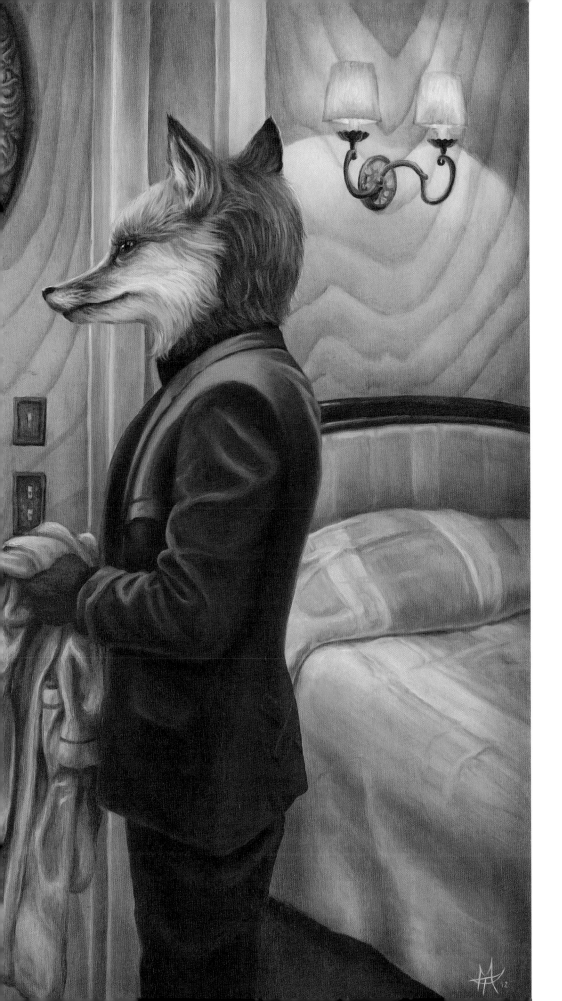

Mandy Tsung
Den of Foxes
Oil on wood
24 × 18"

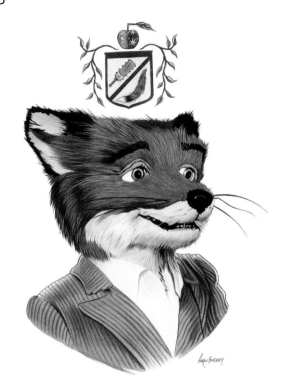

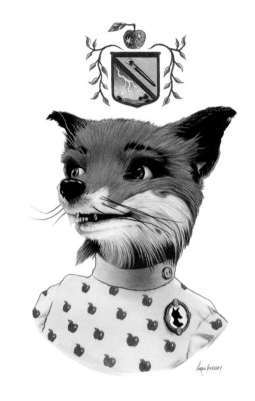

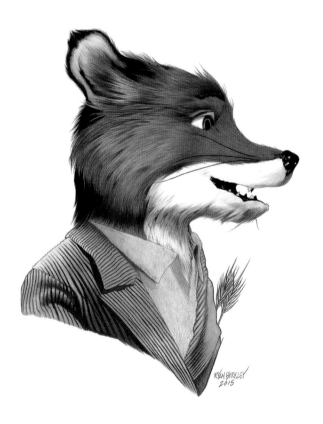

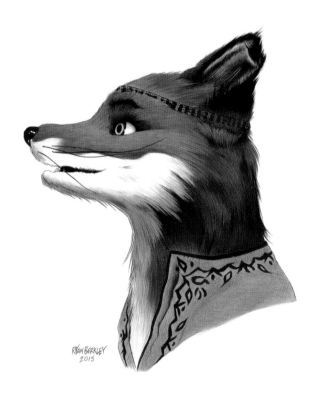

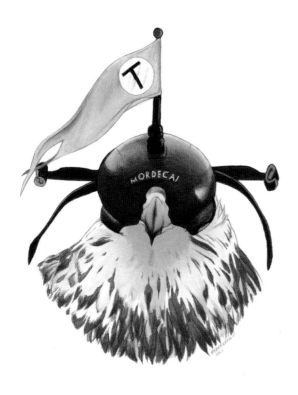

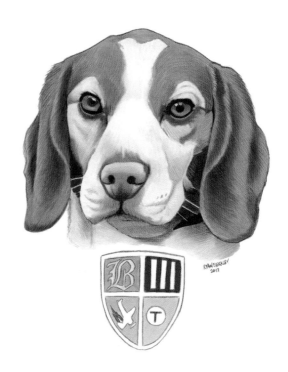

Ryan Berkley

Mr. Fox,
Mrs. Fox,
Young Love I,
Young Love II

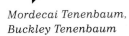

Mordecai Tenenbaum,
Buckley Tenenbaum

Colored pencil and marker
on paper
8 × 10" (each)

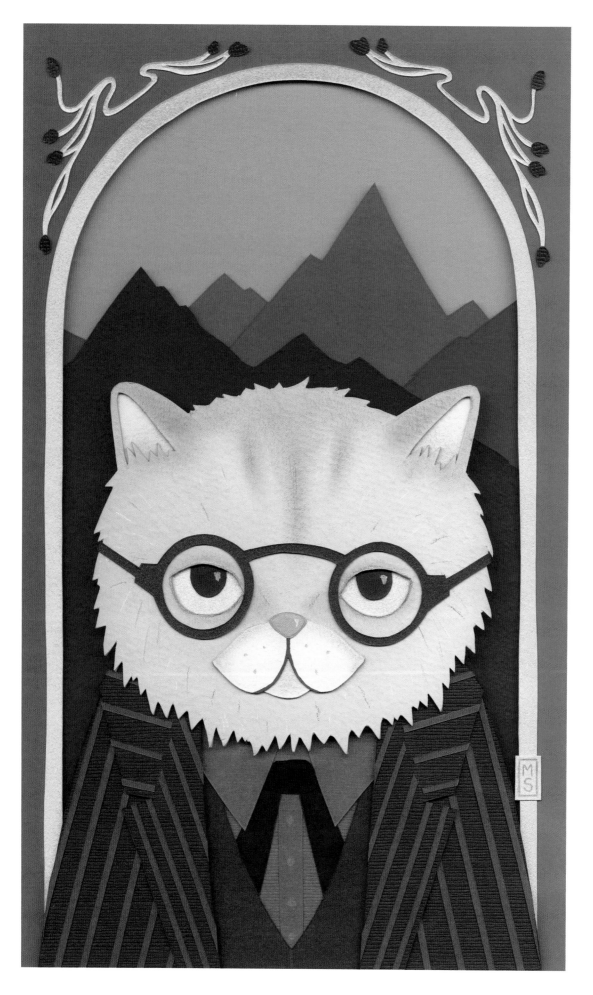

Meghan Stratman

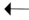

*Did He Just
Throw My
Cat out of the
Window?*
Paper collage
12 × 16"

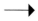

*Do You Think
I'm an Athlete?*
Paper collage
12 × 16"

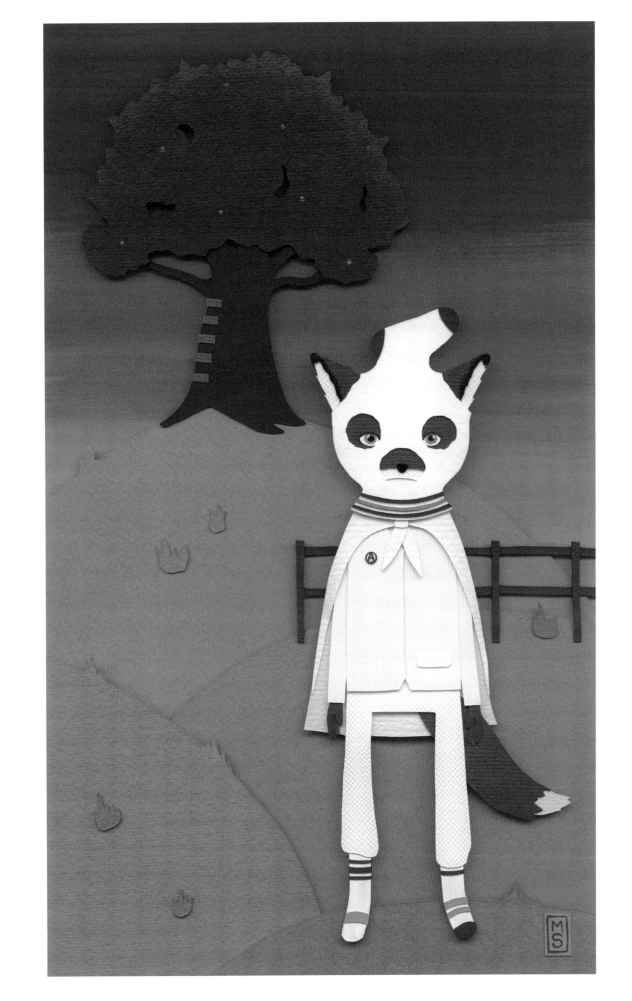

Crowded Teeth
The Rat
Hand-layered paper
collage
14 × 6 × 2"

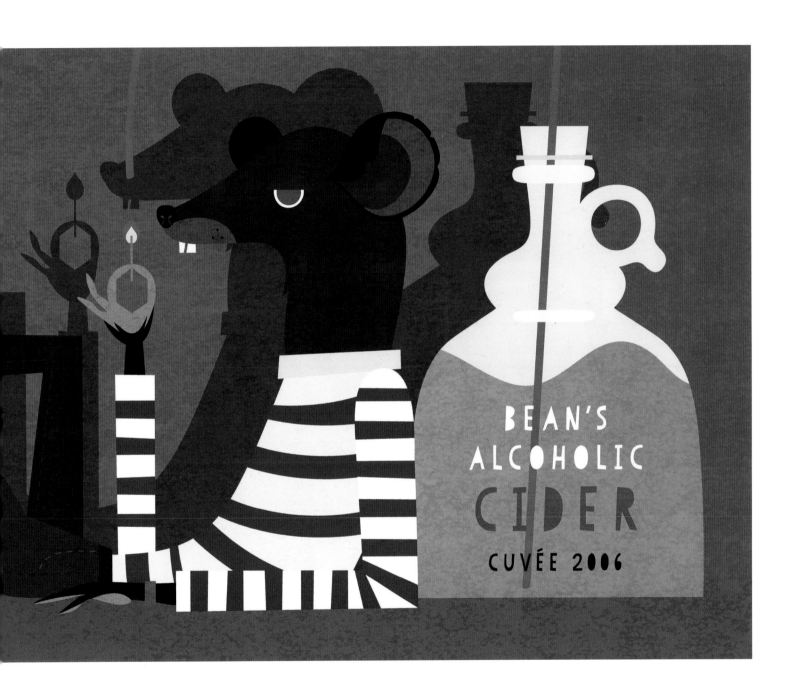

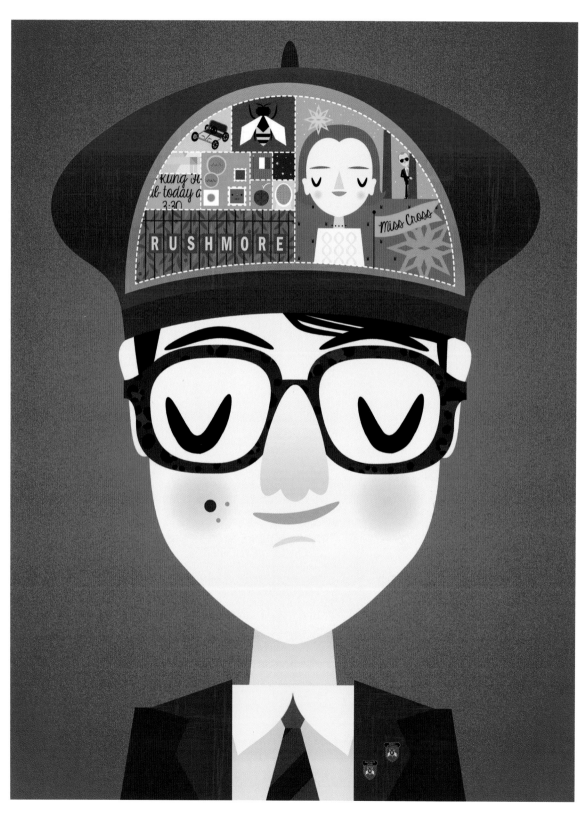

Crowded Teeth

← *Max*
Laser-cut wood, acrylic, and velvet
9 × 12"

→ *Dudley's World*
Hand-layered paper collage
11 × 14"

Raleigh St. Clair

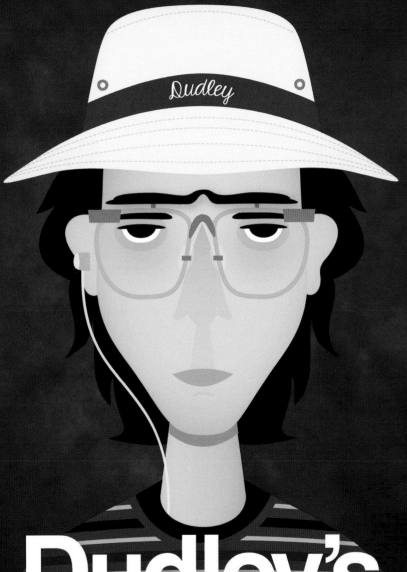

Dudley's World

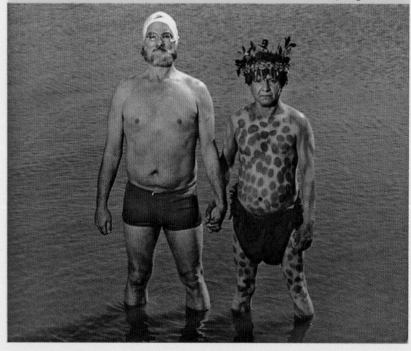

Raleigh St.Clair

The Peculiar Neurodegenerative Inhabitants of the Kazawa Atoll

Sprague

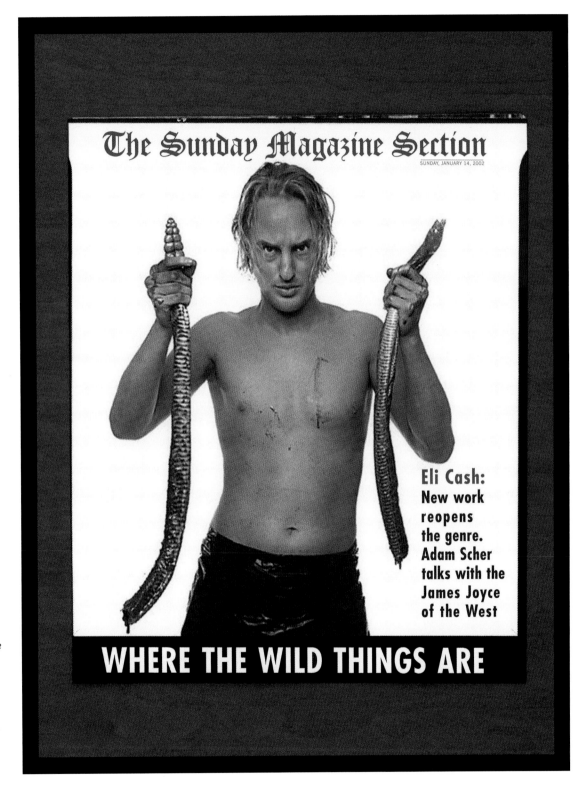

Tim Jordan

← *Neurodegenerative Inhabitants*
Screen print
18 × 24"

→ *James Joyce of the West*
Screen print
18 × 24"

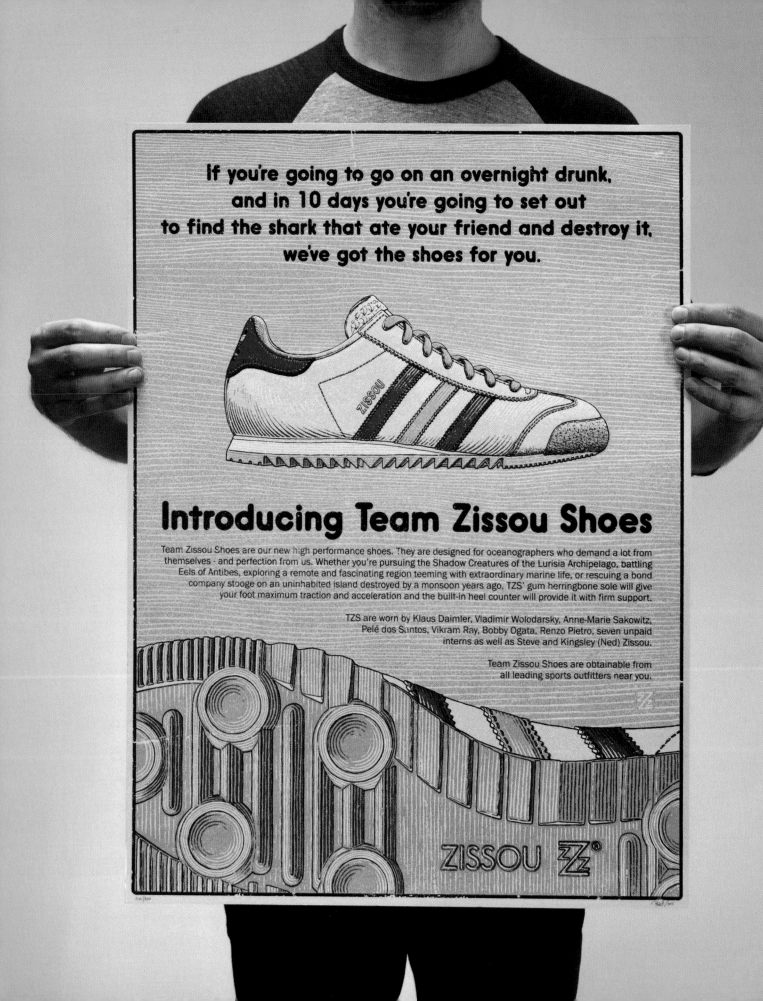

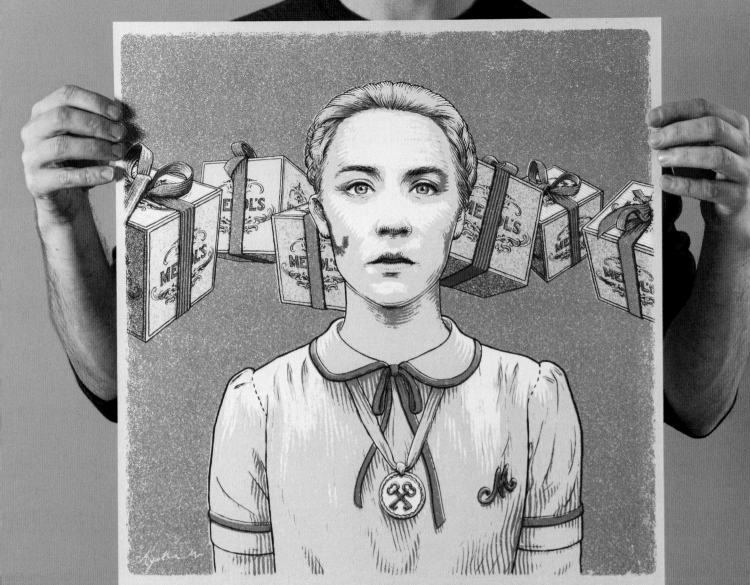

THE
GRAND
BUDAPEST
HOTEL

STARRING RALPH FIENNES · F. MURRAY ABRAHAM · MATHIEU AMALRIC · ADRIEN BRODY · WILLEM DAFOE · JEFF GOLDBLUM · BILL MURRAY
JUDE LAW · EDWARD NORTON · SAOIRSE RONAN · TILDA SWINTON · OWEN WILSON AND INTRODUCING TONY REVOLORI AS ZERO
MUSIC BY ALEXANDRE DESPLAT FILM EDITOR BARNEY PILLING COSTUME DESIGN BY MILENA CANONERO DIRECTOR OF PHOTOGRAPHY ROBERT YEOMAN PRODUCTION DESIGNED ADAM STOCKHAUSEN
SCREENPLAY BY WES ANDERSON DIRECTED BY WES ANDERSON INSPIRED BY THE WRITINGS OF STEFAN ZWEIG

**Bartosz
Kosowski**

*Team Zissou
Shoes*
Screen print
18 × 24"

The Grand

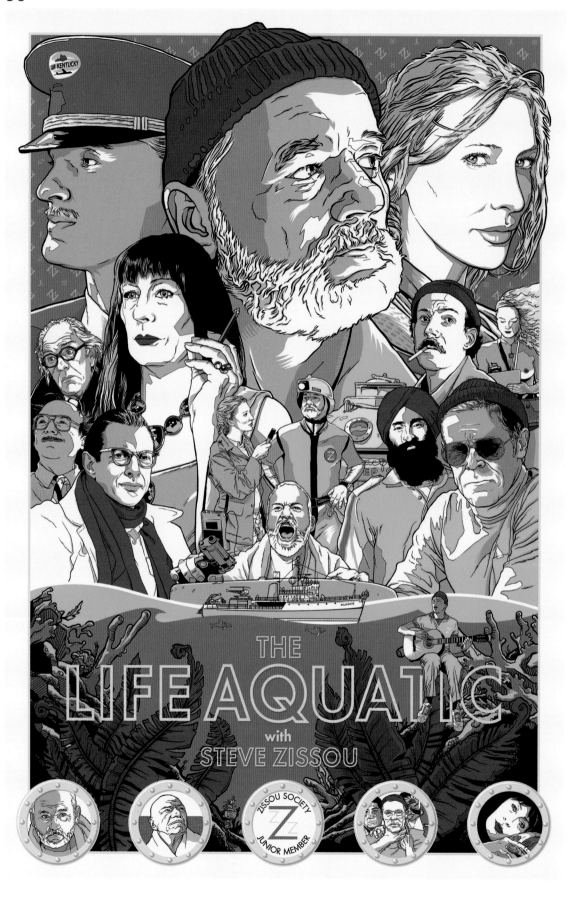

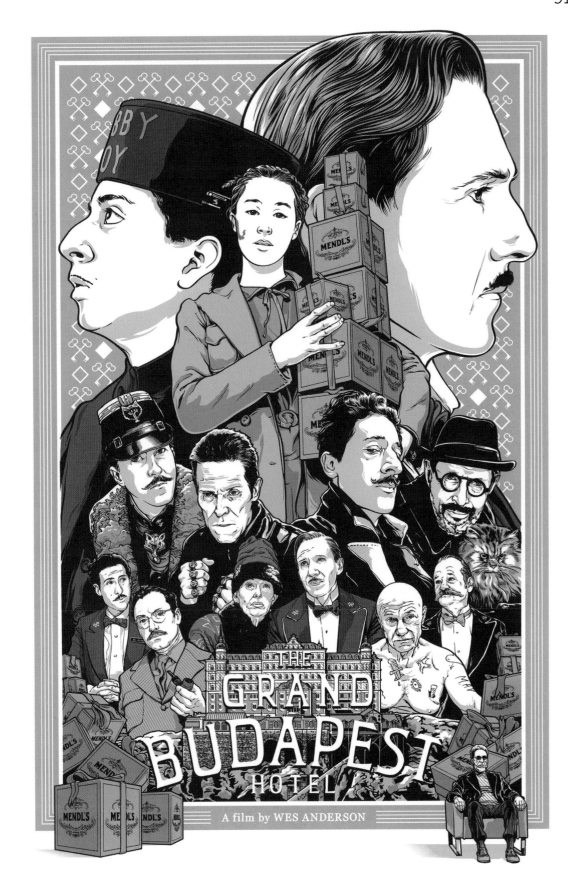

Joshua Budich

The Life Aquatic
Screen print
24 × 36"

→

*The Grand
Budapest Hotel*
Screen print
24 × 36"

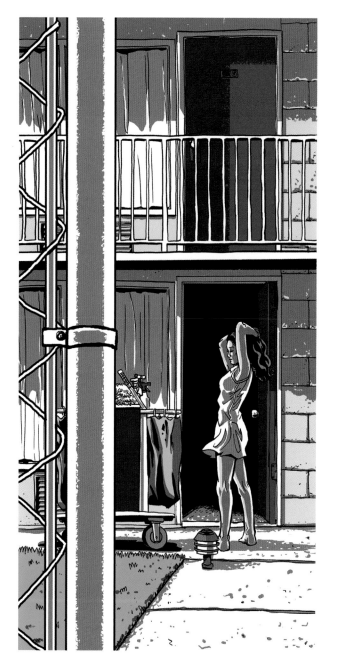

Tim Doyle

Mambo Guajiro
Screen print
12 × 24"

*I Found Out I Was
Wrong*
Screen print
12 × 24"

← *The Author*
Screen print
12 × 24"

→ *The Death of
Mr. Buckley*
Screen print
12 × 24"

Tim Doyle

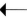

Mutiny on the Belafonte
Screen print
12 × 24"

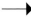

This Time Tomorrow
Screen print
12 × 24"

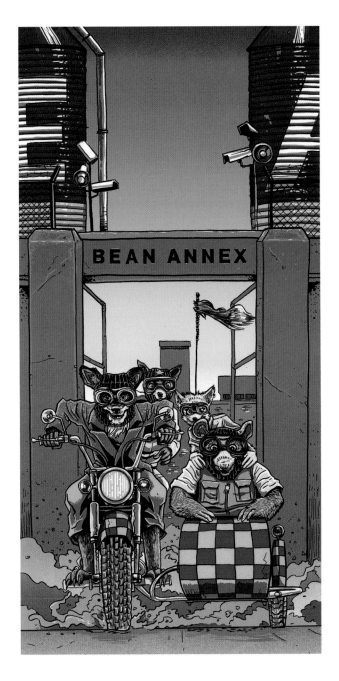

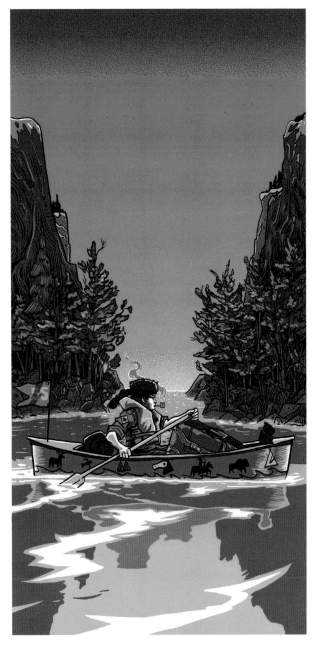

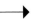

What the Cuss
Screen print
12 × 24"

Ramblin Man
Screen print
12 × 24"

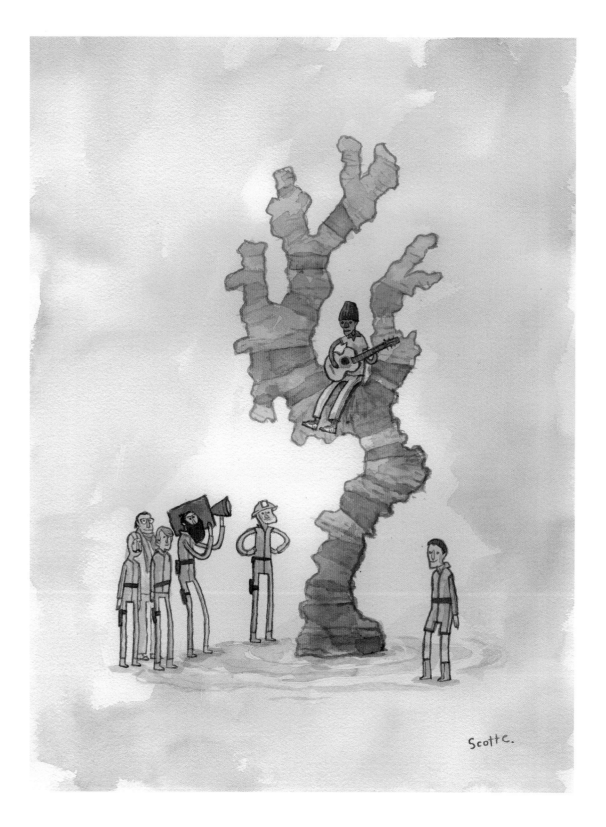

Scott C.
Coral Tunes
Watercolor on paper
12 × 16"

Danielle Murray
She Smokes
Oil on board
12 × 10"

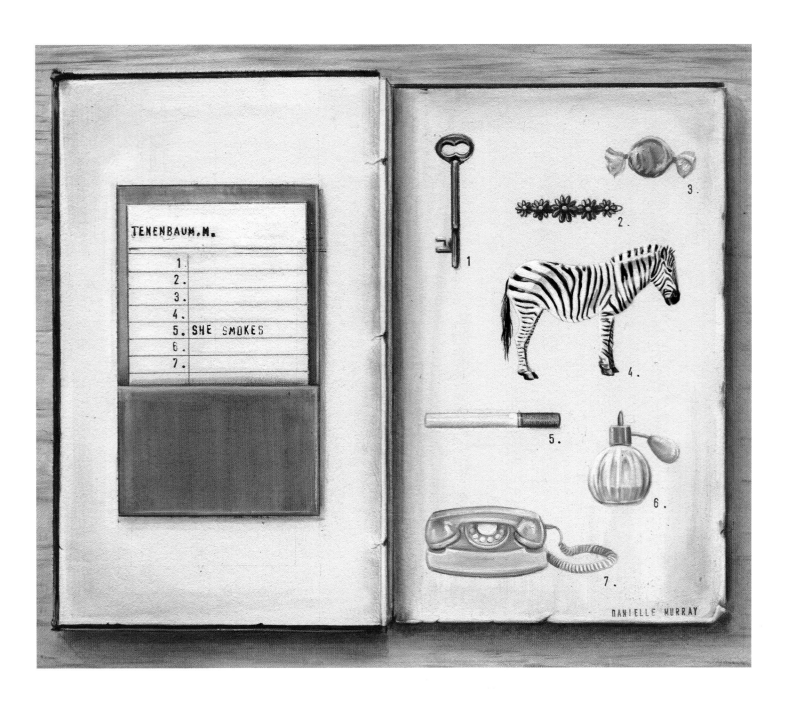

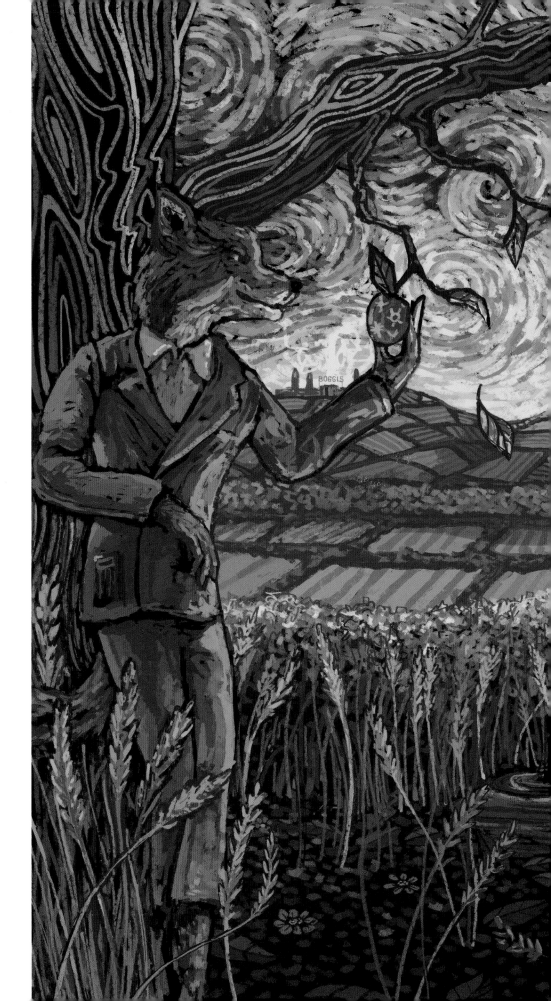

James R. Eads
*You Really Are Kind
of "Fantastic"*
Fine art giclée print
24 × 18"

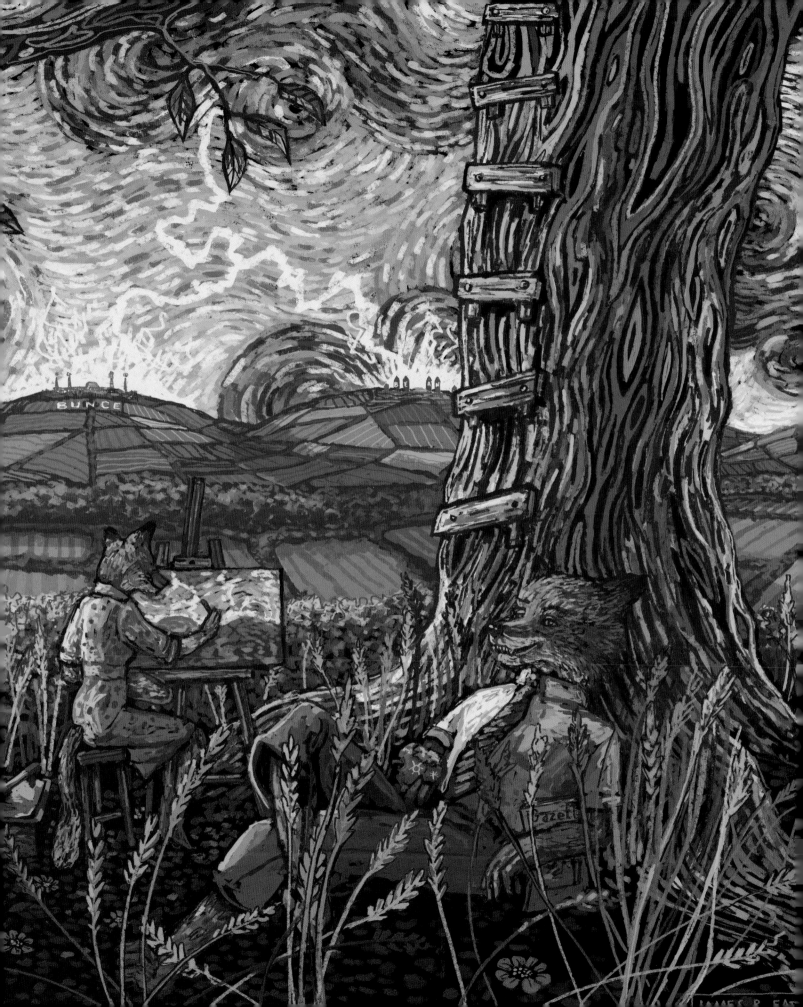

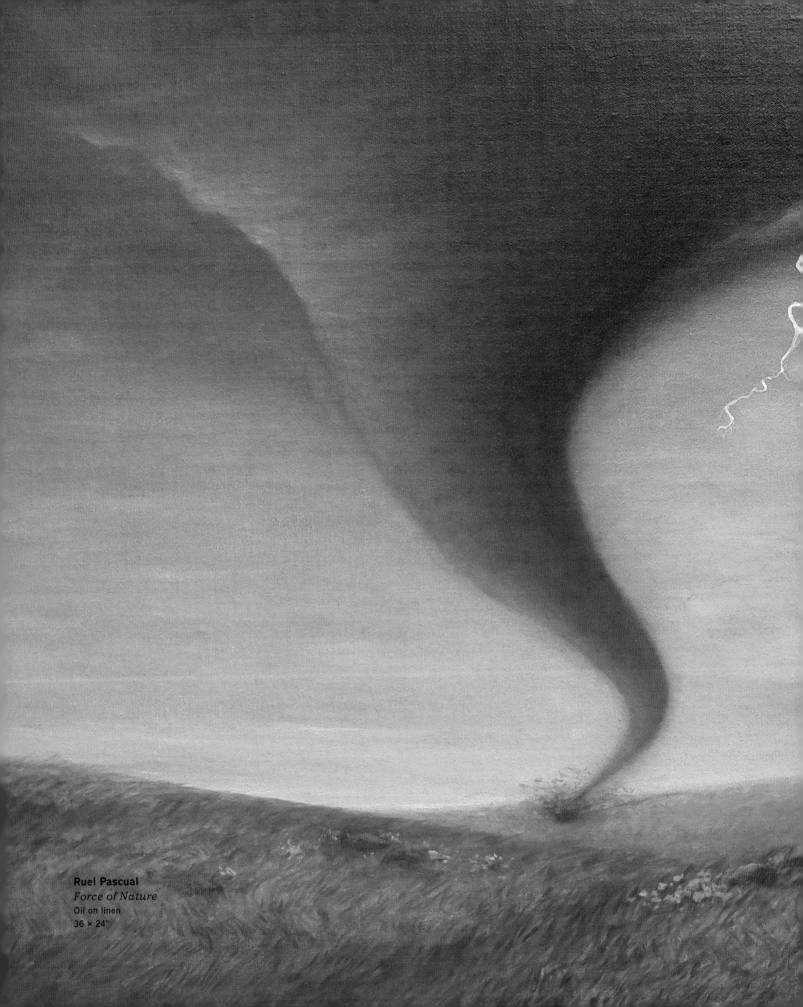

Ruel Pascual
Force of Nature
Oil on linen
36 × 24"

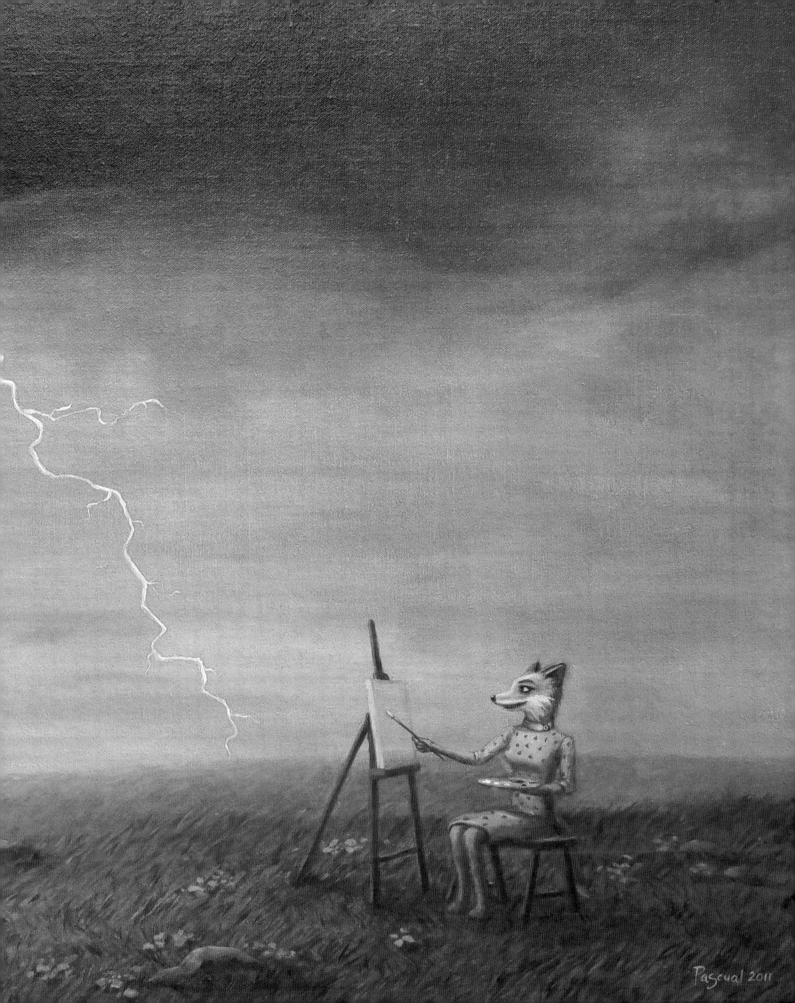

Pascual 2011

Andy Kehoe
Days of Cider
Oil, acrylic, and resin in
wooden box
16 × 20"

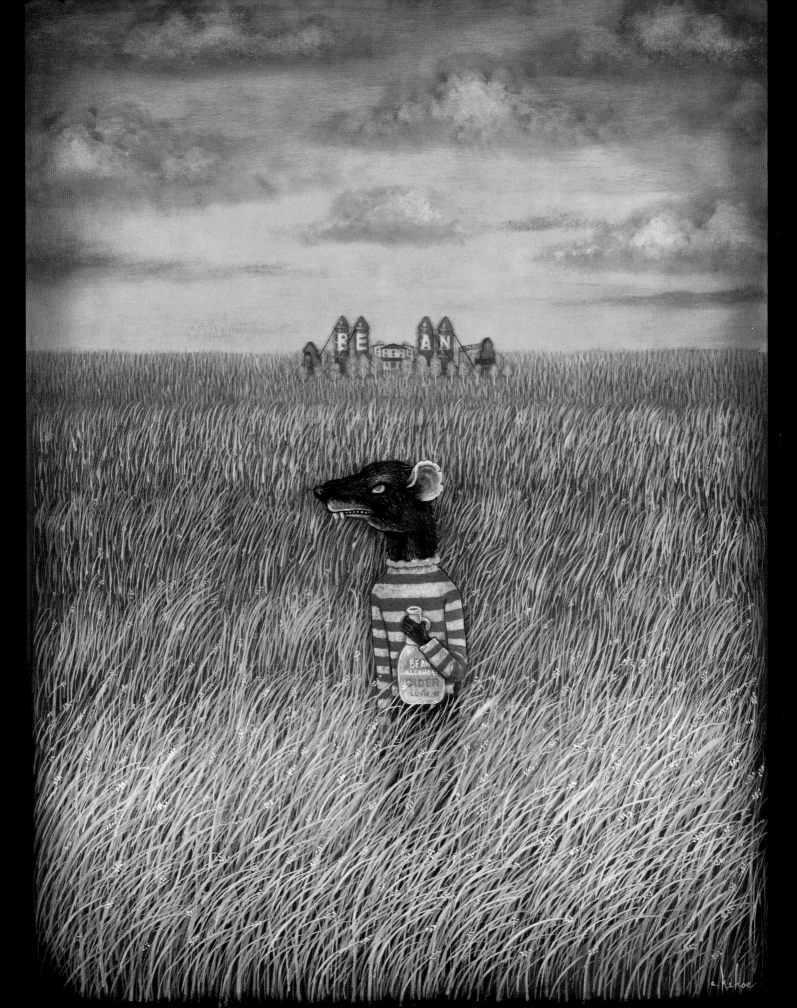

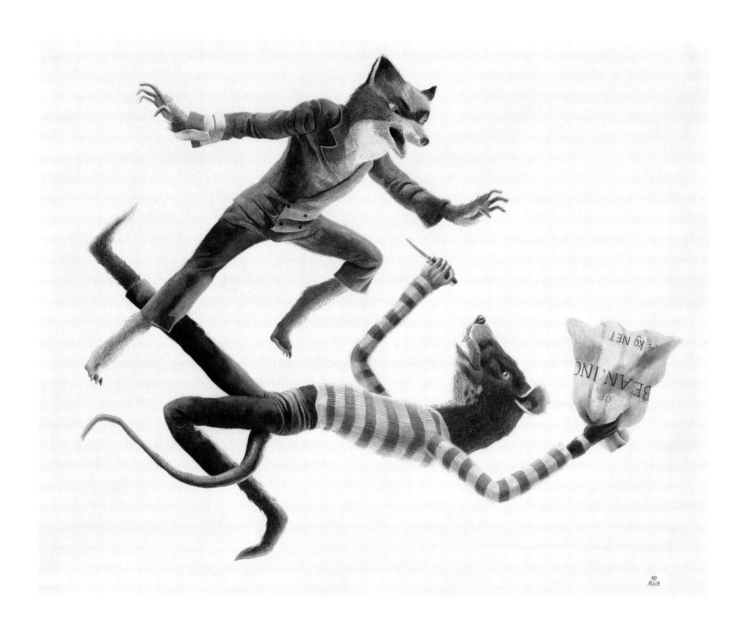

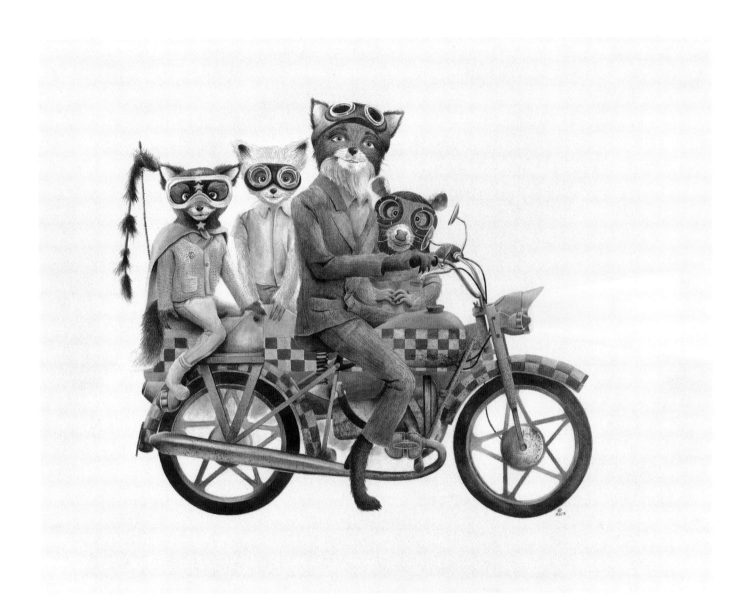

Maryanna Hoggatt

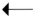

Fox vs. Rat
Watercolor, ink, and
gouache on paper
21 × 16.75"

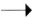

Fantastic Bandits
Watercolor, ink, and
gouache on paper
21 × 16.75"

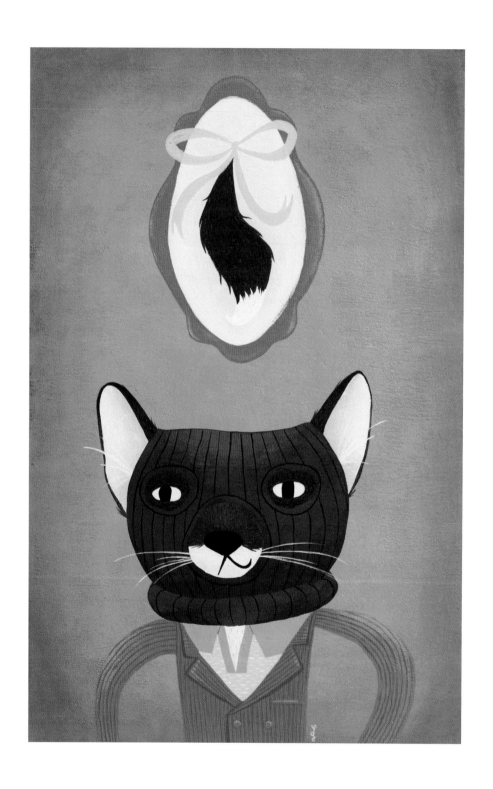

←
Lauren Gregg
*You Know,
You Really Are
Fantastic*
Acrylic on panel
12 × 16"

→
Philip Tseng
You're Disloyal
Fine art giclée print
18 × 24"

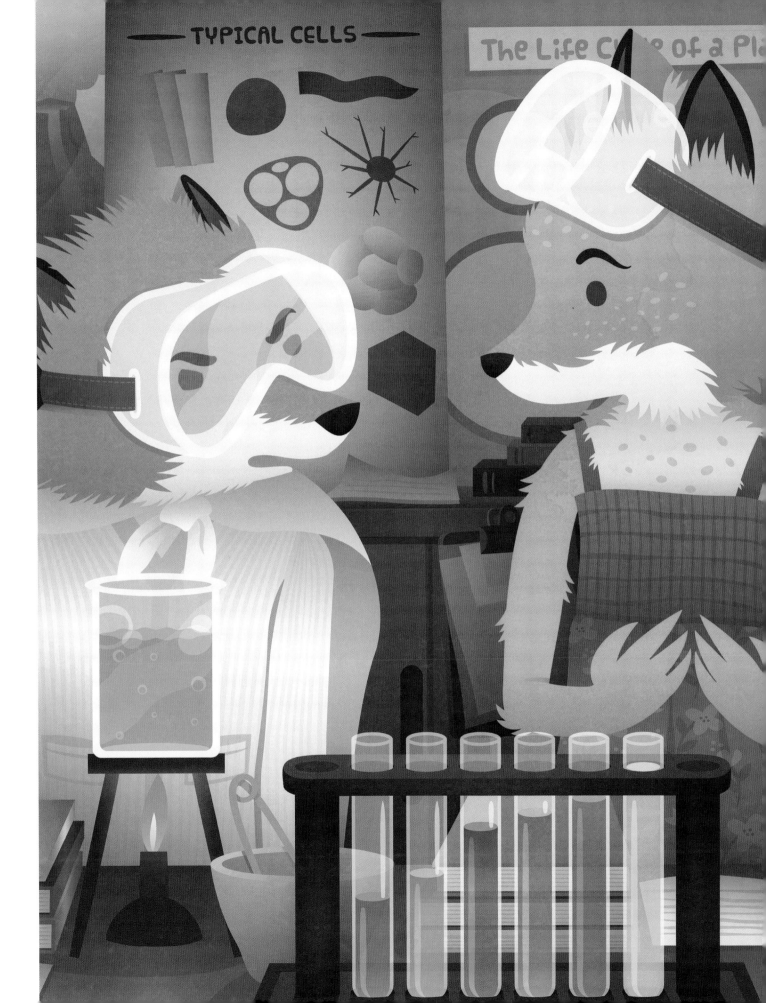

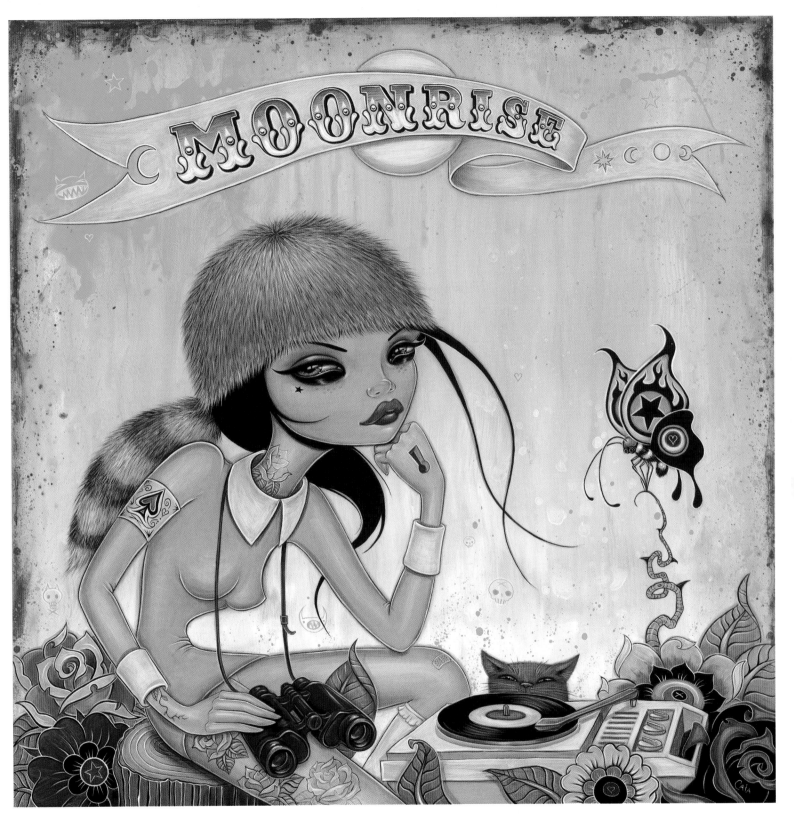

Caia Koopman

Moonrise Owl
Acrylic on wood
11 × 14"

Moonrise Kingdom
Acrylic on wood
24 × 24"

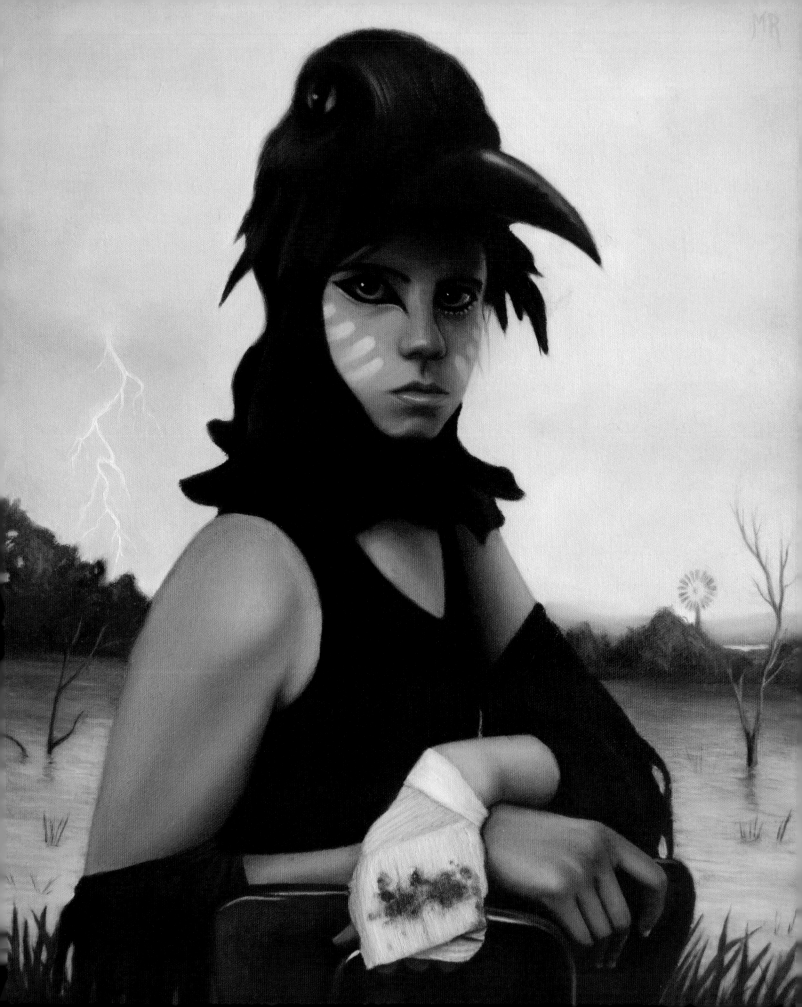

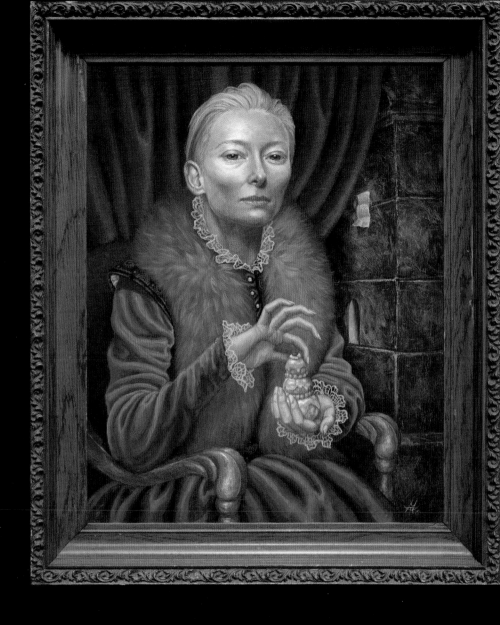

Michael Ramstead
What Kind of Bird Are YOU
Oil on canvas
16 × 20"

Mandy Tsung
Boy with Mendl's
Oil on wood in antique frame

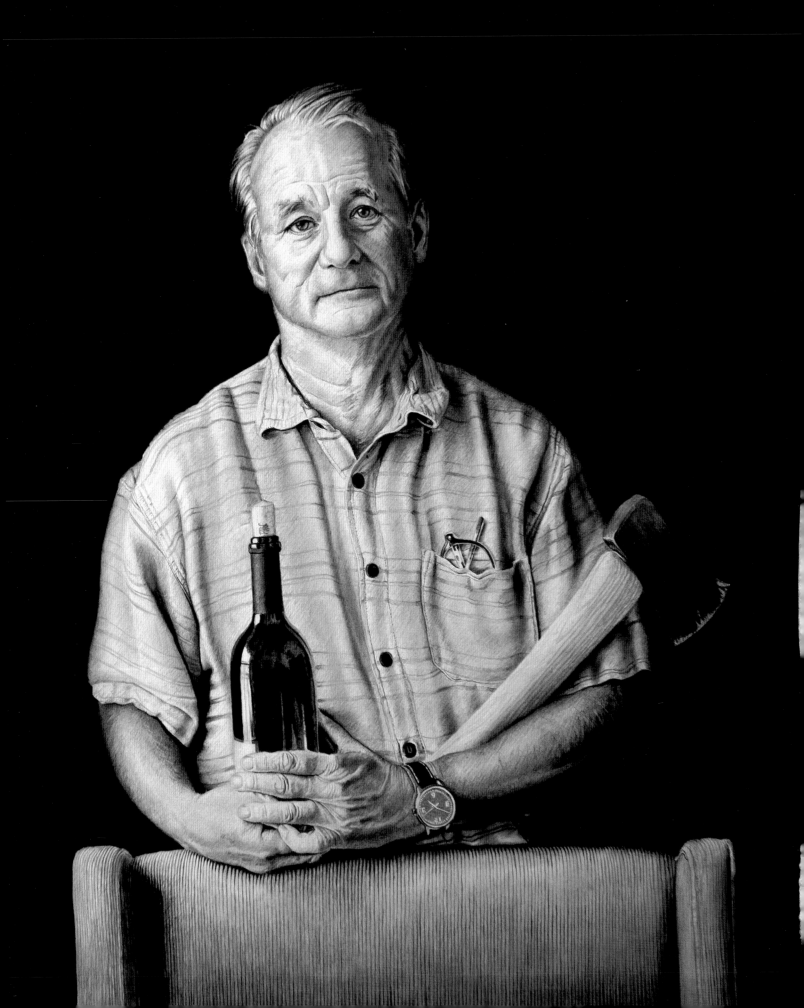

Joel Daniel Phillips
Bill
Charcoal and graphite on
paper
18 × 25"

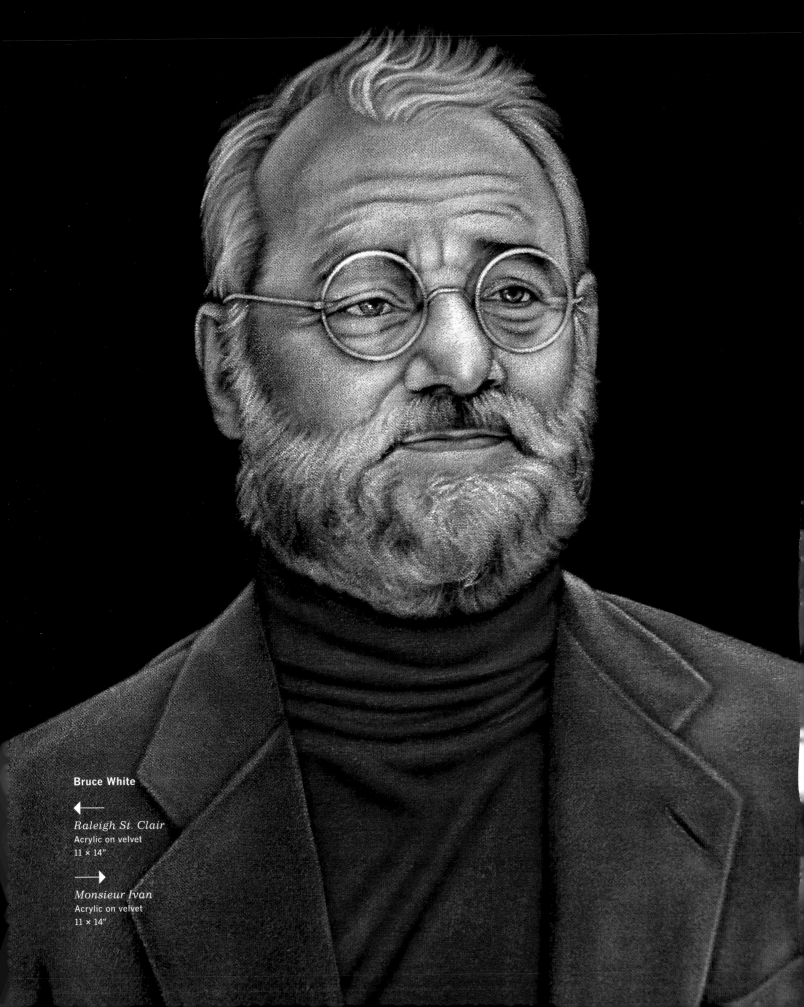

Bruce White

← *Raleigh St. Clair*
Acrylic on velvet
11 × 14"

→ *Monsieur Ivan*
Acrylic on velvet
11 × 14"

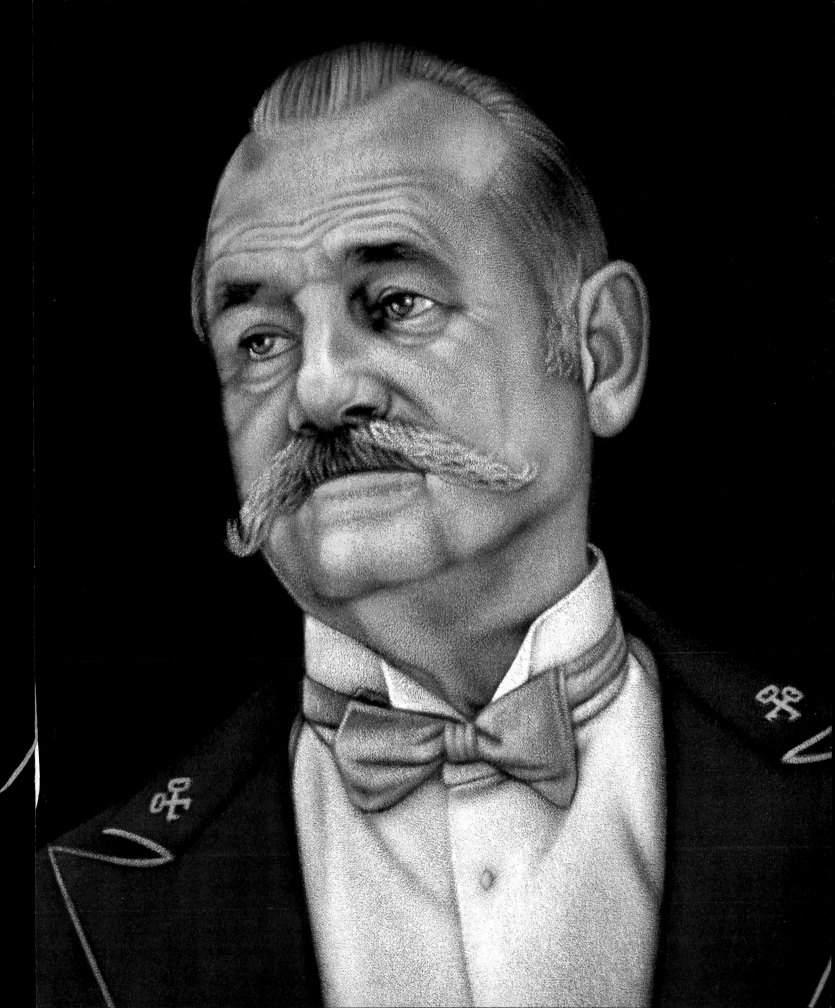

Dan Christofferson
Deadly Poisonous
Acrylic on panel
12 × 12"

Bennett Slater
Voltaire No. 5
Oil on wood
8 × 8"

118

Plate I

Fig. I

Nº. _____

By _____

The Crayon Seahorse
(Hippocampus iridis)

Archives du Zissou Plate II

Fig. I

Fig. II

N°. ____ By. ____

The Sugar Crab
(Cancer saccharum)

Tracie Ching

←

*The Crayon
Seahorse*
Hand-painted
screen print
8 × 10"

→

*The Sugar
Crab*
Hand-painted
screen print
8 × 10"

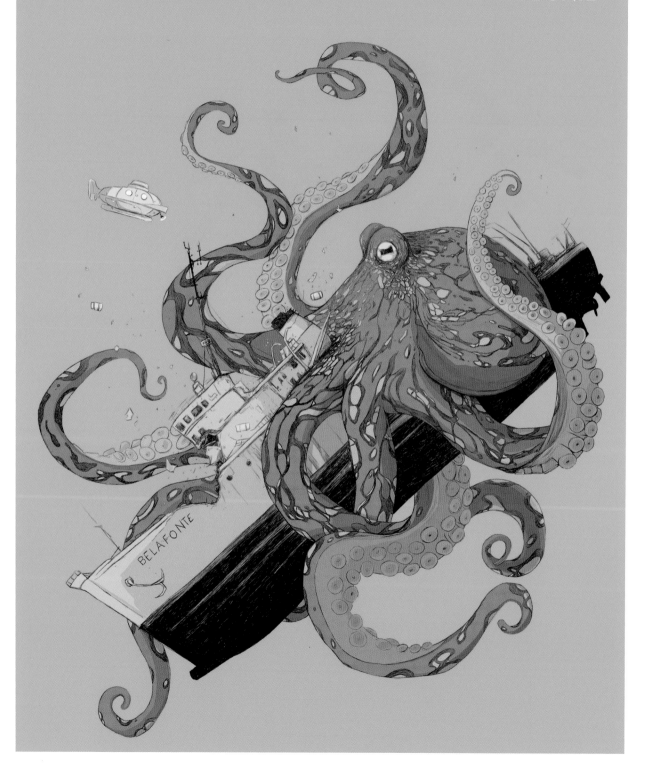

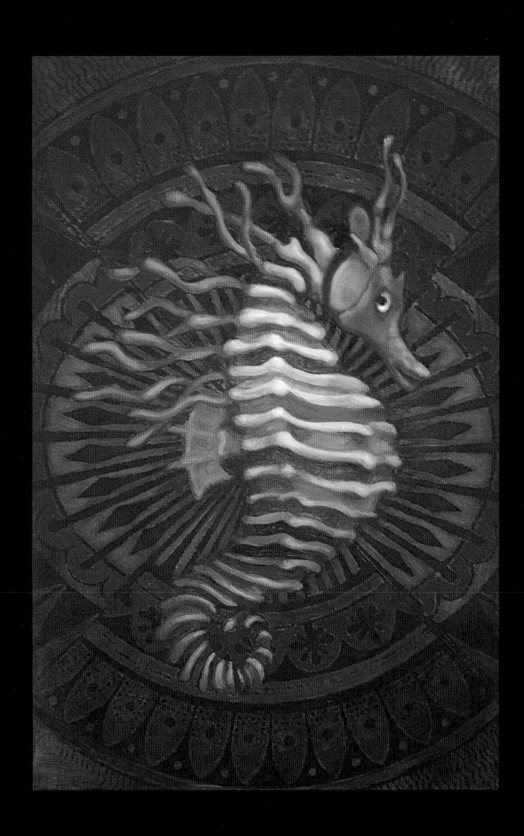

Isaac Bidwell
*The Sinking of the
Belafonte*
Screen print
18 × 24"

Beau Stanton
Crayon Ponyfish
Oil on wood
8 × 12"

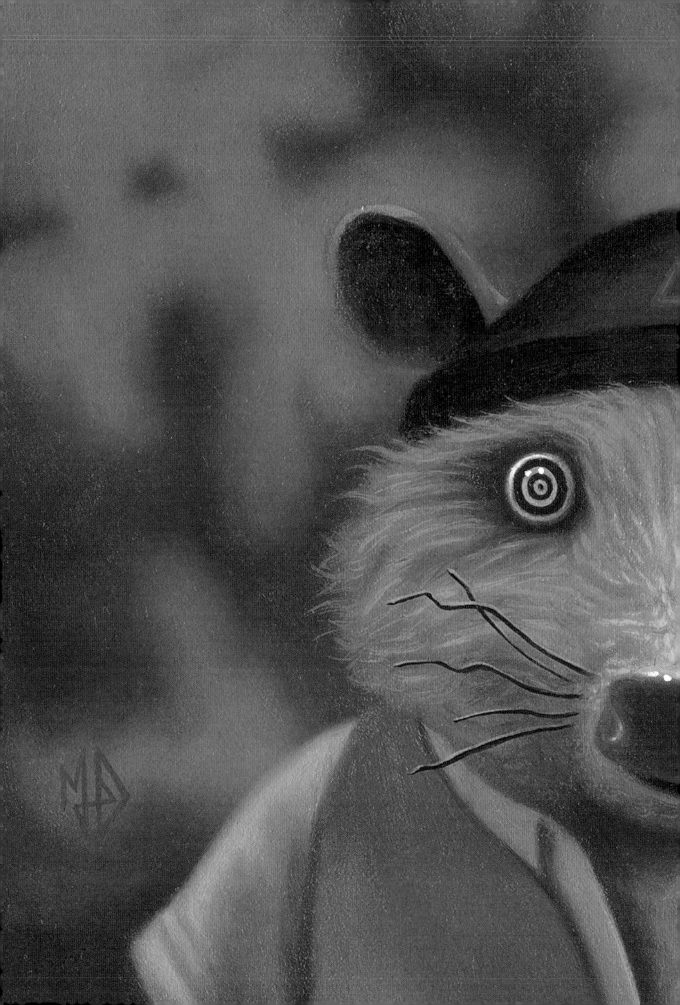

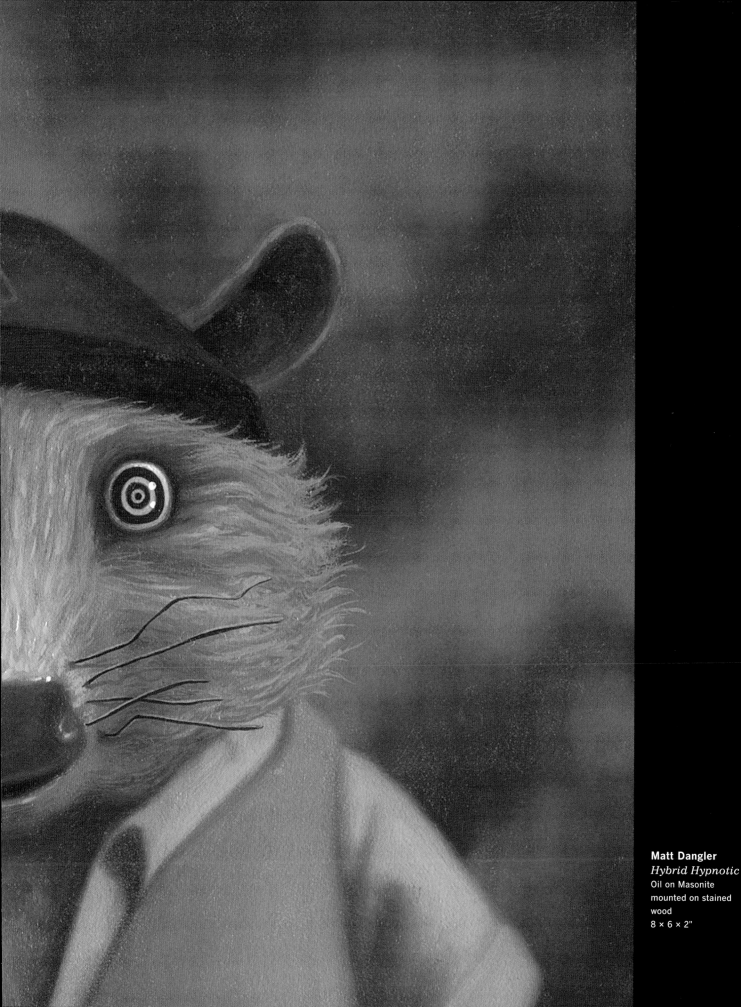

Matt Dangler
Hybrid Hypnotic
Oil on Masonite
mounted on stained
wood
8 × 6 × 2"

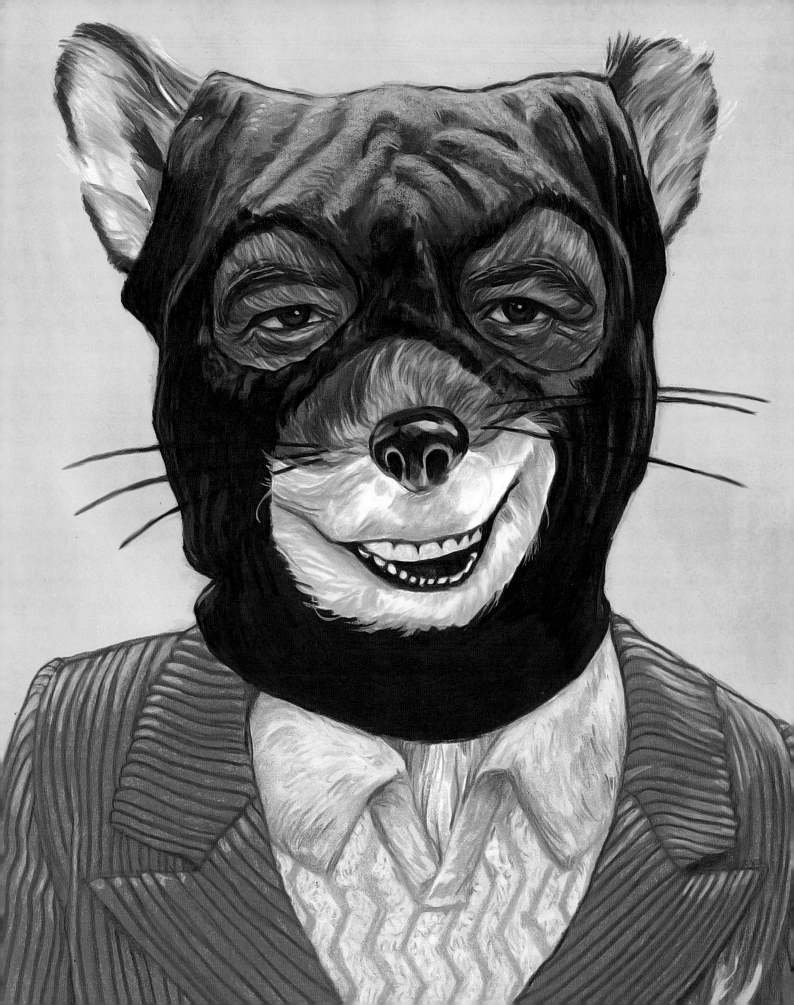

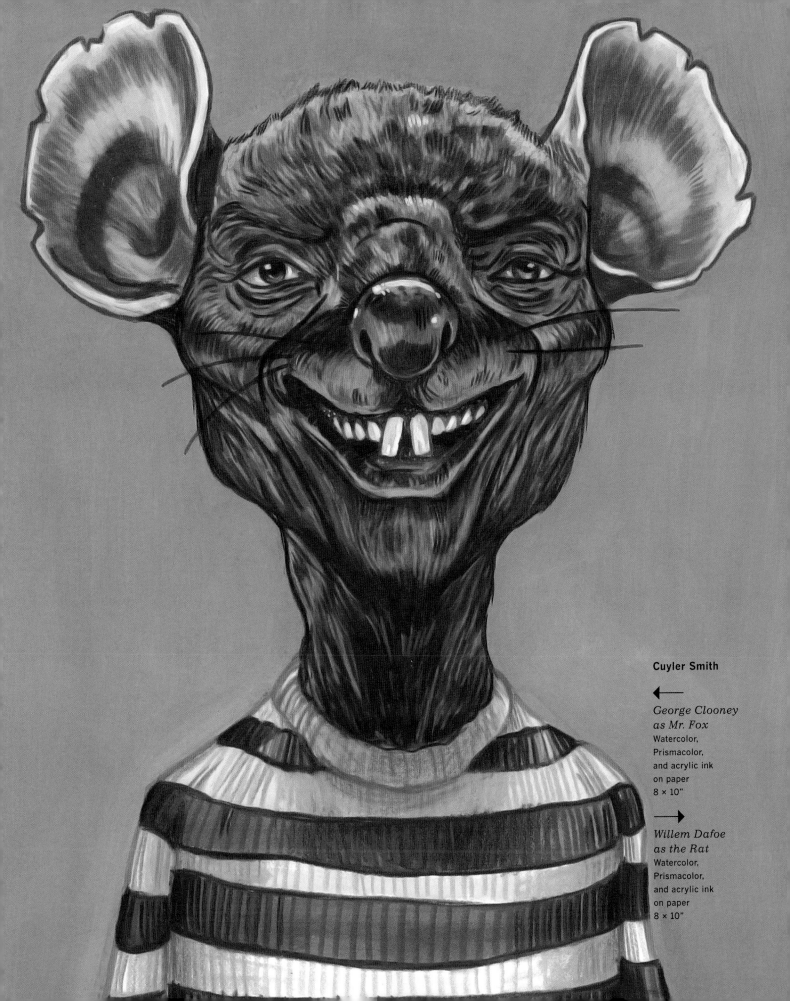

Cuyler Smith

←

*George Clooney
as Mr. Fox*
Watercolor,
Prismacolor,
and acrylic ink
on paper
8 × 10"

→

*Willem Dafoe
as the Rat*
Watercolor,
Prismacolor,
and acrylic ink
on paper
8 × 10"

Jaesun Kim
Fantastic Mr. Fennec Fox
Polymer clay, acrylic, wood, glue,
wire, polyester, and fabric model
6 × 11.5 × 5"

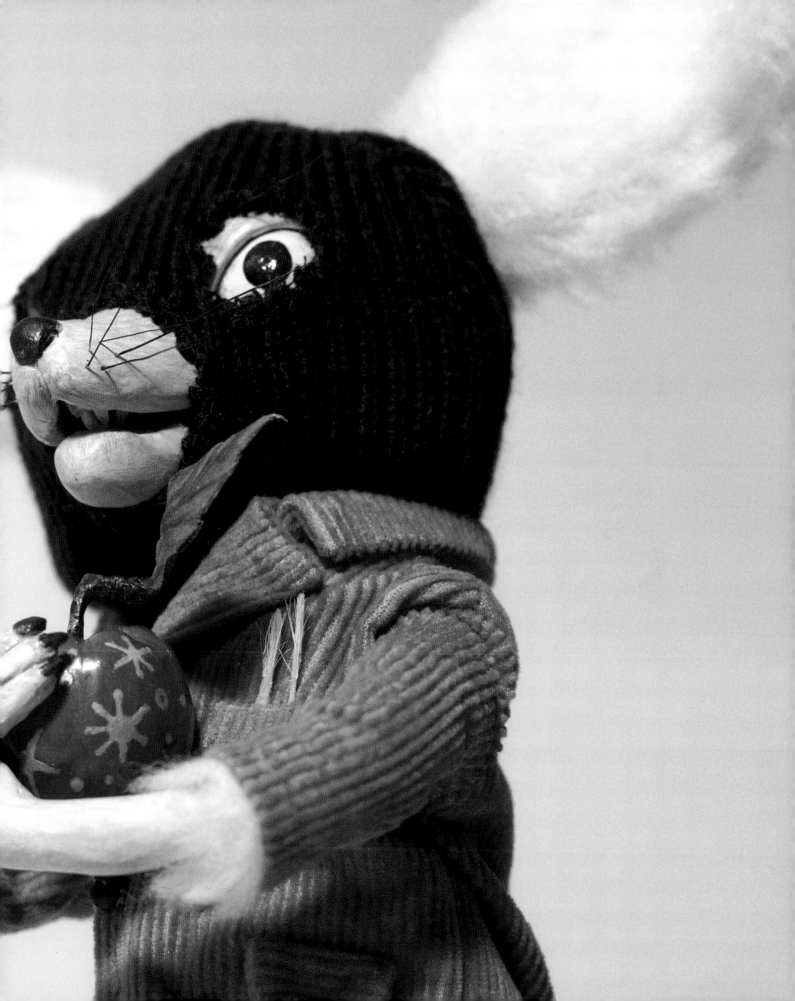

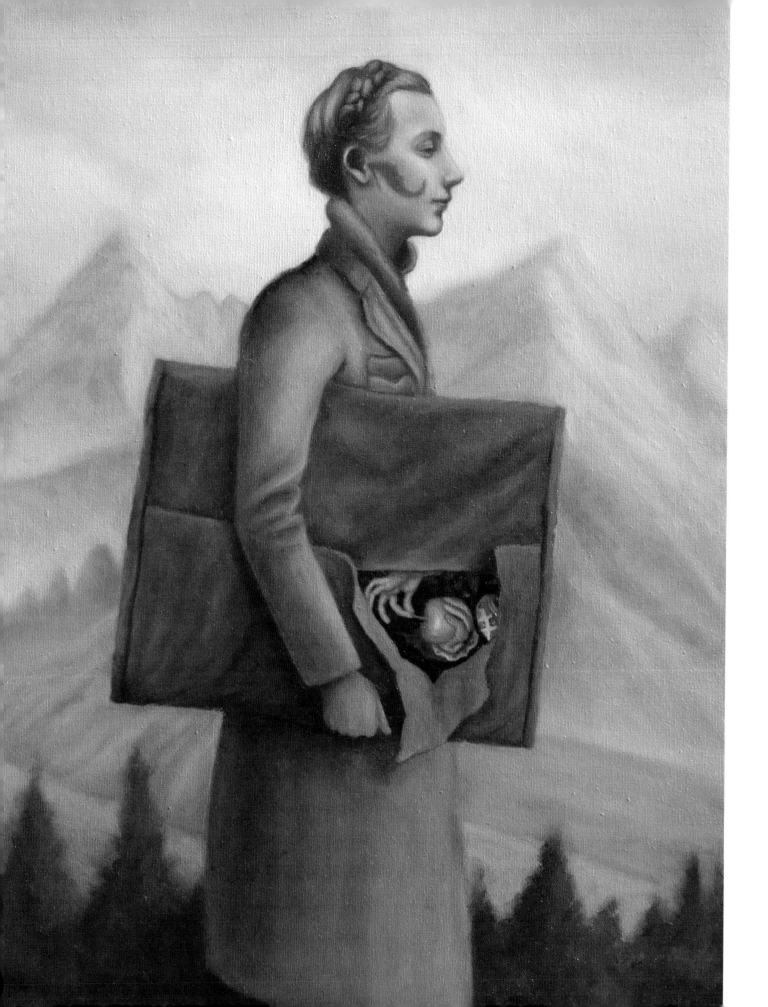

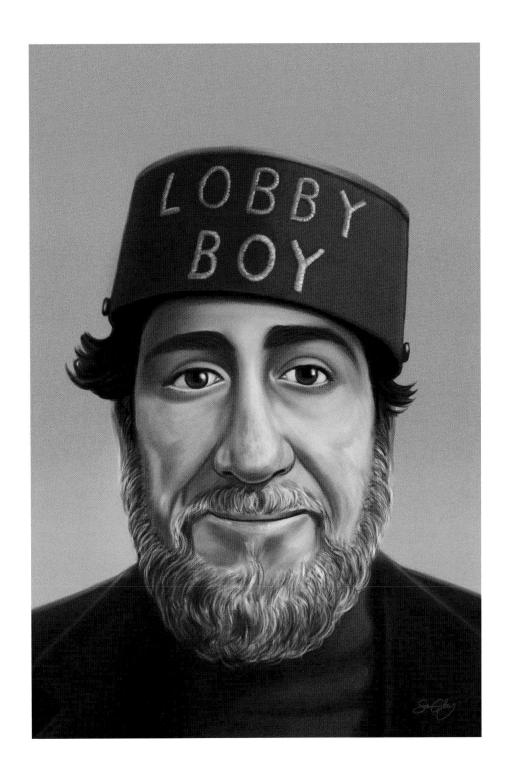

Michael Ramstead
*Girl with Boy
with Apple*
Oil on canvas
18 × 24"

Sam Gilbey
Zero + Zero
Fine art giclée print
12 × 18"

LOBBY BOY

Stanley Chow
Lost Time
Fine art giclée print
16.5 × 11.5"
(Illustration used in
the *New Yorker*
for David Denby's
review of *The Grand
Budapest Hotel*)

GRAND

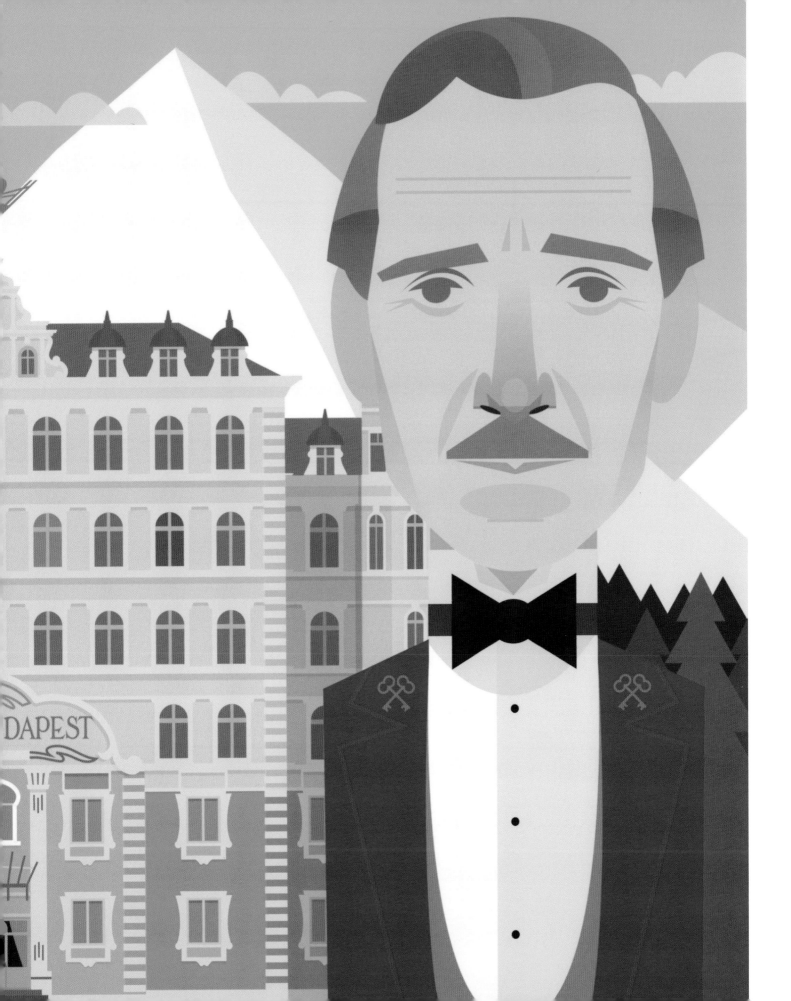

James Gilleard
*The Grand
Budapest Hotel*
Digital Illustration
24 × 18"

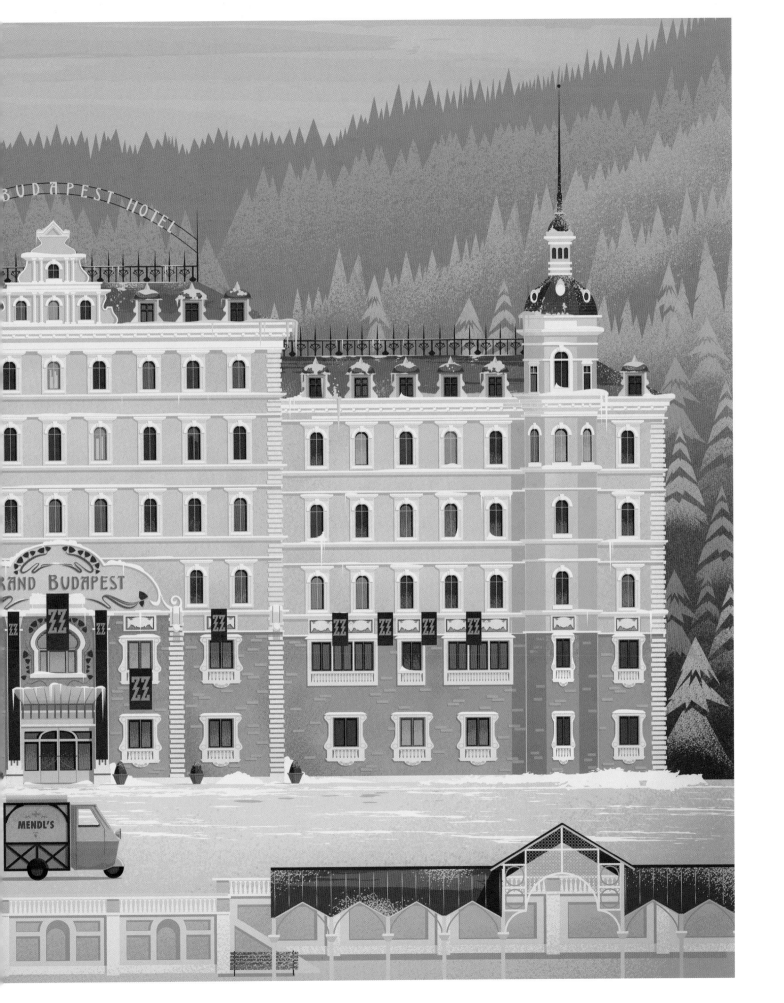

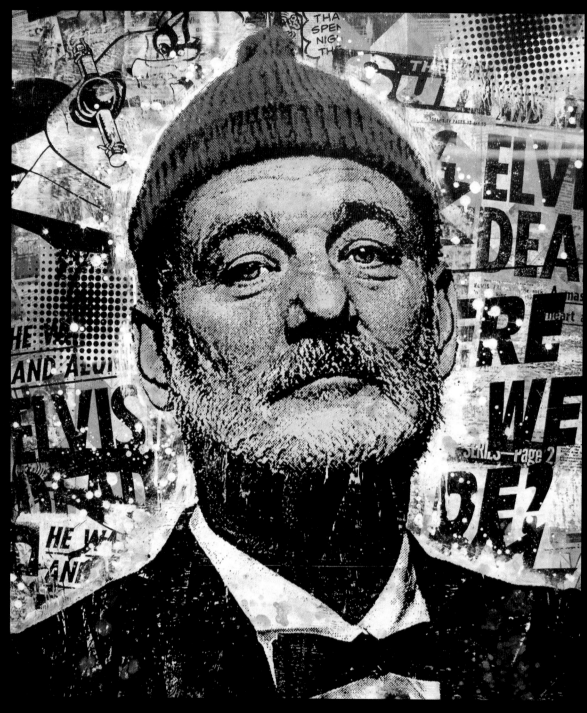

←

Greg Gossel
Zissou
Hand-collaged and
hand-painted screen
print
22 × 26"

→

Allison Reimold
Interesting
Specimen
Oil on canvas
16 × 20"

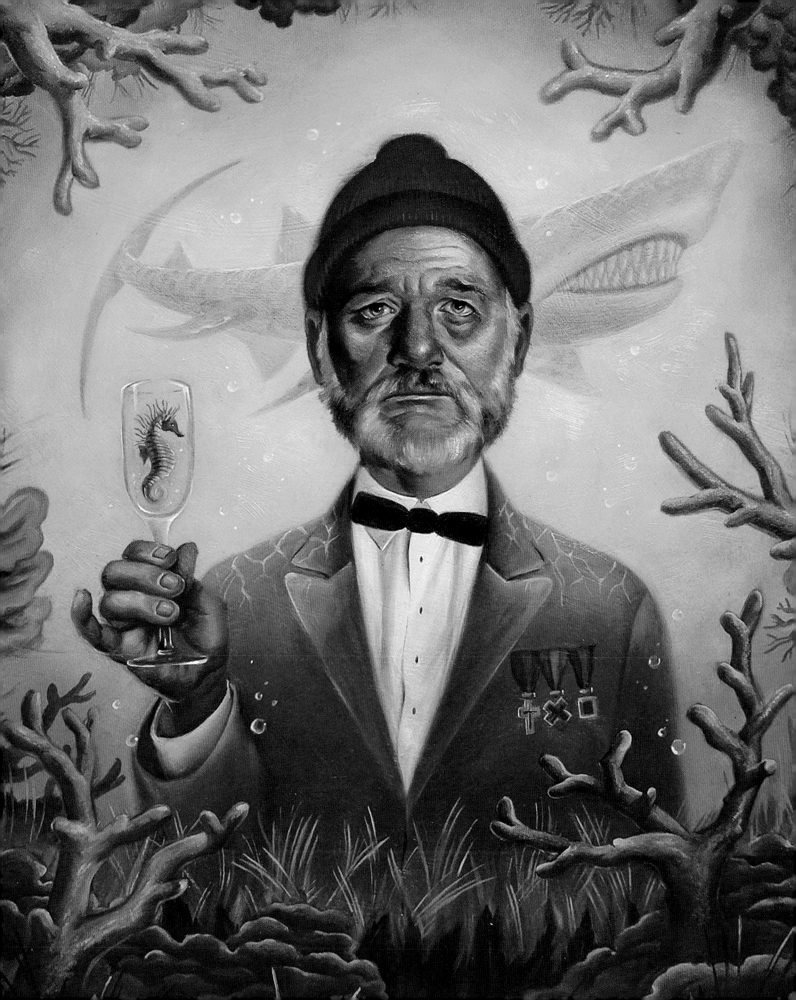

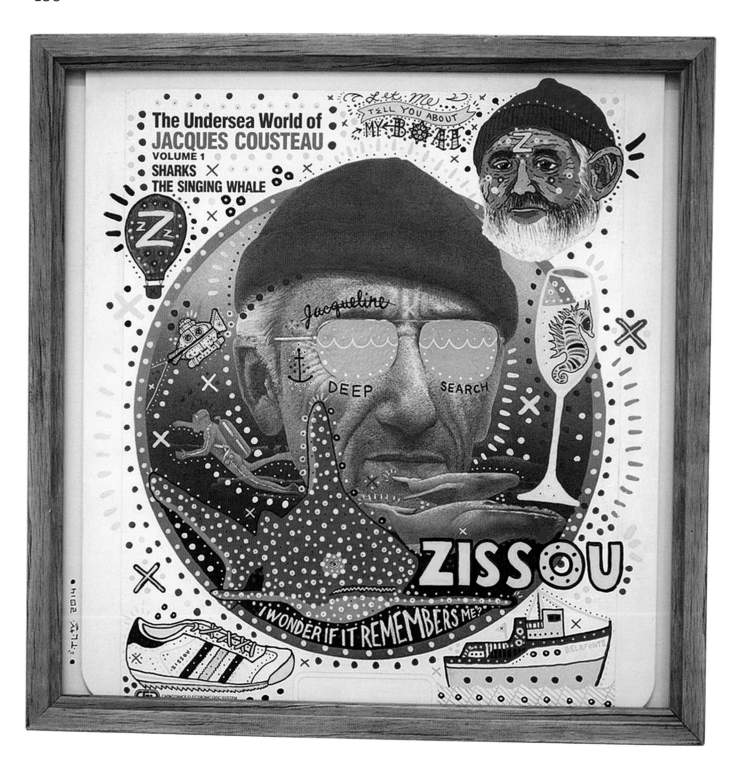

The Undersea World of
JACQUES COUSTEAU
VOLUME 1
SHARKS ✕
THE SINGING WHALE

Let me
TELL YOU ABOUT
MY BOAT

Jacqueline

DEEP SEARCH

ZISSOU

I WONDER IF IT REMEMBERS ME?

BELAFONTE

←
TLtv
B Squad
Acrylic and ink on
vintage video disc
15 × 15"

→
Tim Jordan
*Zissou Jaguar
Shark Laser Disc*
Screen print
18 × 24"

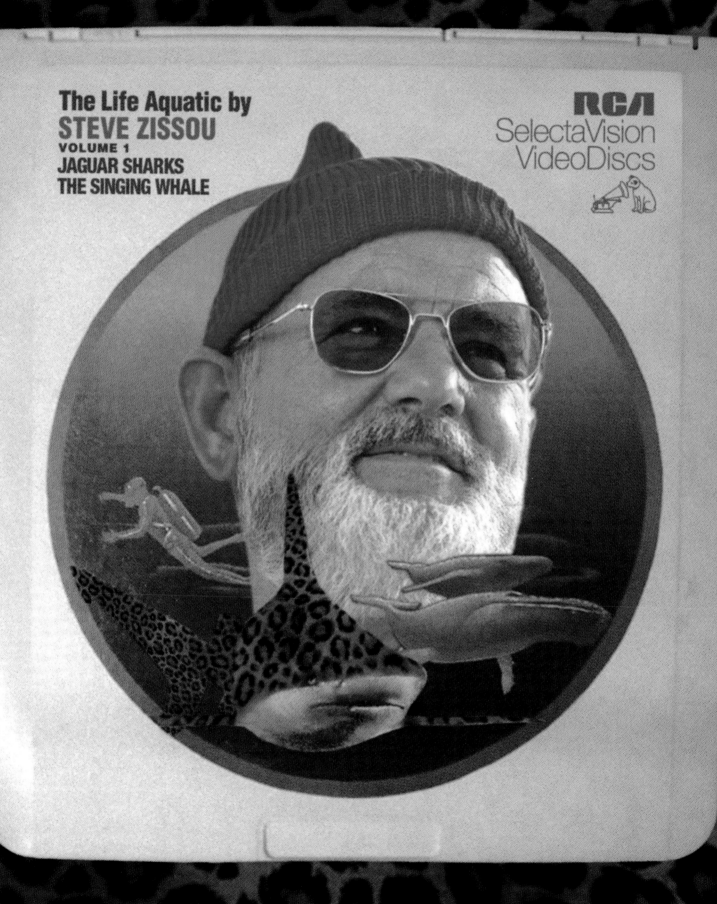

Jasper Wong
I Like Her Hairdo
Acrylic on paper
20 × 26"

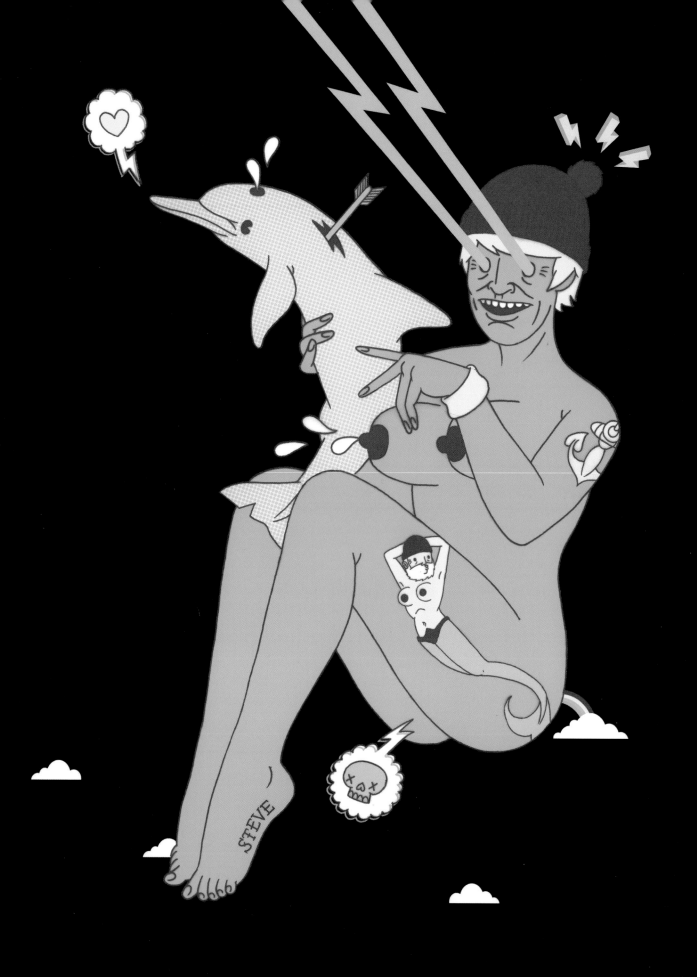

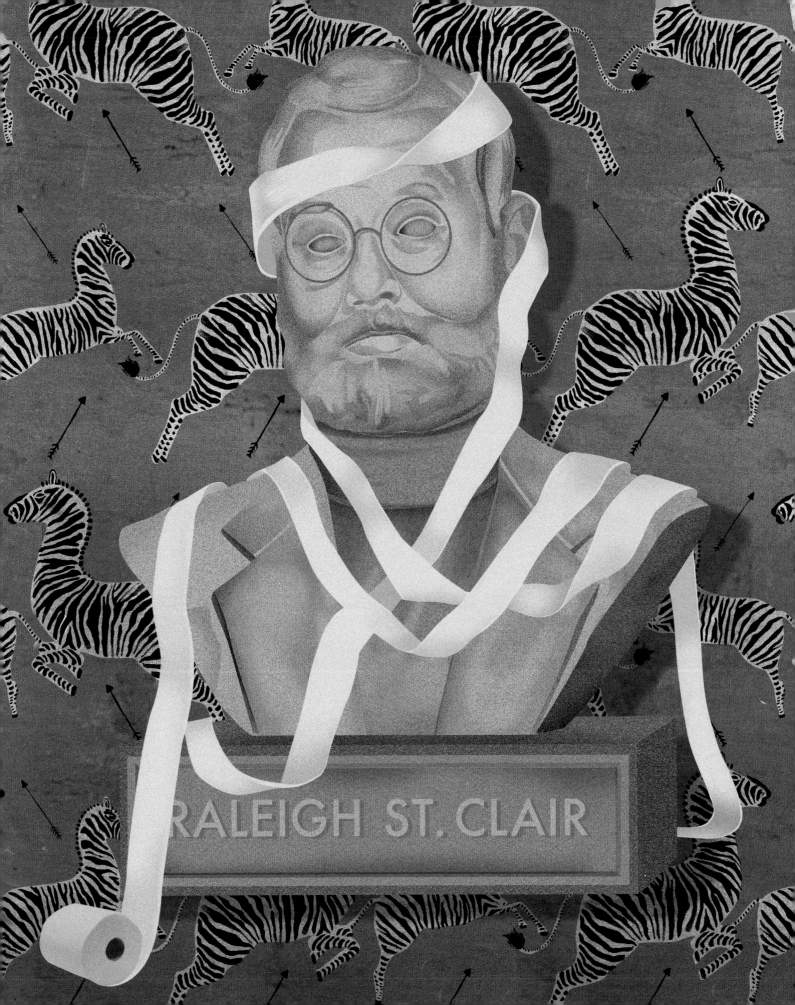

RALEIGH ST. CLAIR

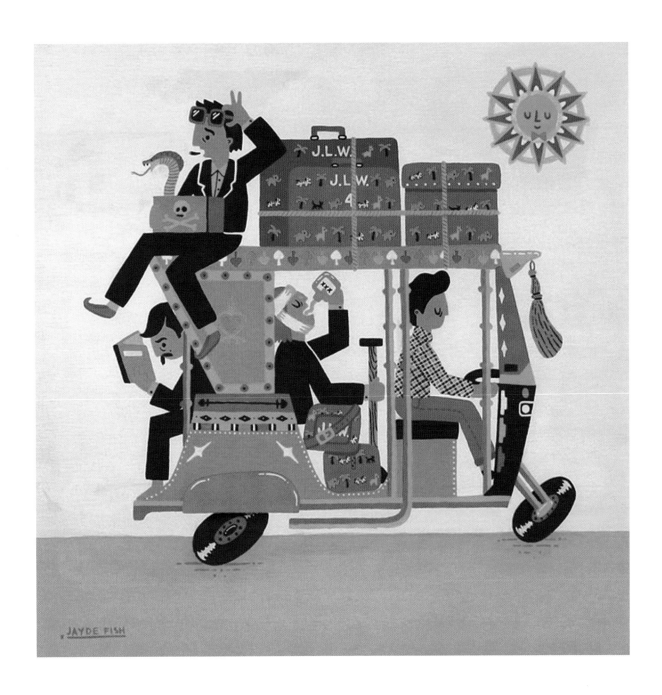

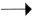

Kathryn Macnaughton
Statue of Raleigh
St. Clair
Fine art giclée print
18 × 24"

Jayde Fish
Bajaj
Acrylic on wood panel
10 × 10"

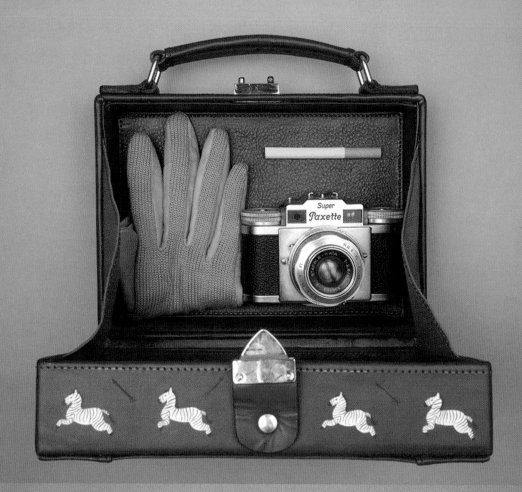

Jayde Fish

↑

The Margot
Acrylic on custom
leather train case
8.5 × 6 × 4"

←

The Sweet Lime
Acrylic on custom
leather train case
8.5 × 6 × 4"

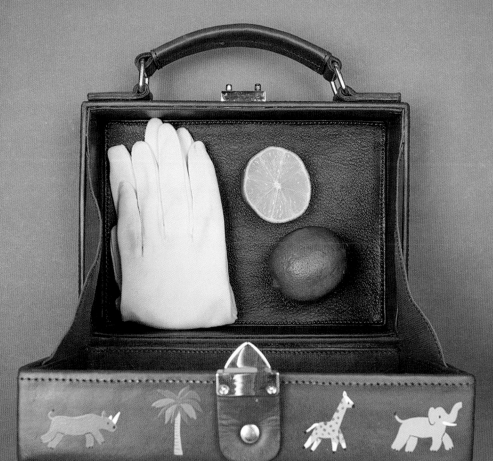

Jayde Fish

↑

The Madame D.
Acrylic on custom
leather train case
8.5 × 6 × 4"

→

The Felicity Fox
Acrylic on custom
leather train case
8.5 × 6 × 4"

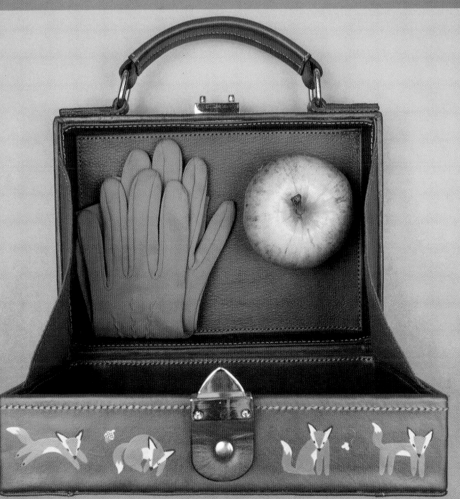

144

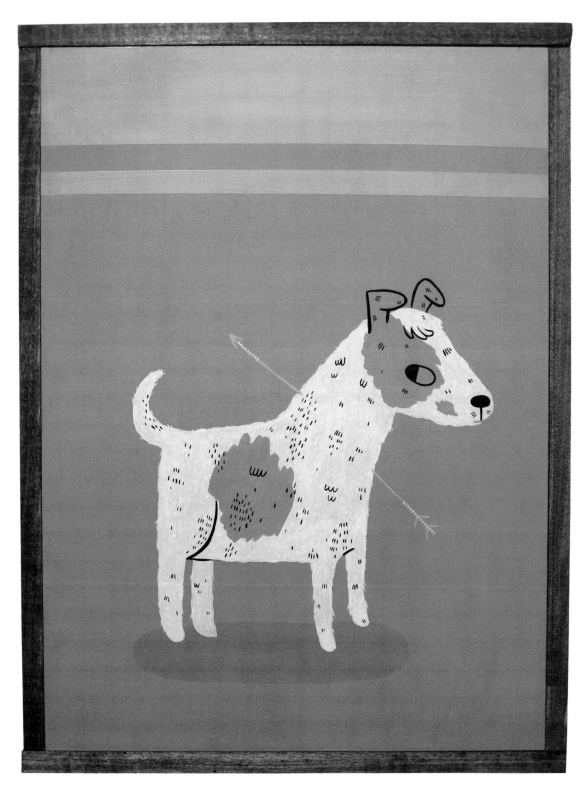

Lauren Gregg

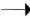

Was He a Good Dog?
Cel-Vinyl on wood
13 × 17"

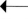

Suzy & Sam
Cel-Vinyl on wood
18 × 21"

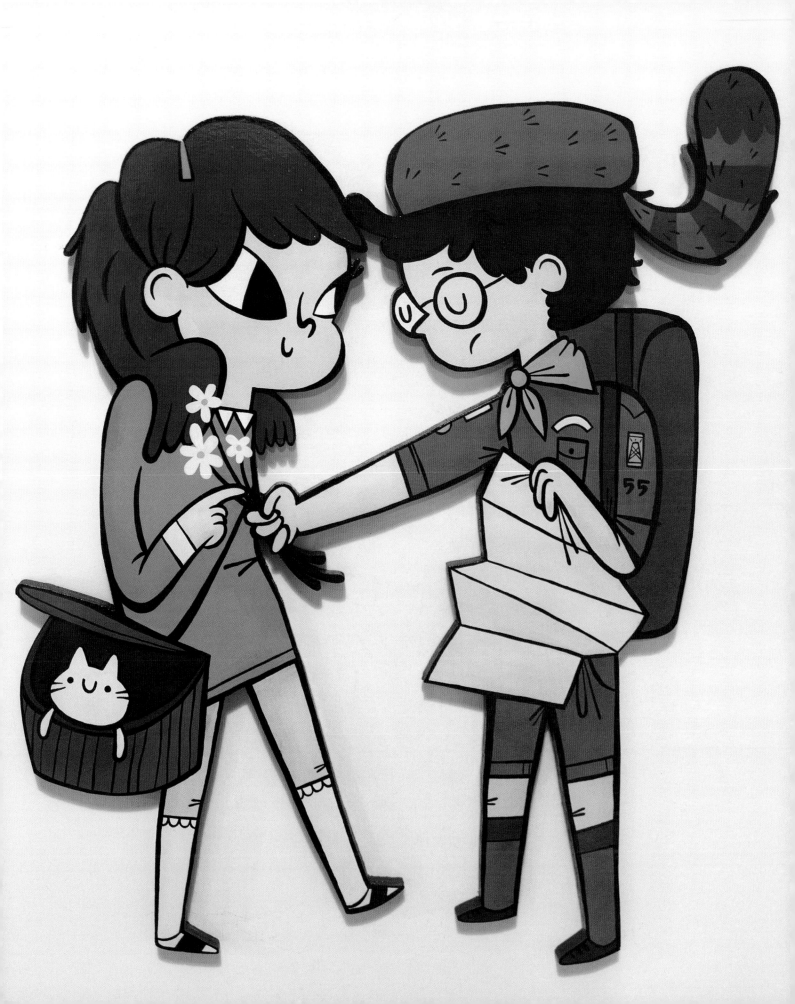

Emily Dumas

←

This Is an Adventure
Fine art giclée print
11 × 14"

→

Dear Sam, Dear Suzy
Fine art giclée print
11 × 14"

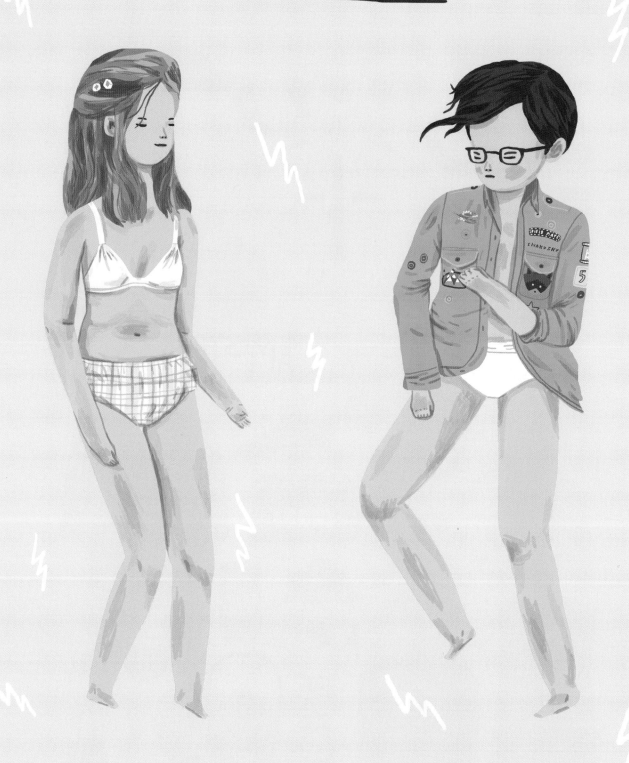

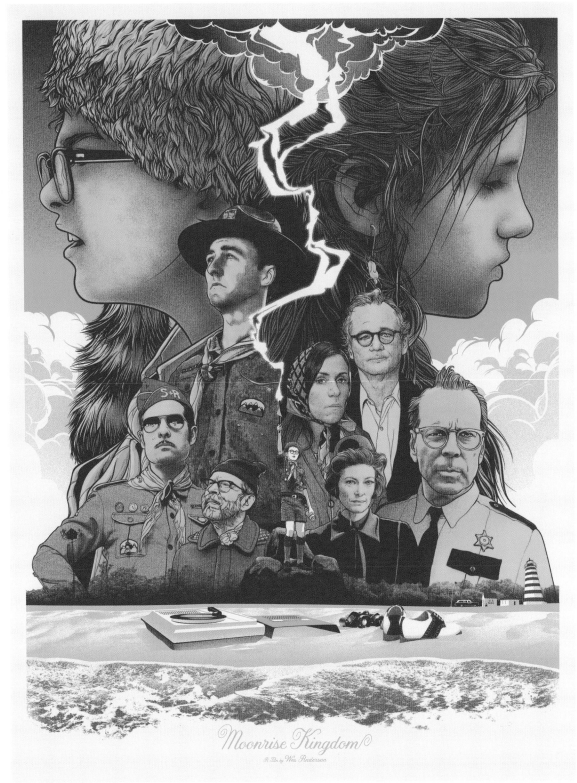

◀
Ivonna Buenrostro
Le temps de l'amour
Fine art giclée print
16 × 20"

➡
Joshua Budich
Moonrise Kingdom
Screen print
18 × 24"

Paige Jiyoung Moon
Sam and Suzy
Acrylic on wood panel
10 × 8"

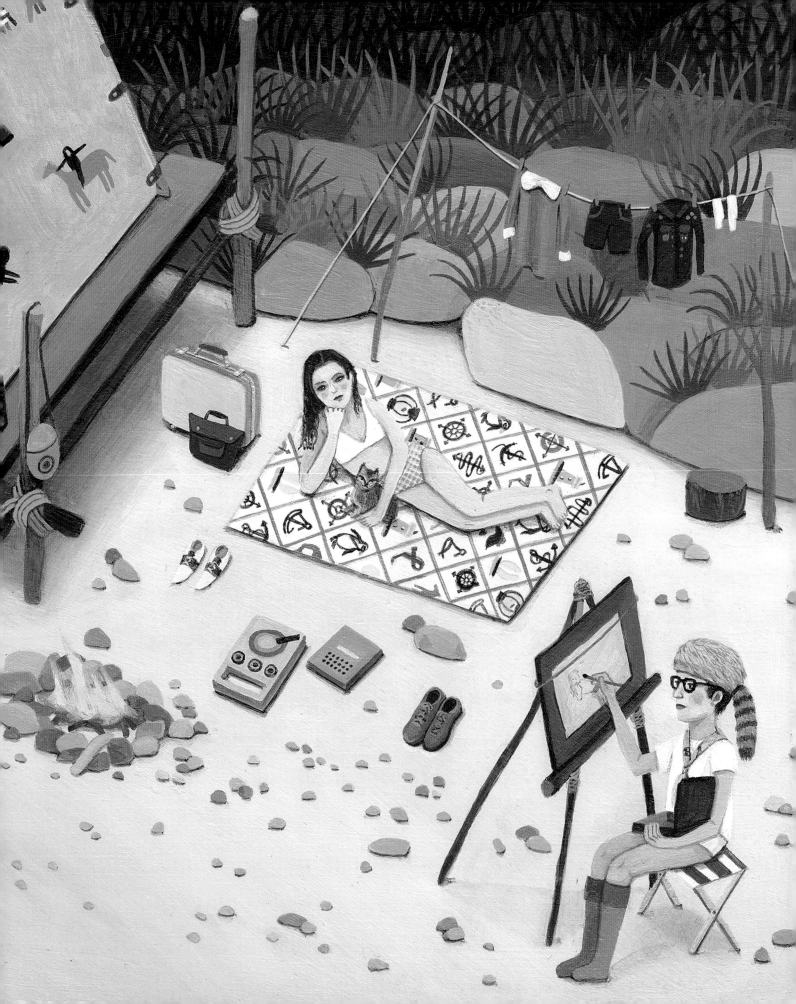

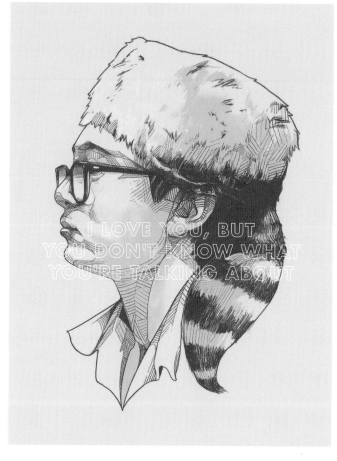

Oliver Barrett

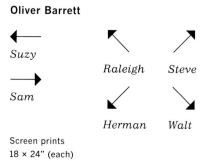

Screen prints
18 × 24" (each)

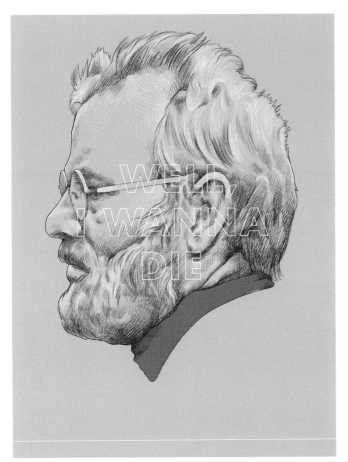

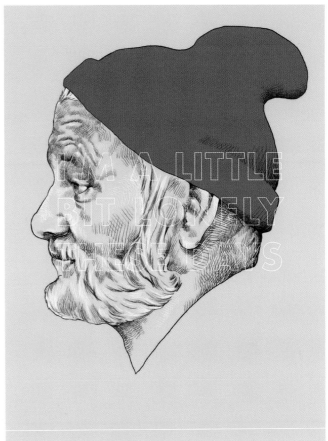

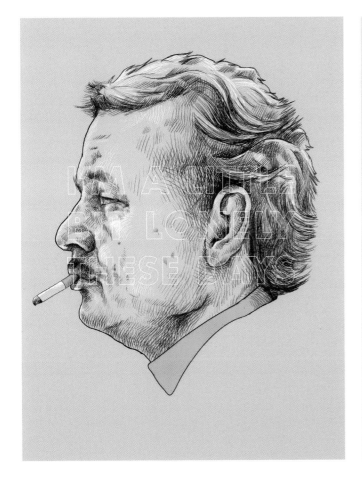

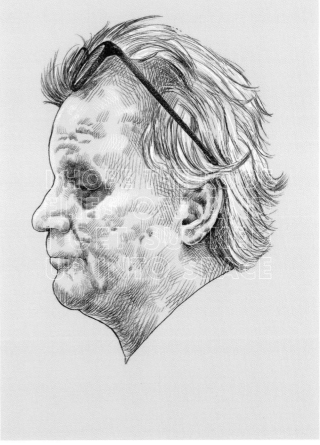

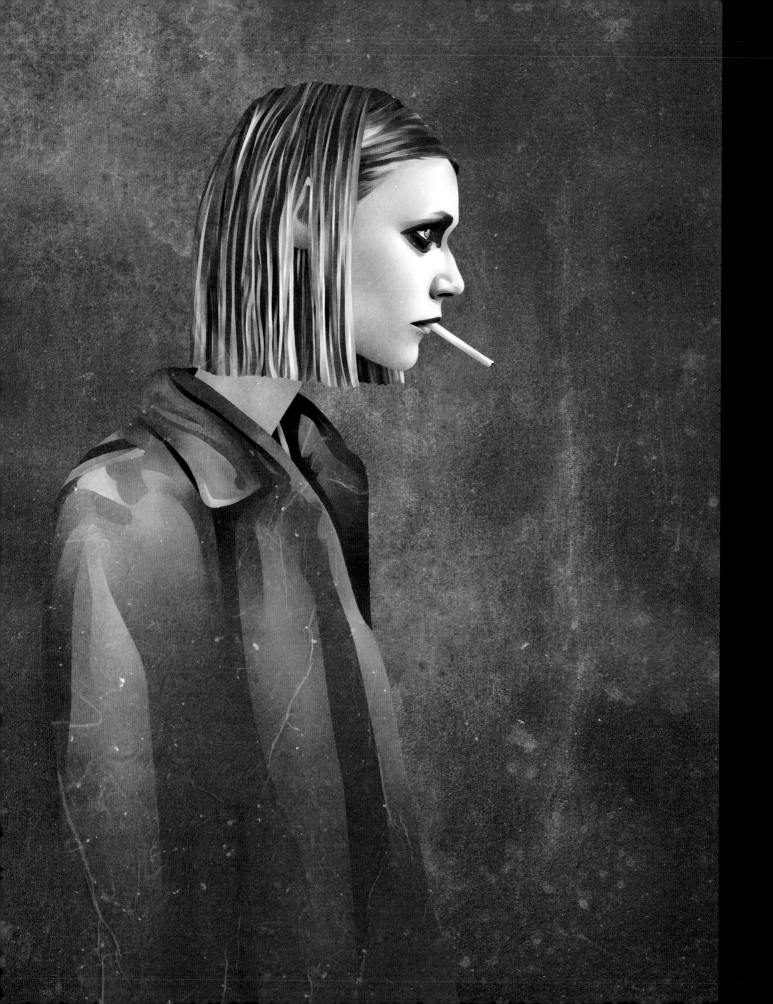

155

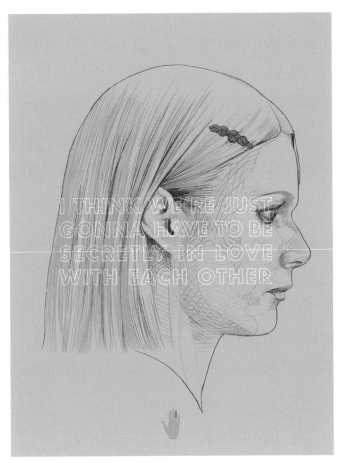

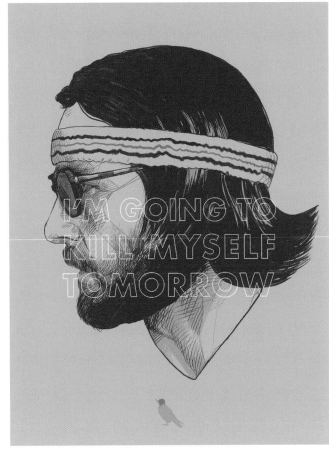

Oliver Barrett

←

*We're Not
Actually Related
Anyway*
Screen print
18 × 24"

→

*Why'd You Choke
Out That Day,
Baumer?*
Screen print
18 × 24"

←

Ruben Ireland
Margot
Fine art giclée print
16 × 20"

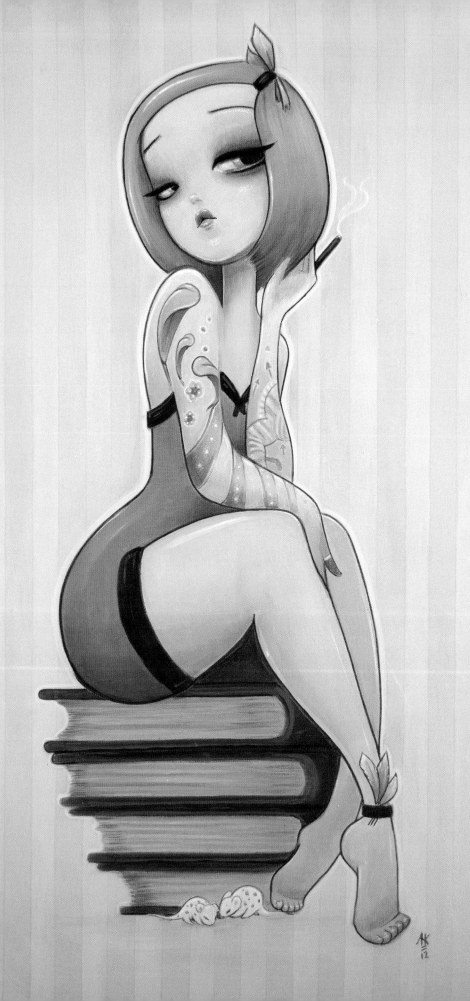

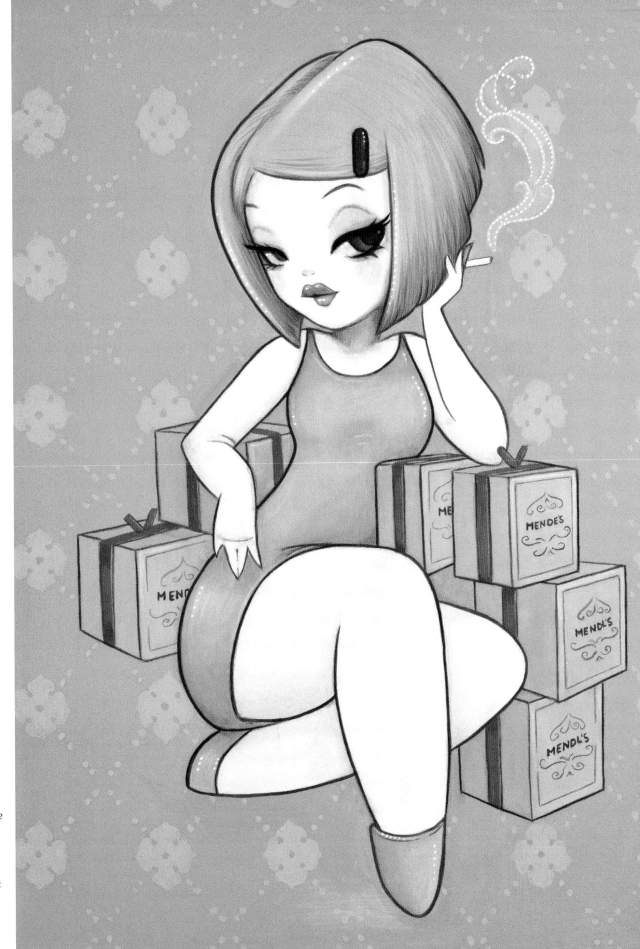

Anarkitty

Secretly in Love
Acrylic on canvas
15.7 × 23.6"

Margot's Secret
Acrylic on canvas
15.7 × 23.6"

Ana Bagayan
Margot Tenenbaum
Fine art giclée print
20 × 16"

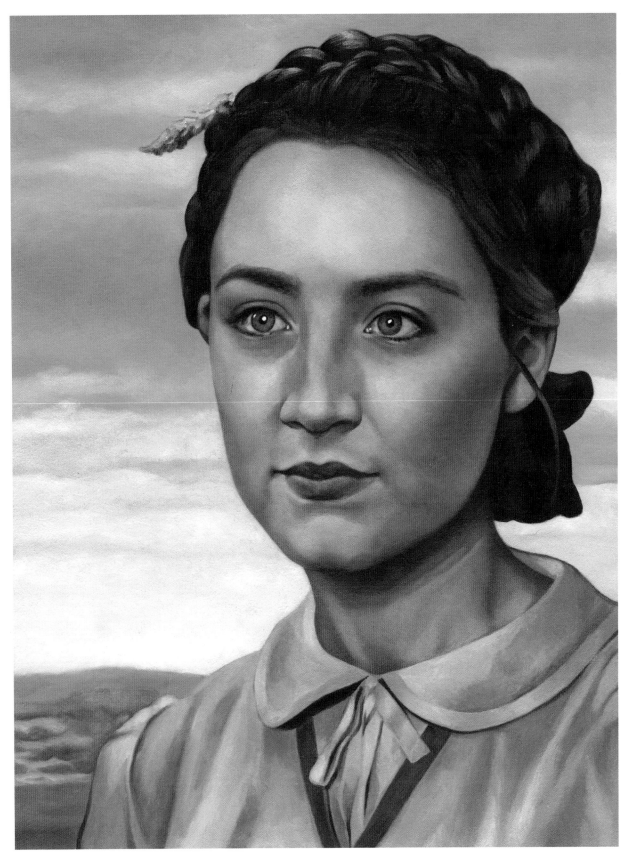

Bec Winnel
Natalie
Digital collage and
painting finished with
acrylic, pencil, and
pastel
12 × 17"

Johannah O'Donnell
Agatha
Acrylic on wood
12 × 16"

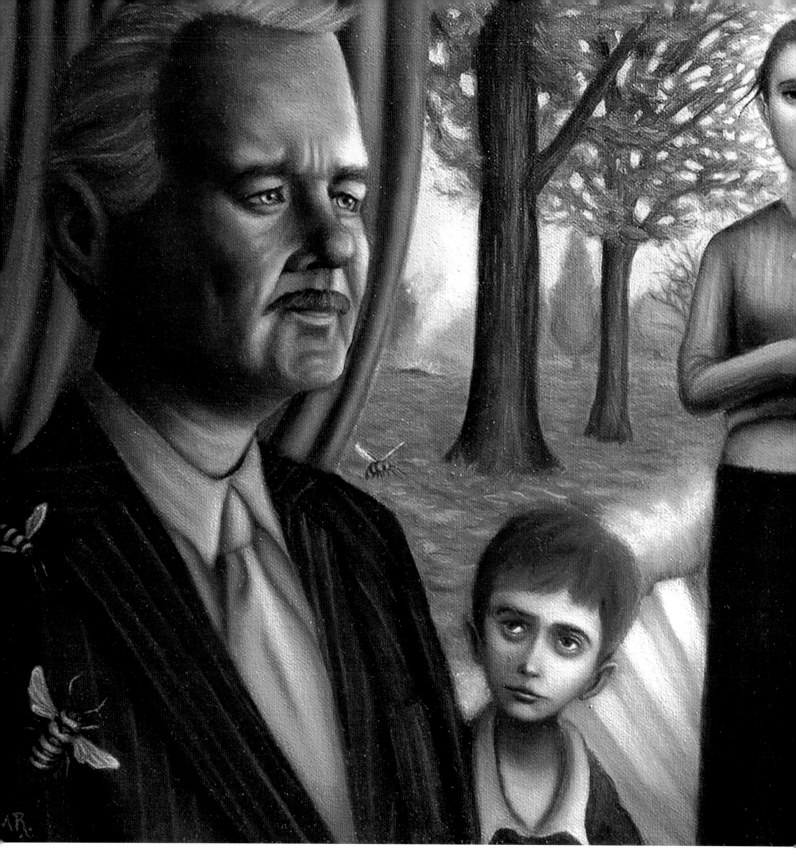

Michael Ramstead
She's My Rushmore
Oil on canvas
24 × 12"

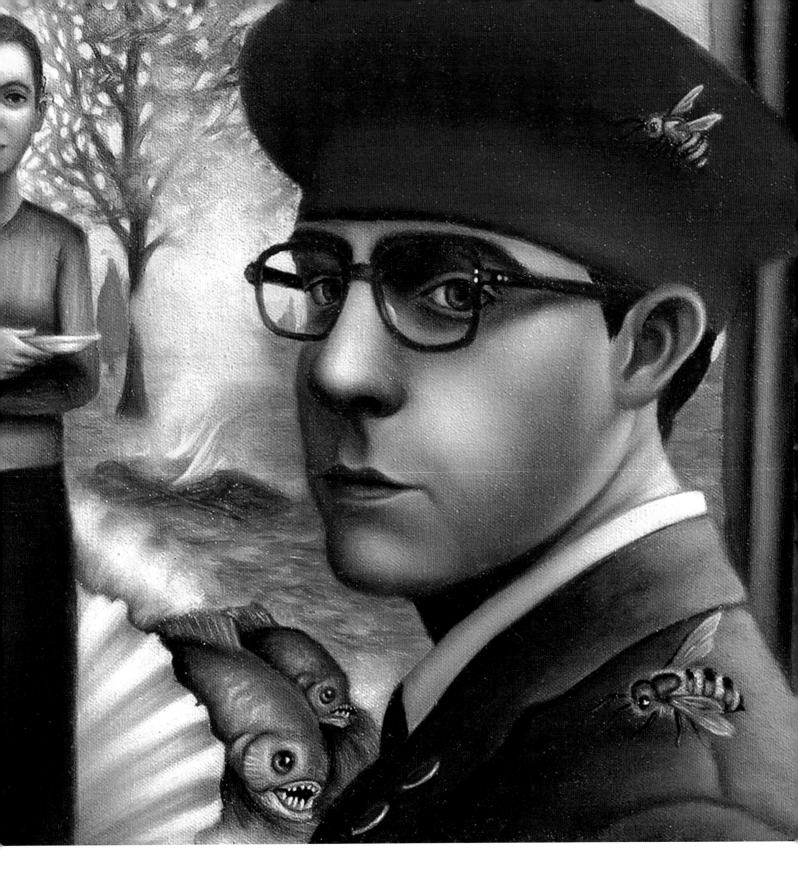

Alec Huxley
Foxes at Night
Acrylic on canvas
20 × 15"

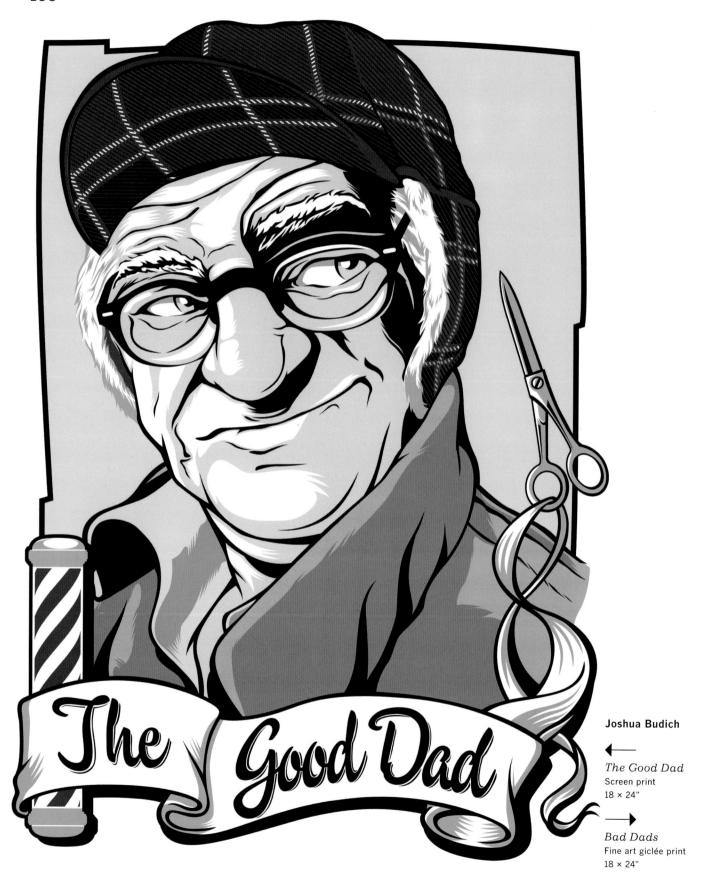

Joshua Budich

← *The Good Dad*
Screen print
18 × 24"

→ *Bad Dads*
Fine art giclée print
18 × 24"

BAD DADS

An art show tribute to the films of
WES ANDERSON

Sunday October, 30th | Halloween Party / Opening
Spoke Art Gallery - 816 Sutter Street - San Francisco, CA | Show on view until November 25th | spoke-art.com

spoke ART

Josh Ellingson
Kumar
Fine art giclée print
18 × 12"

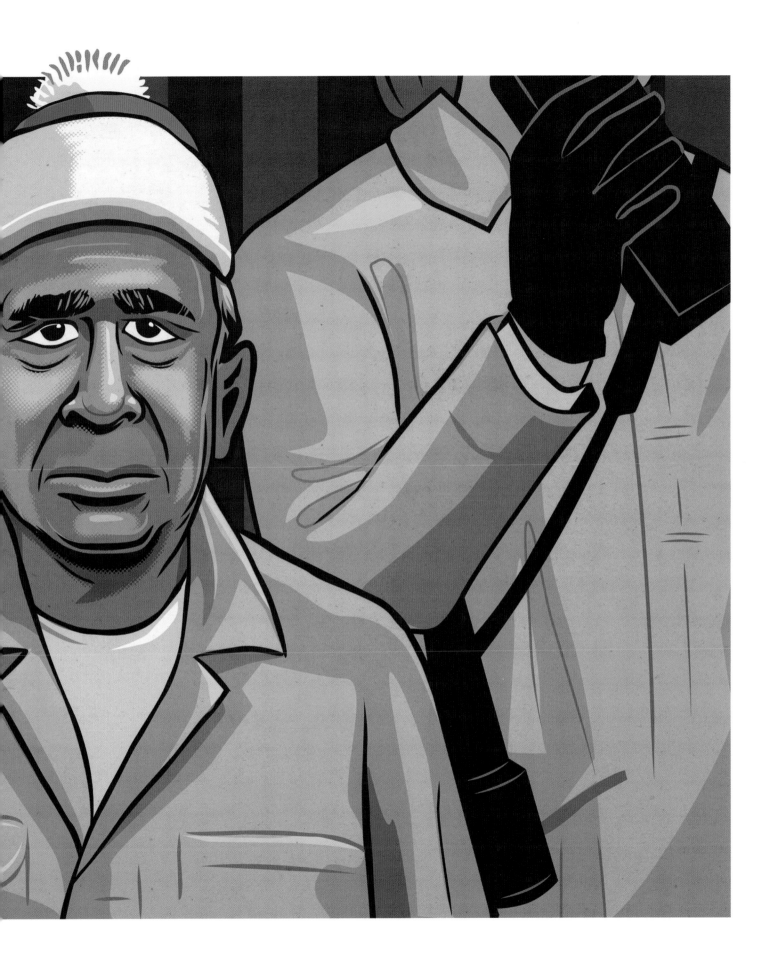

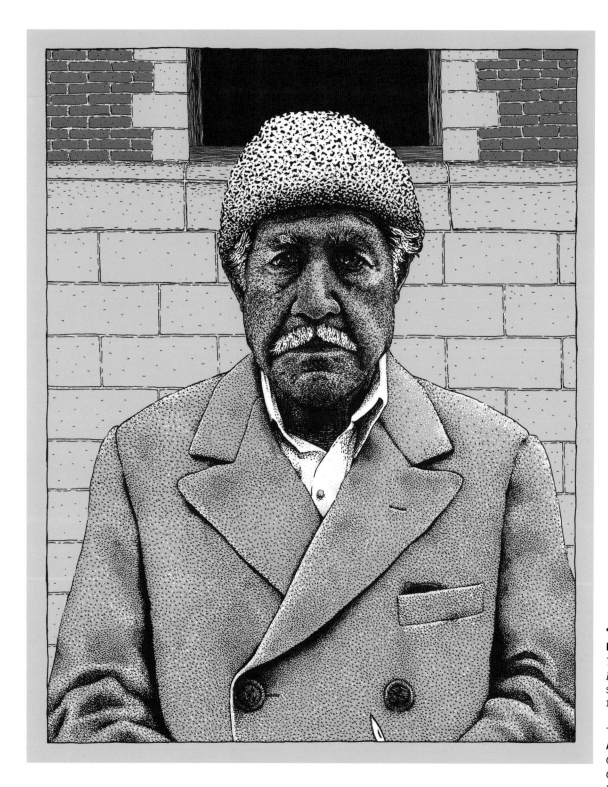

Dan Grissom
You Son of a Bitch
Screen print
16 × 20"

Aaron Jasinski
Coach Dignan Chuck Eli Whitman Plimpton
Acrylic on board
11 × 14"

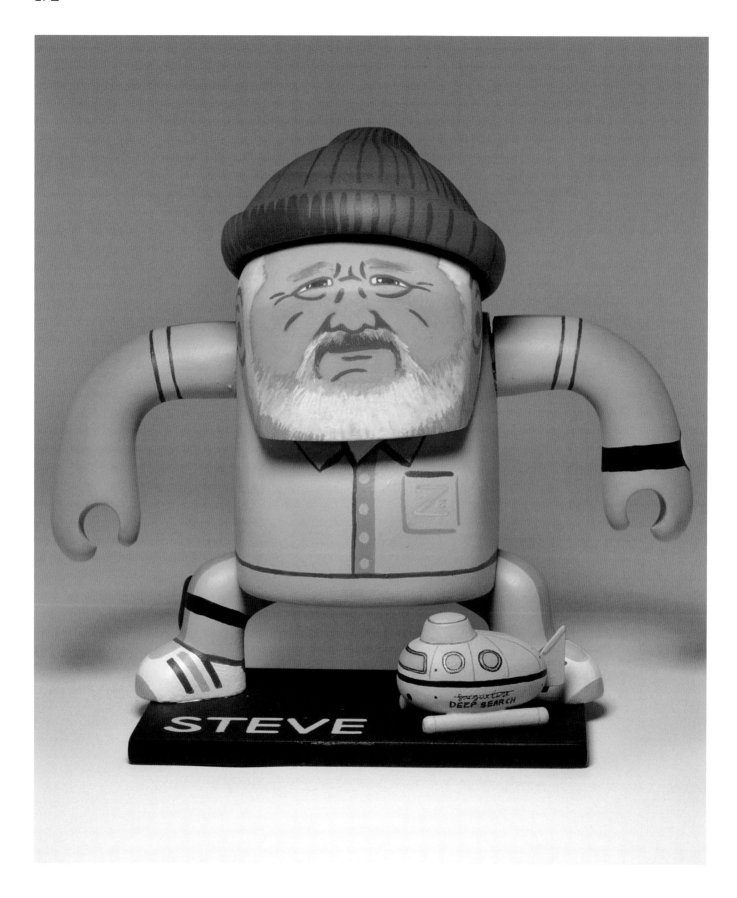

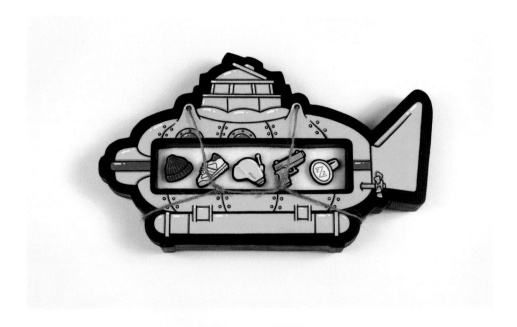

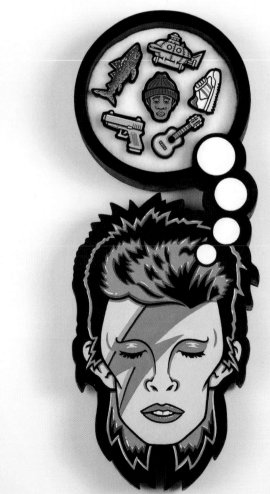

Geoff Trapp
Steve
Acrylic and Sculpey
on vinyl
3 × 4"

Matt Ritchie

Jacqueline
Acrylic on cut wood
12.5 × 4.5"

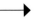

Ziggy's Dream
Acrylic on cut wood
4.5 × 12.5"

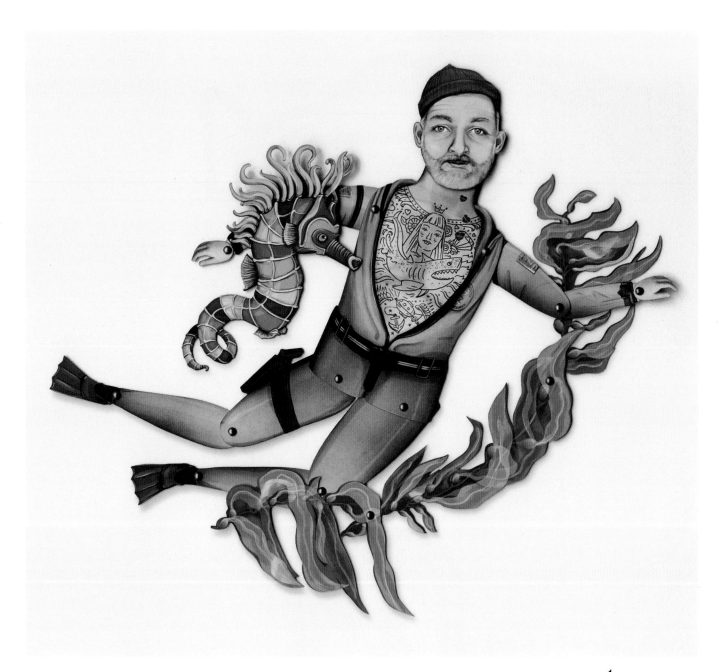

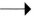
Crankbunny
Steve Zissou
Hand-cut paper doll
12 × 16" (variable)

Meghan Stratman
*I Wonder if It
Remembers Me?*
Paper collage
12 × 16"

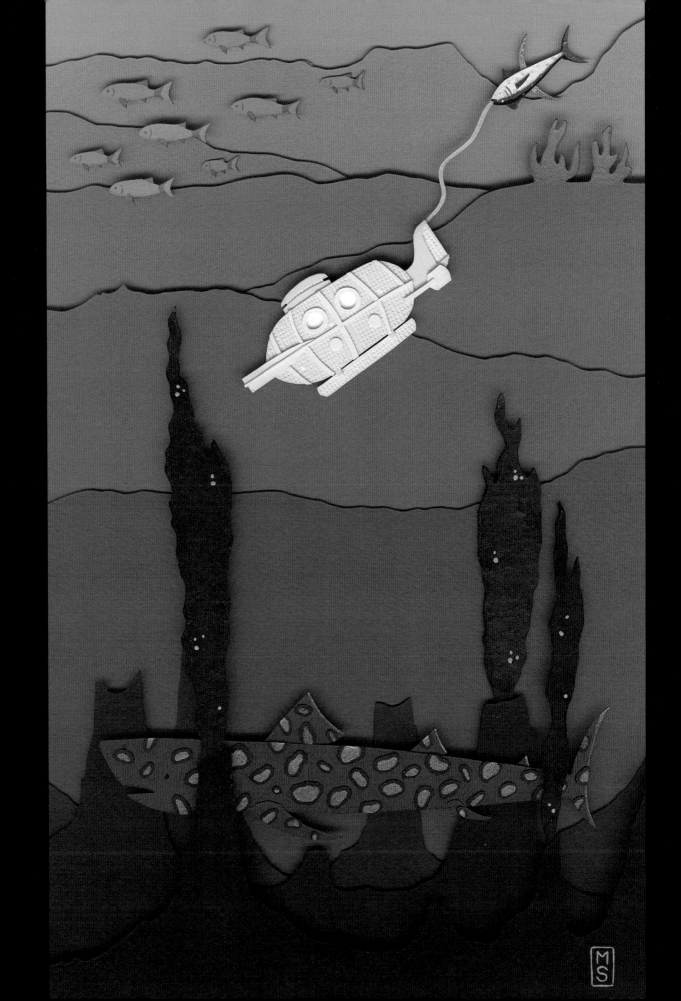

178

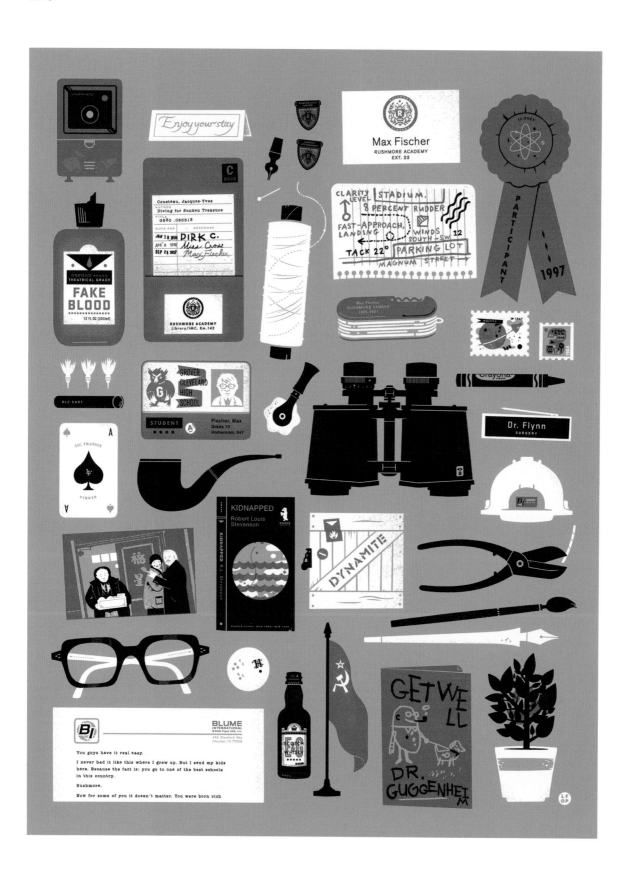

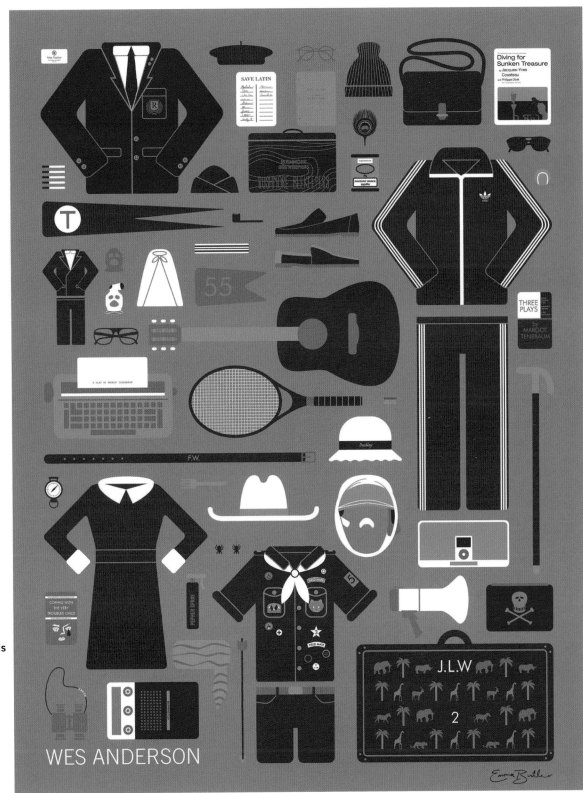

The Little Friends
of Printmaking
Rushmore
Screen print
19 × 25"

Emma Butler
*The Wes
Anderson
Collection*
Screen print
18 × 24"

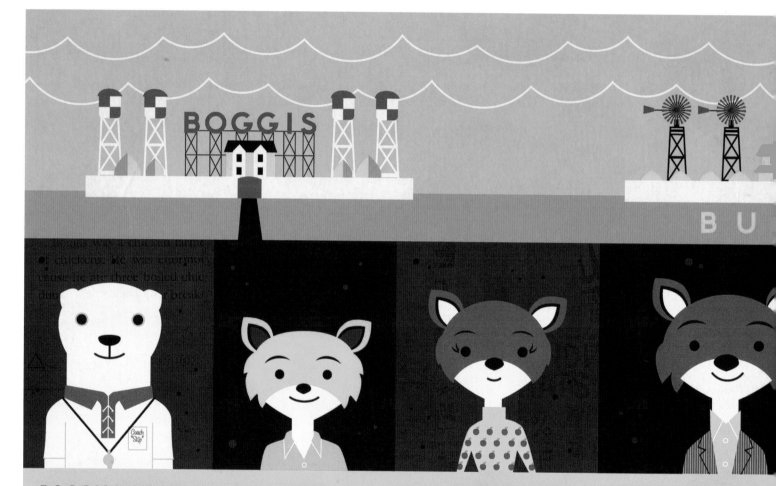

Dave Perillo
Boggis, Bunce and Bean
Fine art giclée print
24 × 9"

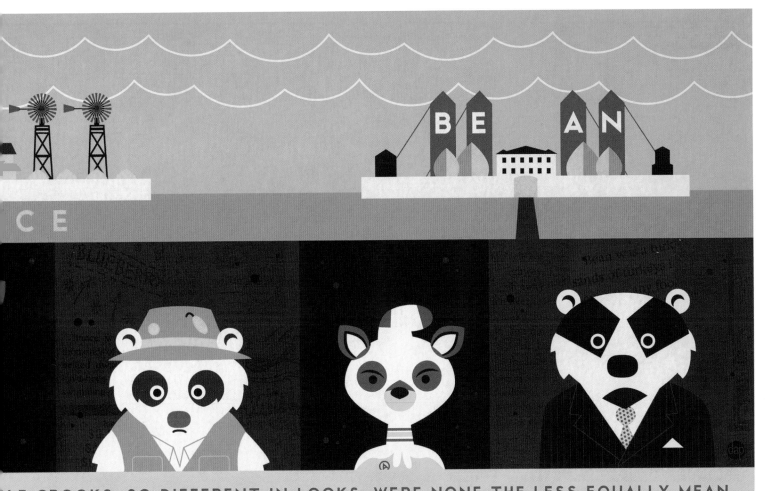

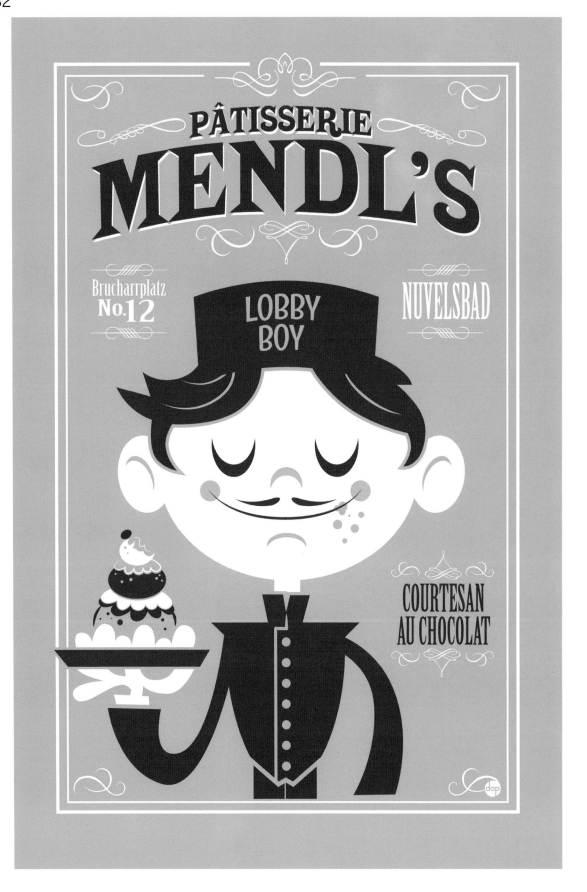

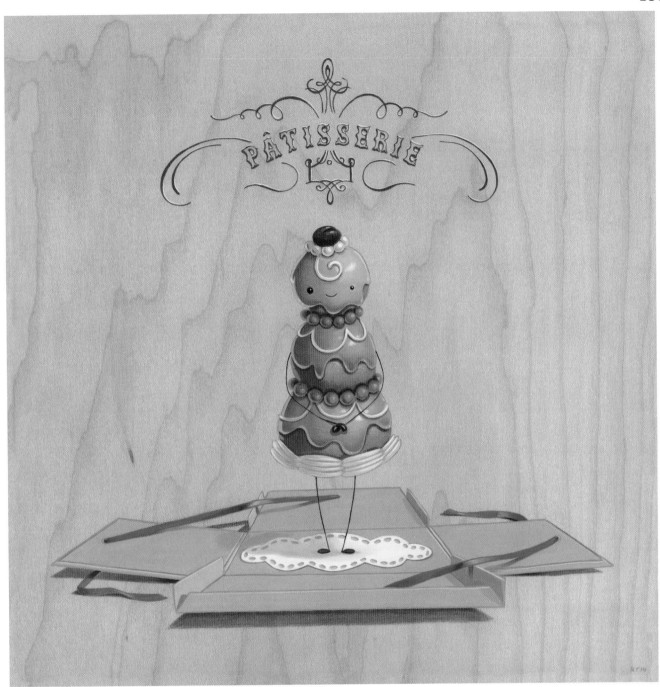

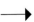
Dave Perillo
Courtesan au Chocolat
Screen print
12 × 18"

→
Cuddly Rigor Mortis
Serve Fresh
Acrylic on maple
9.5 × 9.5 × .75"

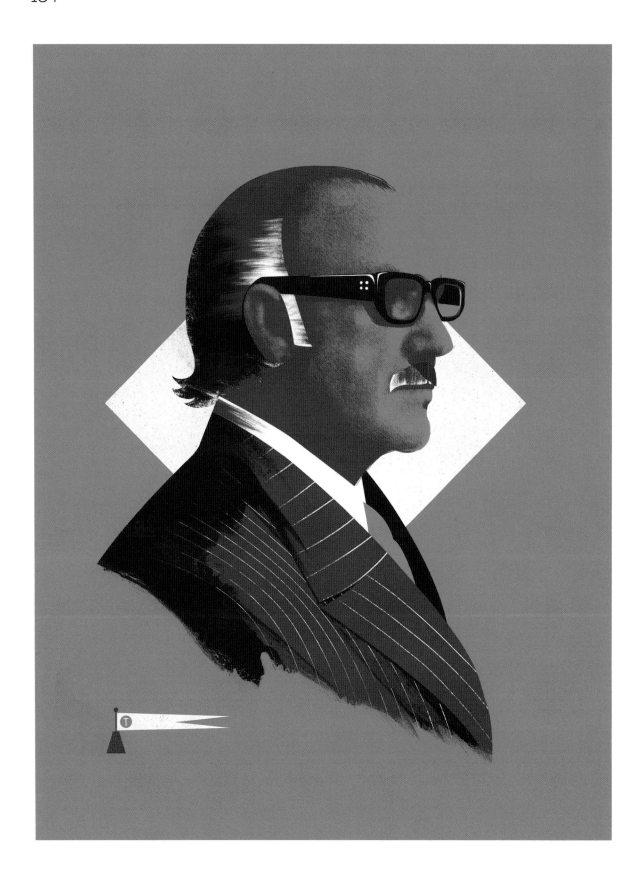

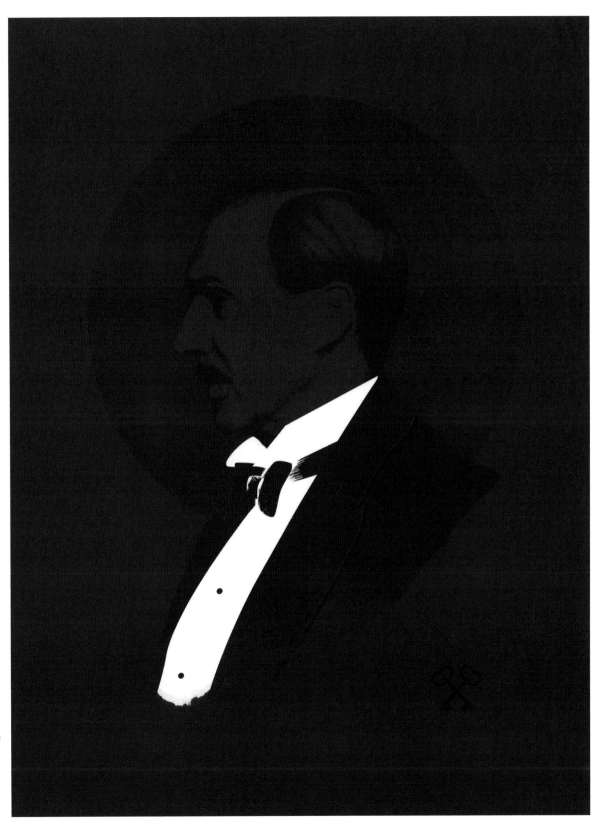

**Justin Van
Genderen**

←

M. Gustav Bust
Screen print
18 × 24"

→

Royal Bust
Screen print
18 × 24"

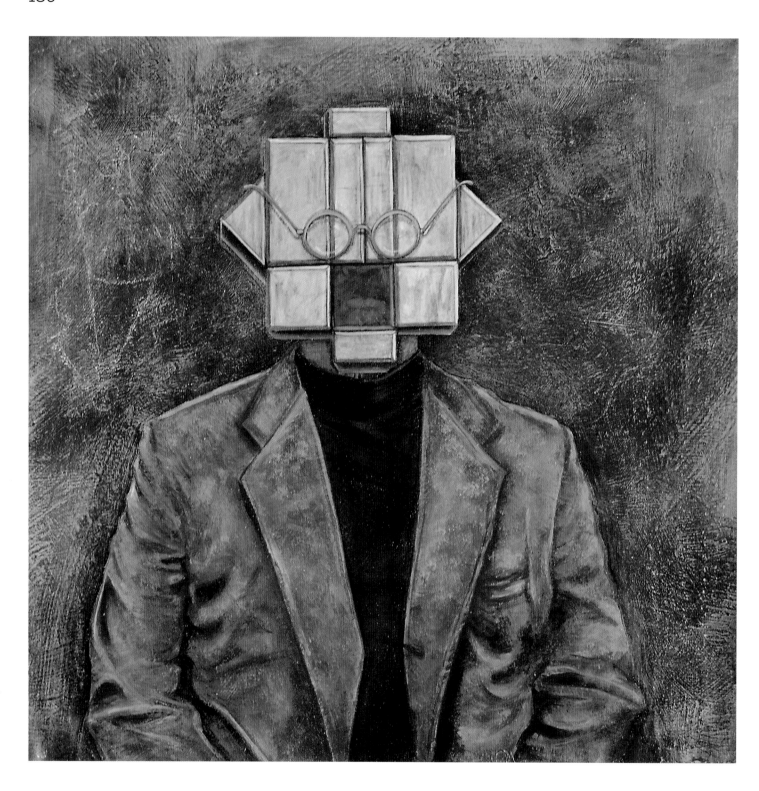

Joseph Murdach
Blockheads
Acrylic and chalk on Masonite
31 × 15.5"

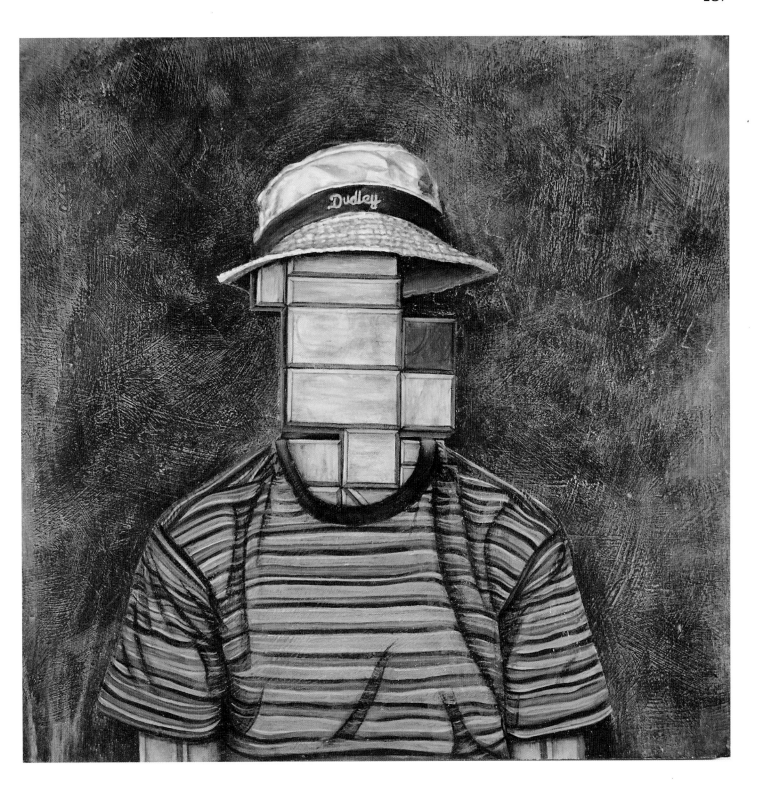

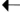

Christine Aria Hostetler

←

"I Think He's on to Us."
"Of Course, He Is." "Of Course,
He Is?"
Watercolor, pen and ink on paper
10 × 8.75"

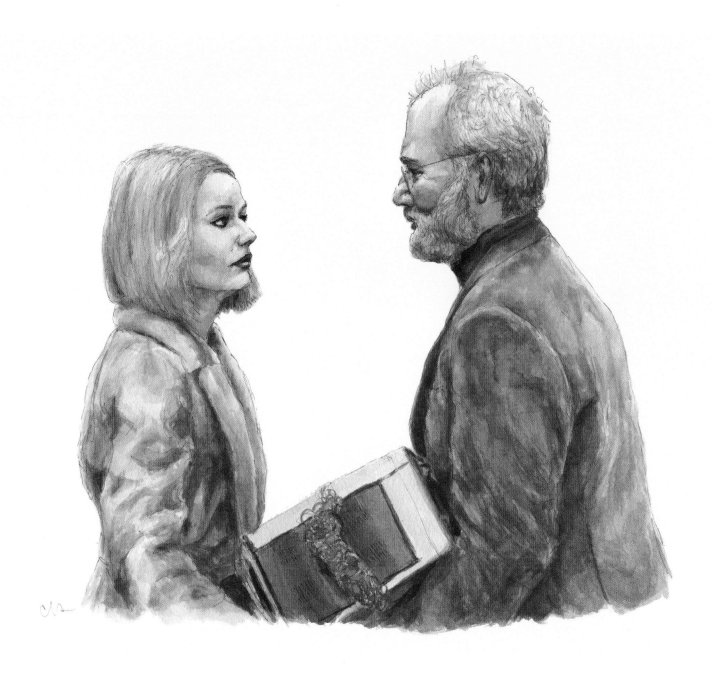

➡
*"You Don't Love Me Anymore,
Do You?" "I Do, Kind Of"*
Watercolor, pen and ink on paper
13.75 × 10"

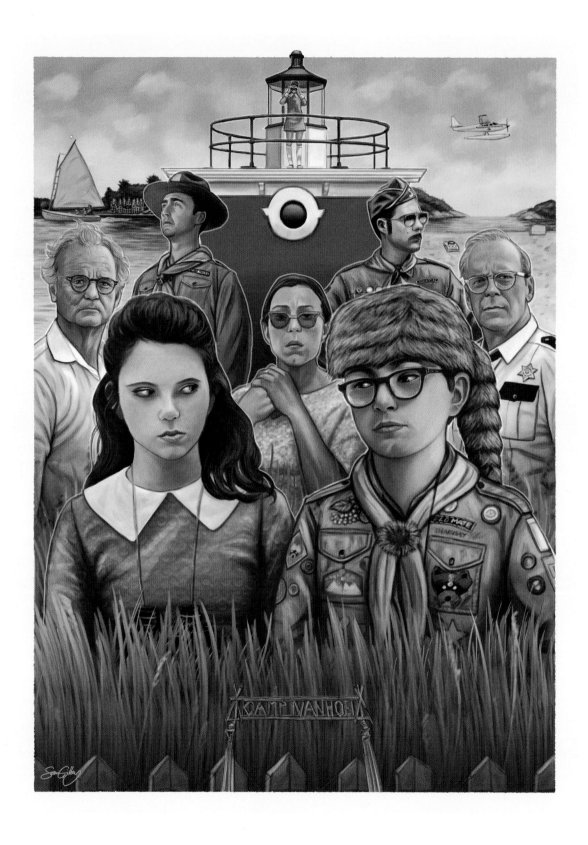

Sam Gilbey

←

*When We First
Met Each Other,
Something
Happened to Us*
Fine art giclée print
18 × 24"

→

*You Still Consider
Me Your Father?*
Fine art giclée print
18 × 24"

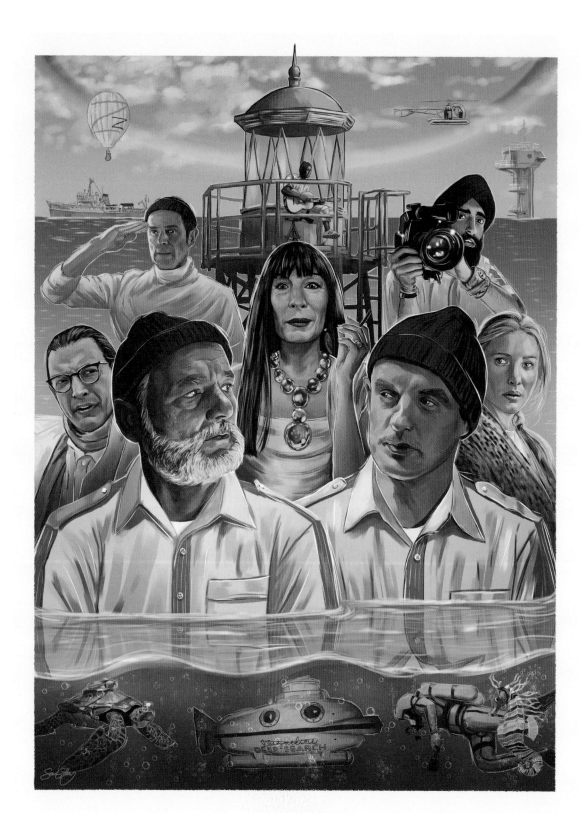

←

Sam Gilbey
I Hate Fathers,
and I Never
Wanted to Be One
Fine art giclée print
18 × 24"

→

Allison Reimold
Stevesie
Oil on board
9 × 12"

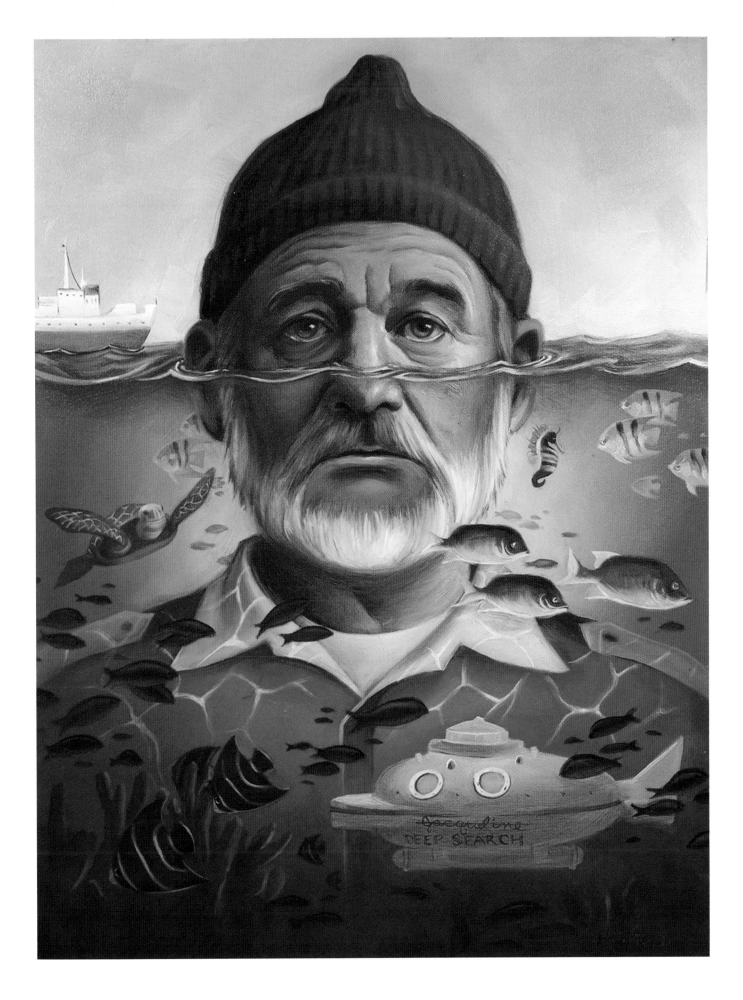

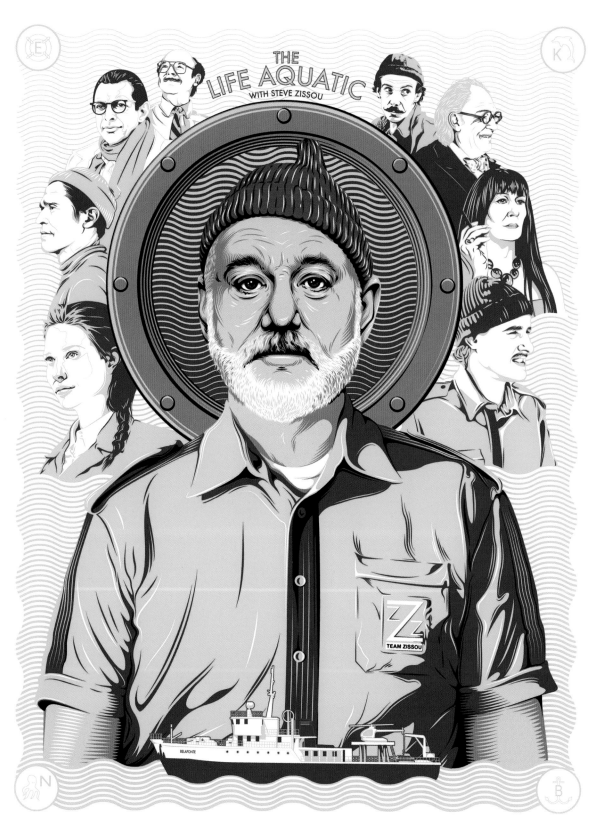

Tracie Ching

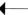

The Life Aquatic
Screen print
18 × 24"

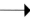

*The Royal
Tenenbaums*
Screen print
18 × 24"

THE CASTRO THEATRE & SPOKE ART PRESENT

The
ROYAL TENENBAUMS

A WES ANDERSON FILM

THE CASTRO THEATRE 429 CASTRO ST, SAN FRANCISCO, CA 94114 NOV. 3RD, 2013

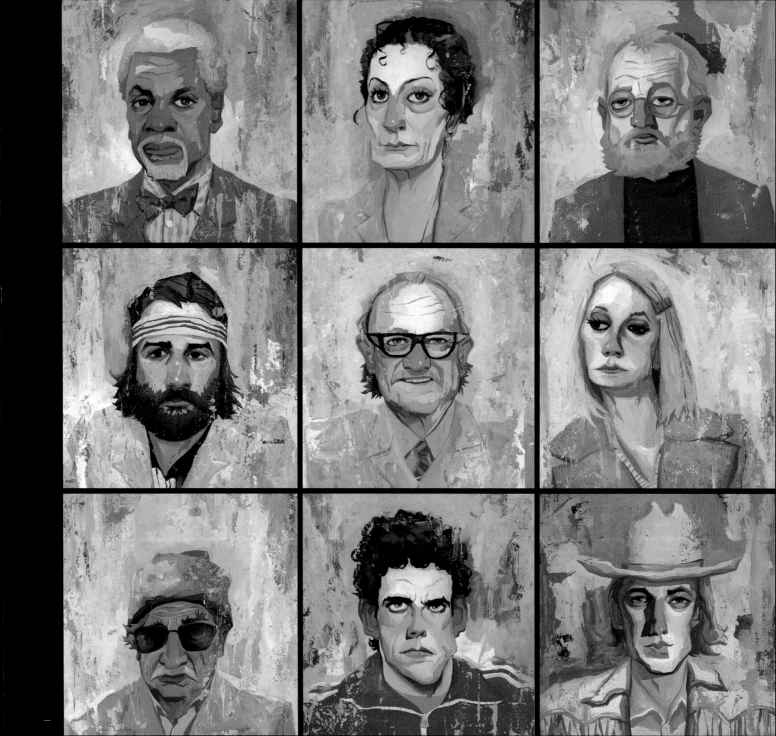

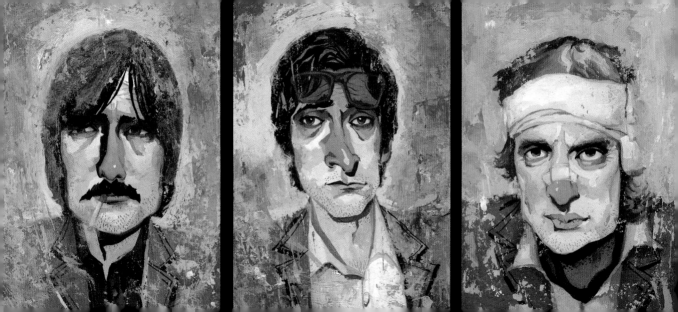

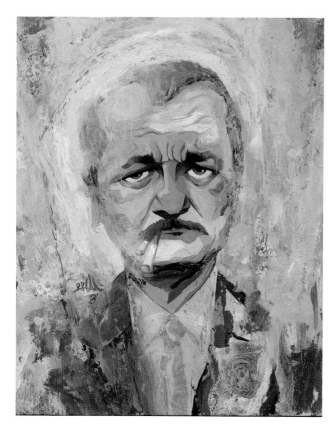 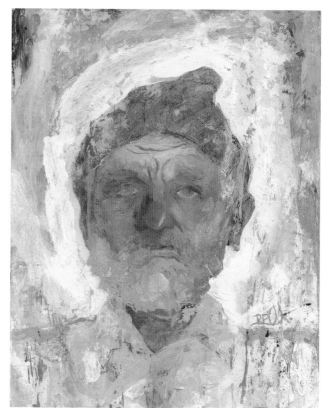

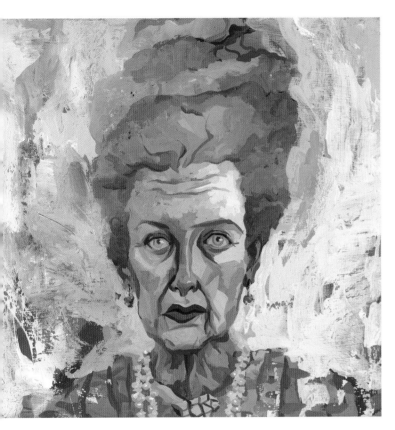

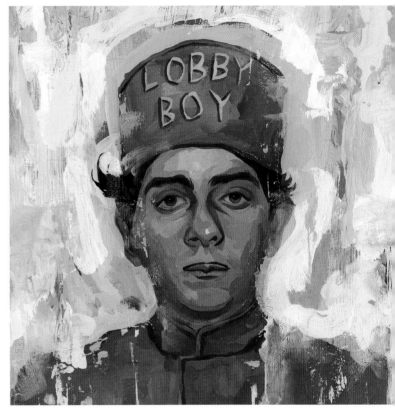

Rich Pellegrino

Mr. Blume,
Mr. Zissou
Acrylic on panels
8 × 10" (each)

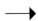

Madame D.,
Lobby Boy
Acrylic on panels
8 × 8" (each)

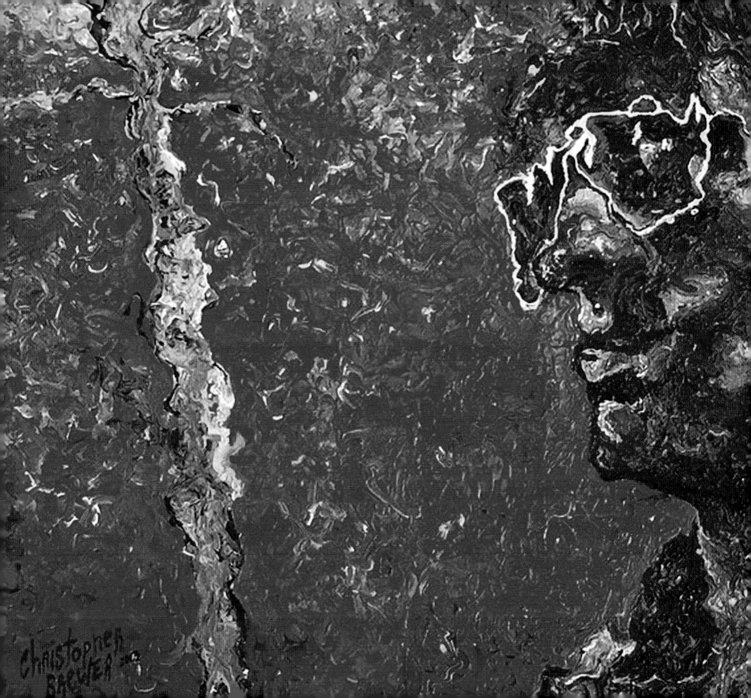

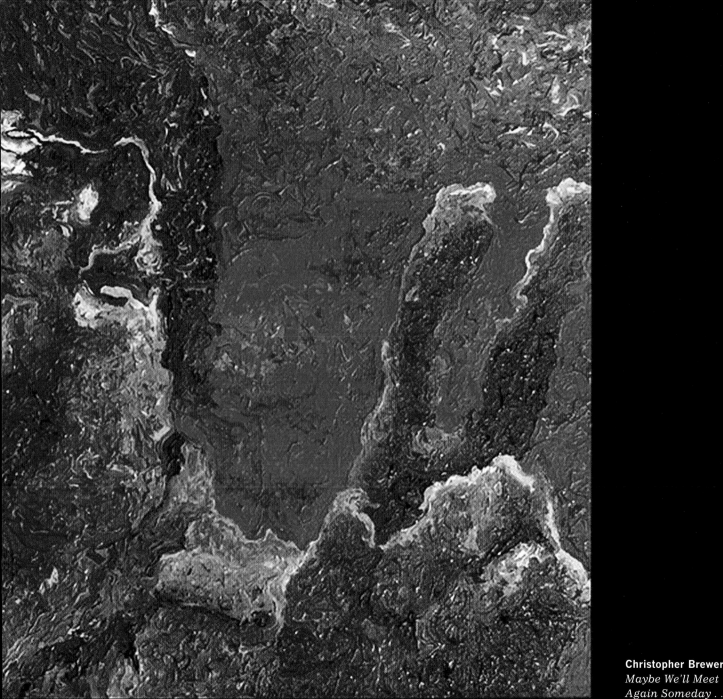

Christopher Brewer
*Maybe We'll Meet
Again Someday*

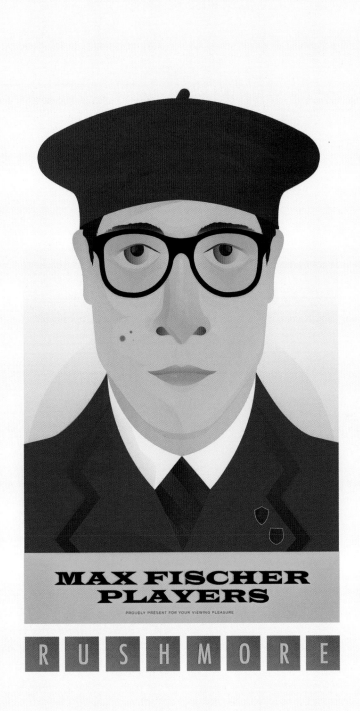

MAX FISCHER
PLAYERS

PROUDLY PRESENT FOR YOUR VIEWING PLEASURE

R U S H M O R E

Robert Wilson IV
Heaven & Hell
Screen print
18 × 24"

Matt Needle
Rushmore
Fine art giclée print
18 × 24"

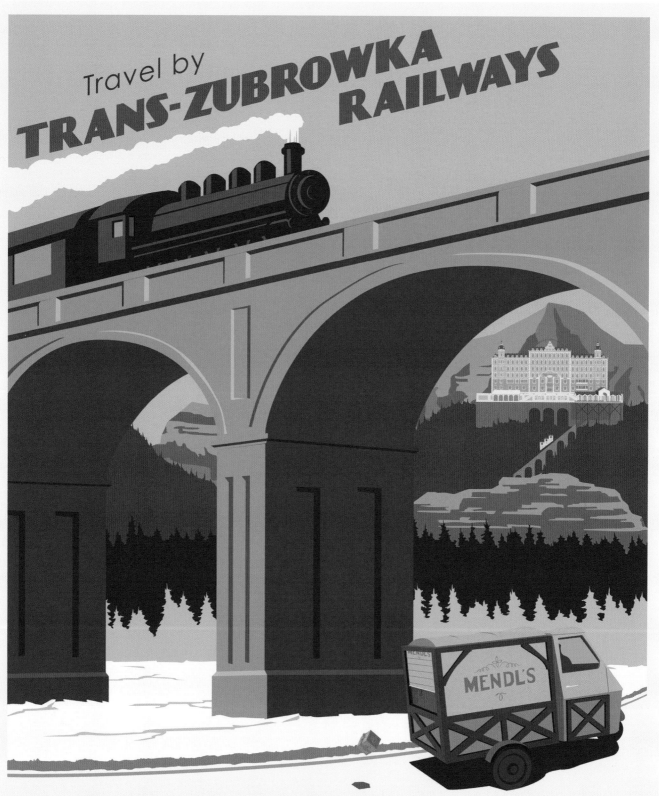

Travel by
TRANS-ZUBROWKA RAILWAYS

MENDL'S

THE
REPUBLIC OF ZUBROWKA
WELCOMES YOU!
TRAVEL COUPONS IN THE TRANS-ALPINE YODEL MORNING EDITION

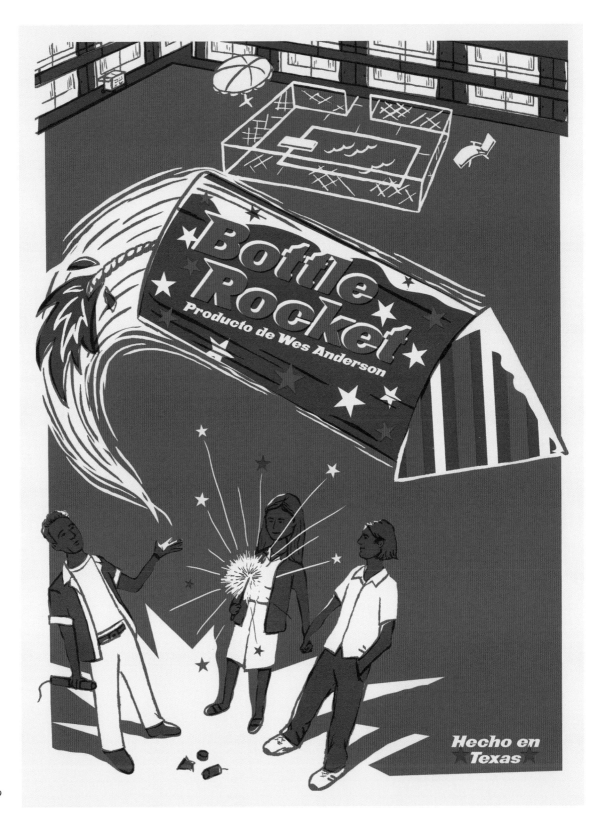

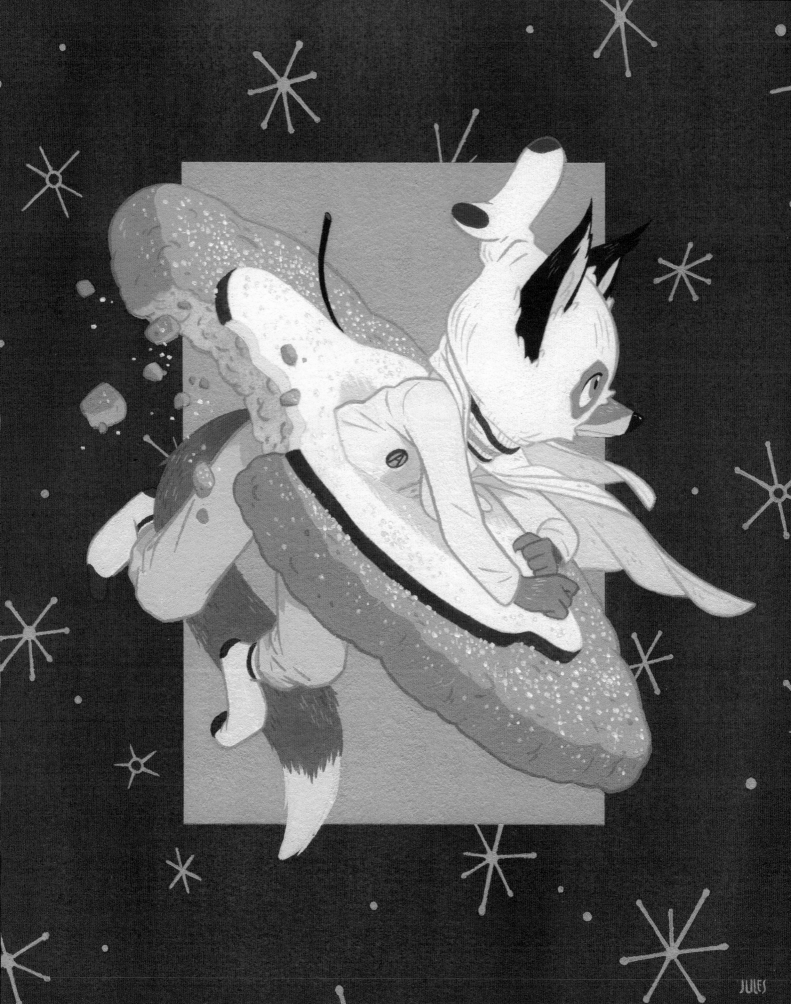

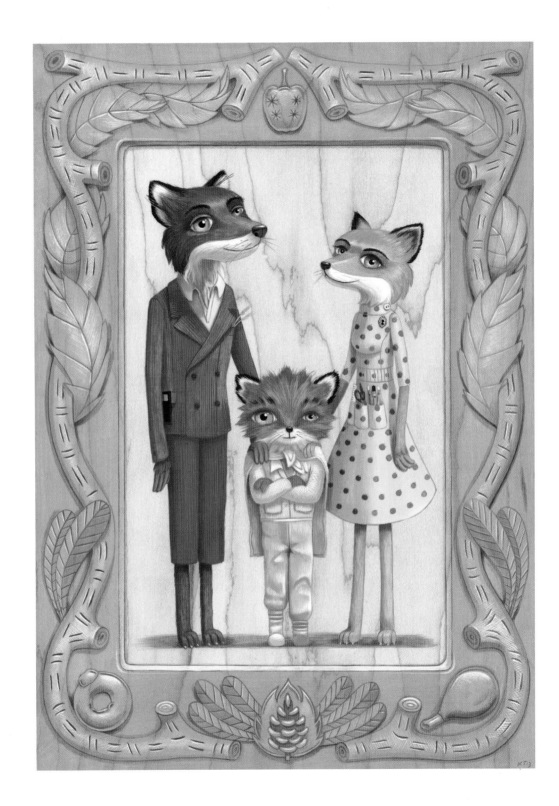

Julian Callos
Amateur Bandit
Acrylic and gouache on
Rives BFK mounted on
cradled panel
8 × 10"

Cuddly Rigor Mortis
*Fantastic Family
Portrait*
Acrylic on maple
8.5 × 12"

208

Meghan Stratman
Hot Box
Paper collage
12 × 4"

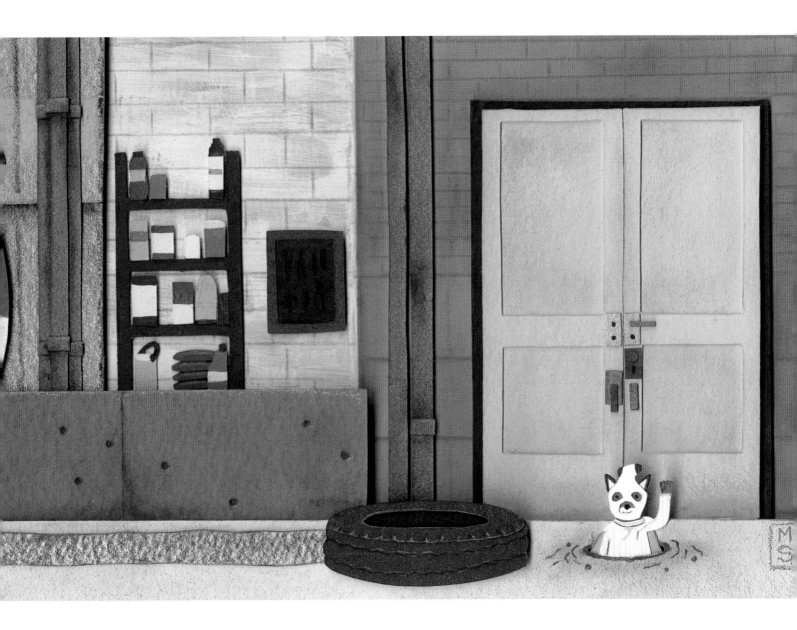

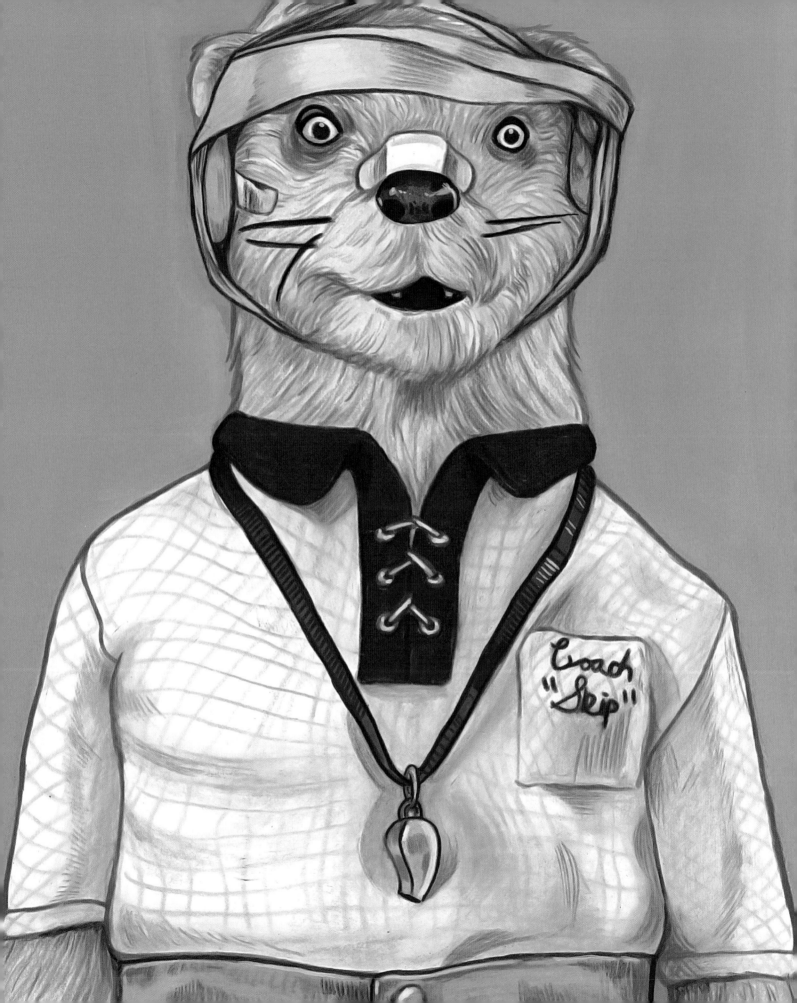

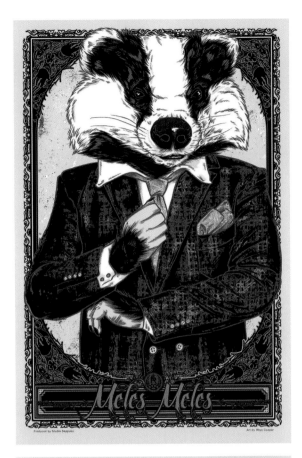

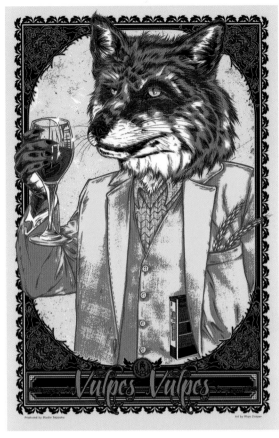

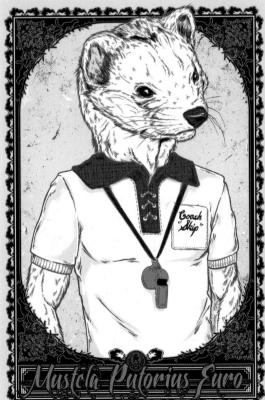

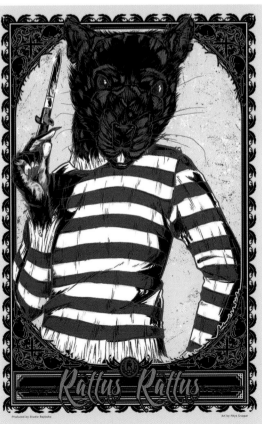

← **Cuyler Smith**
Coach Skip as Francis
Watercolor, gouache, and colored pencils on Rives BFK
8 × 10"

→ **Rhys Cooper**
Meles Meles, Vulpes Vulpes, Mustela Putorius Furo, Rattus Rattus
Screen prints
12 × 18" (each)

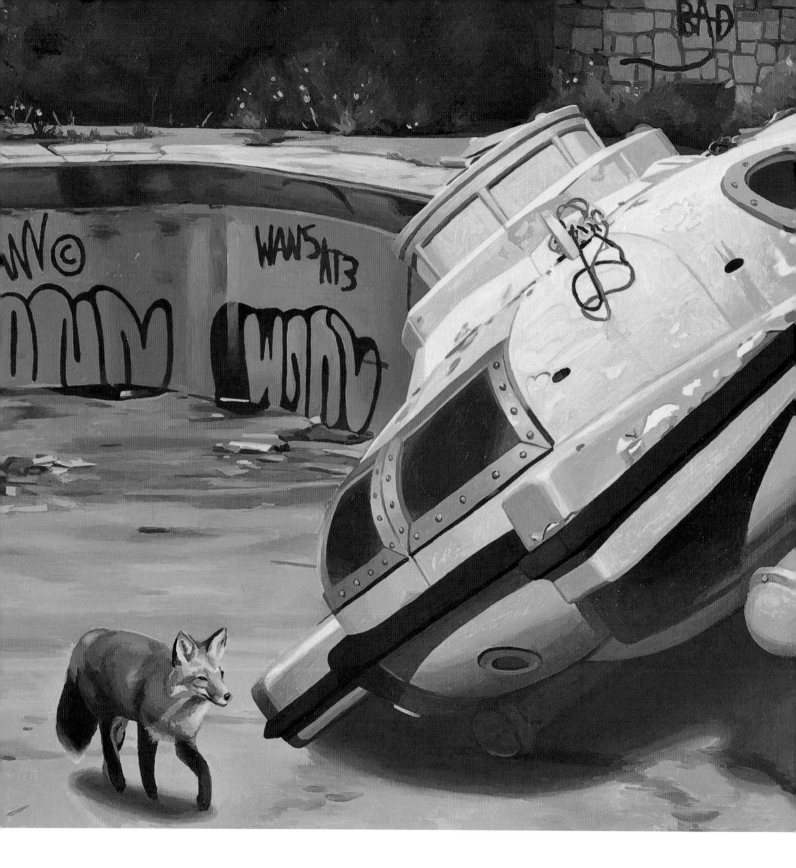

Scott Listfield
The Life Unaquatic
Oil on canvas
24 × 12"

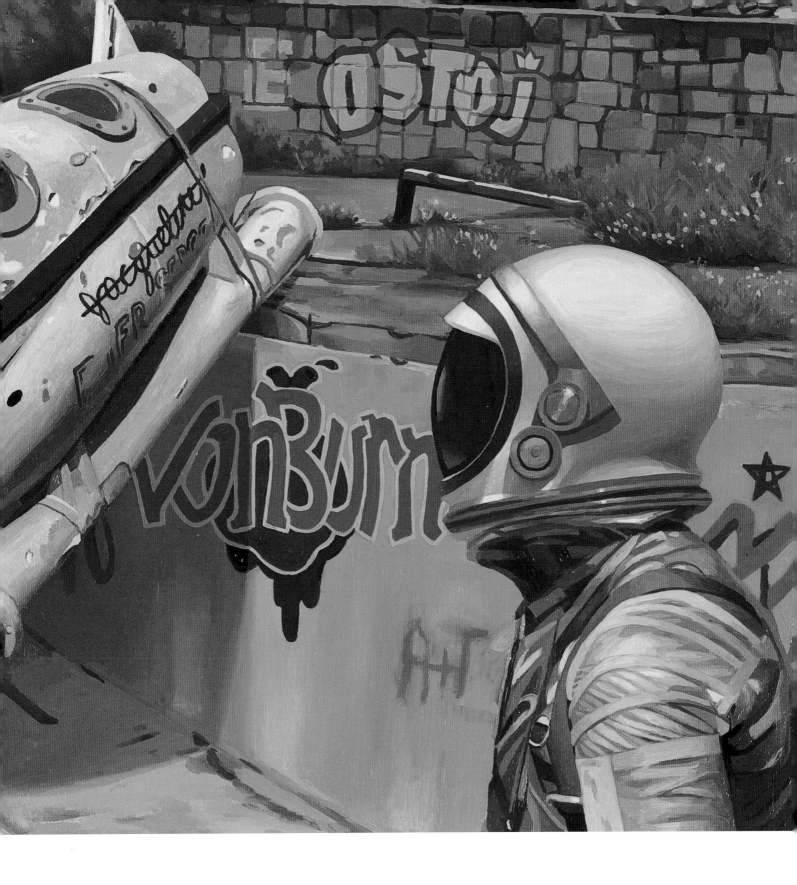

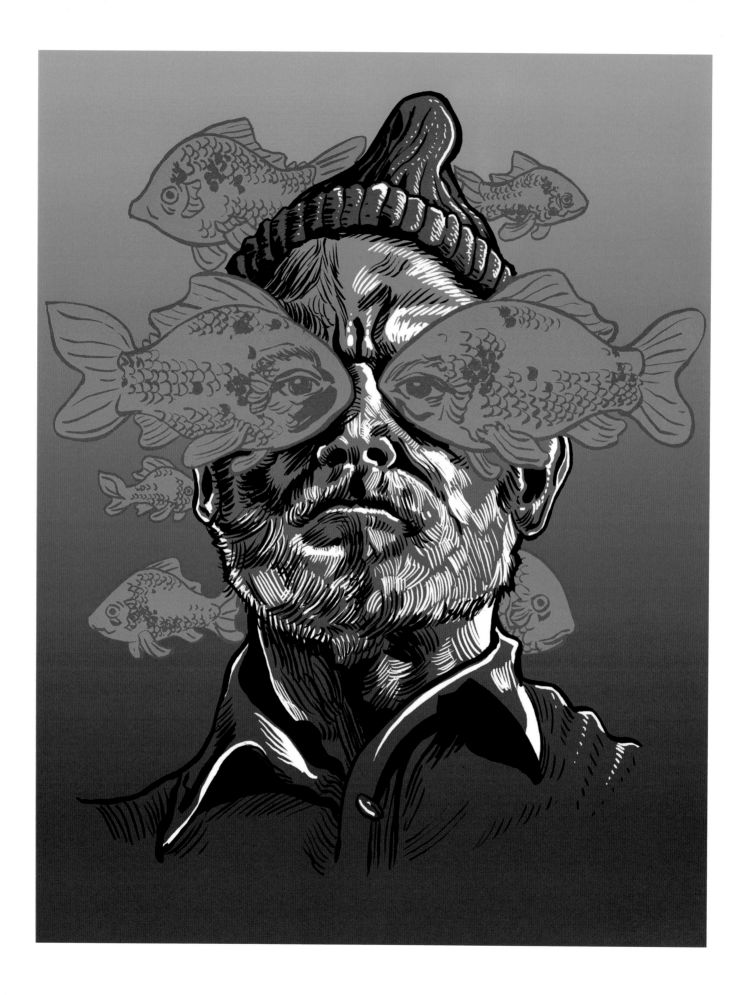

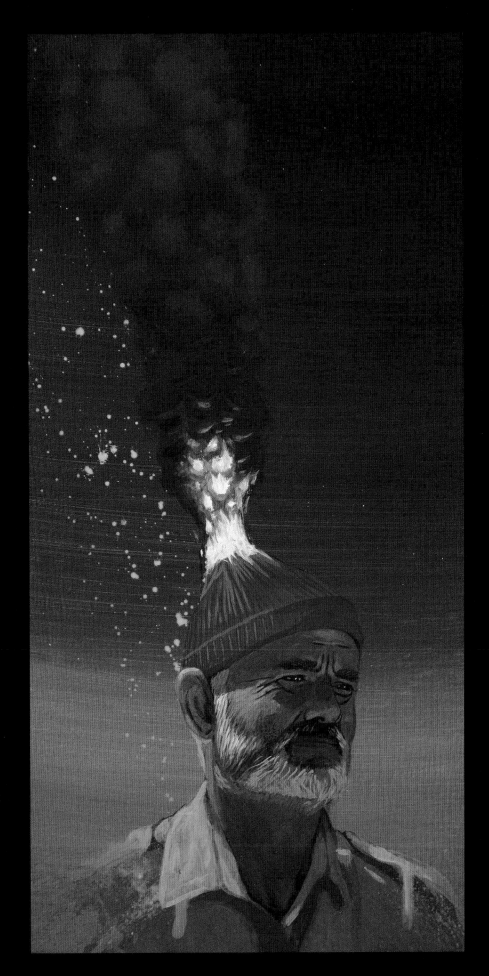

←

Tim Doyle
He Is the Zissou
Screen print on wood
16 × 20"

→

Robert Bowen
*This Is an
Adventure*
Acrylic on panel
8 × 16"

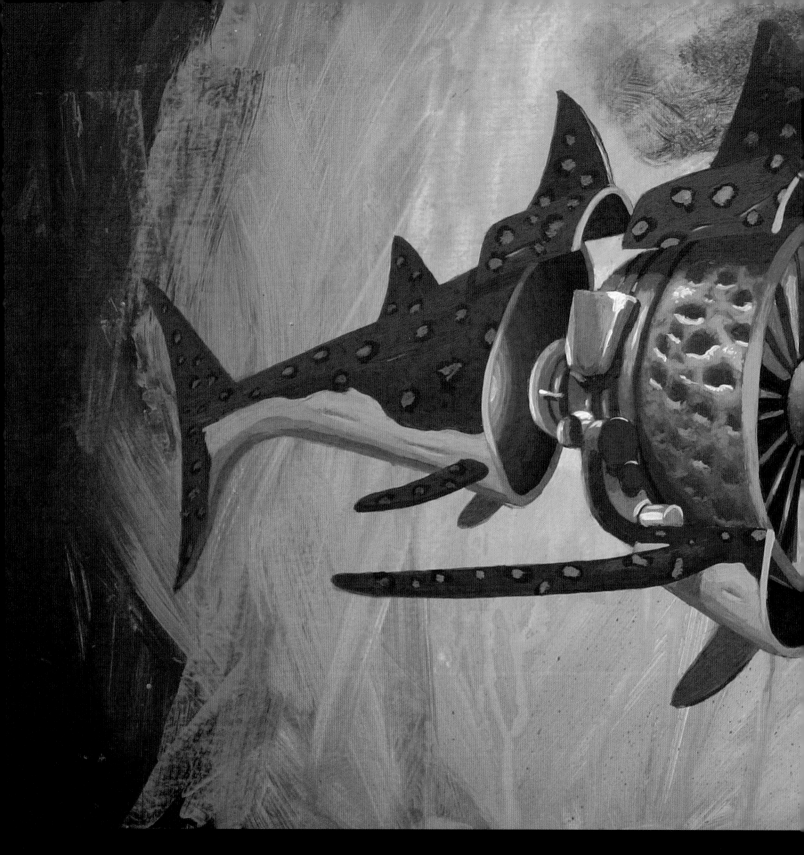

Robert Bowen
*"Jaguar Shark" (It Does
Remember You, Zissou)*
Acrylic on panel
16 × 8"

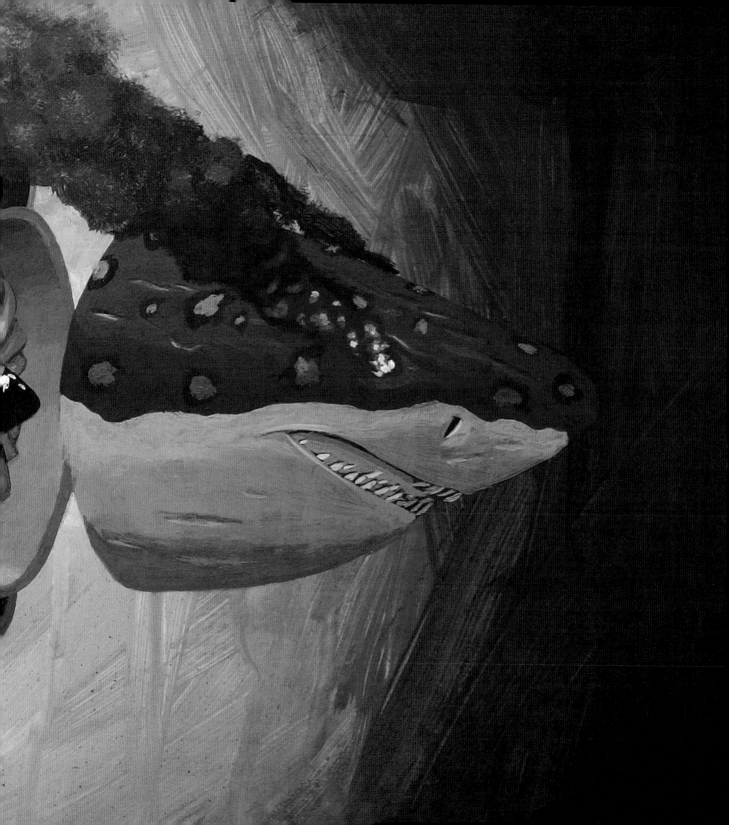

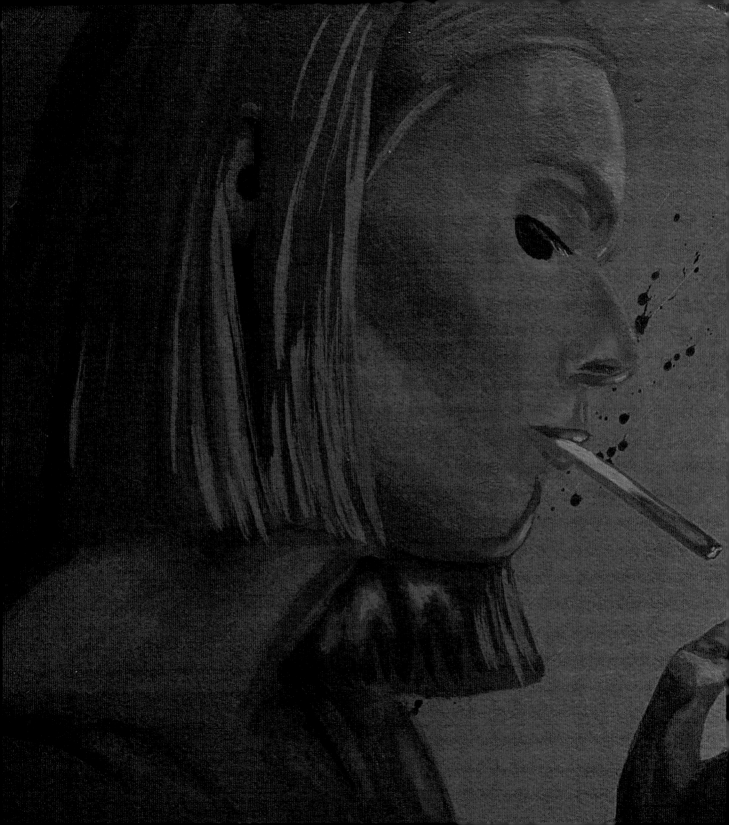

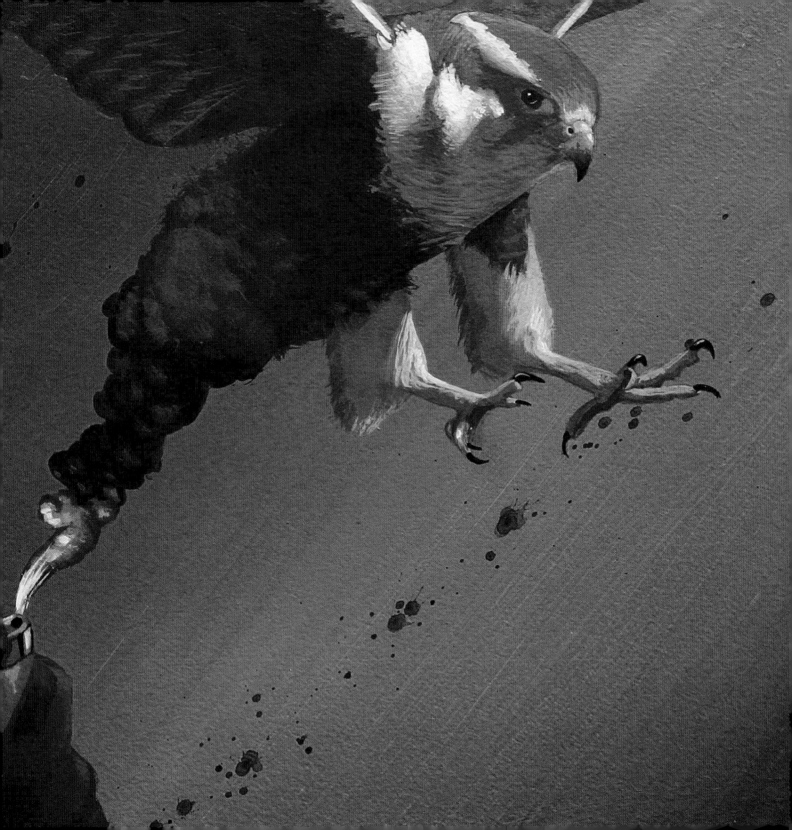

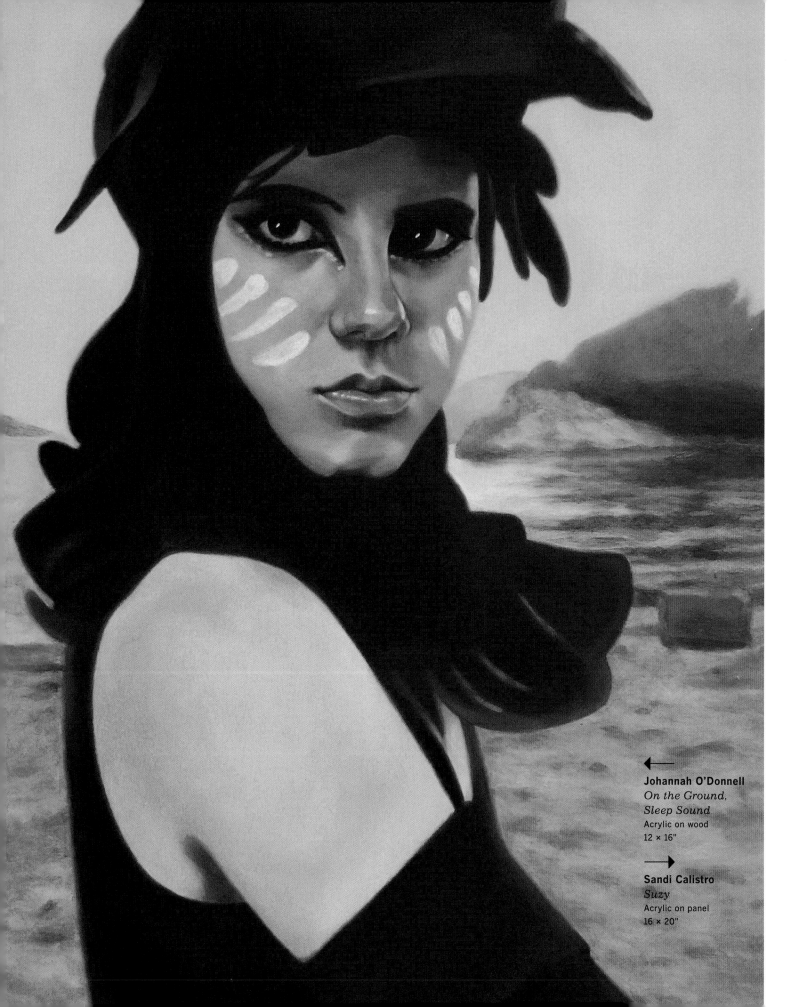

Johannah O'Donnell
On the Ground,
Sleep Sound
Acrylic on wood
12 × 16"

Sandi Calistro
Suzy
Acrylic on panel
16 × 20"

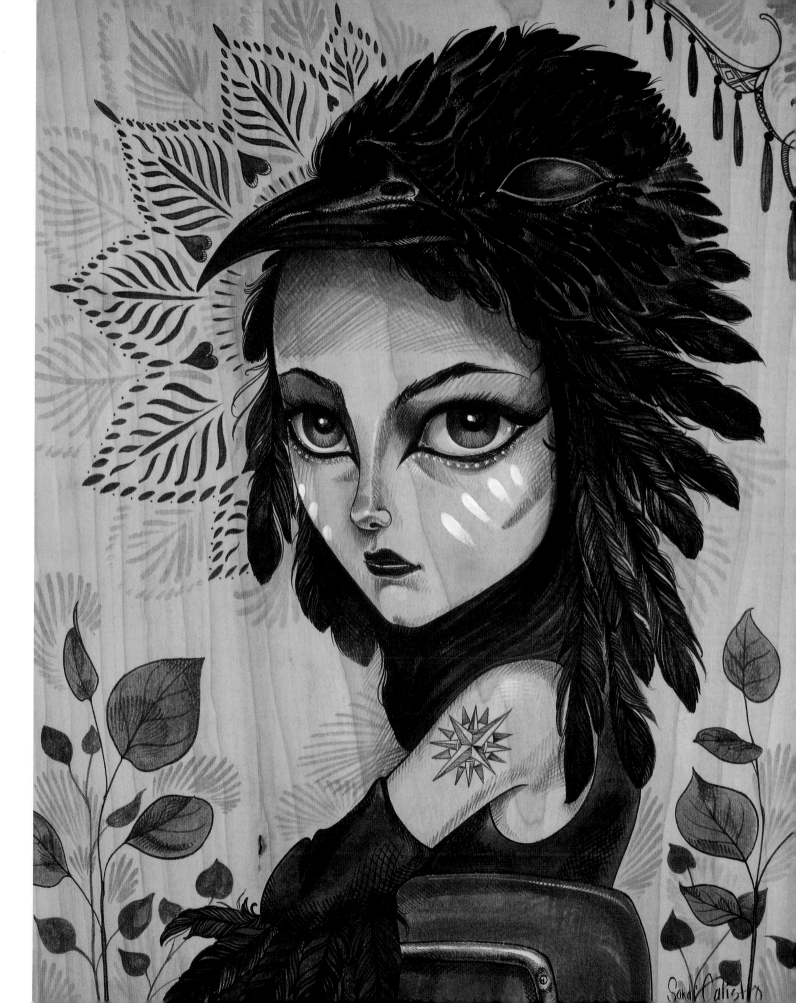

Sarah Callister

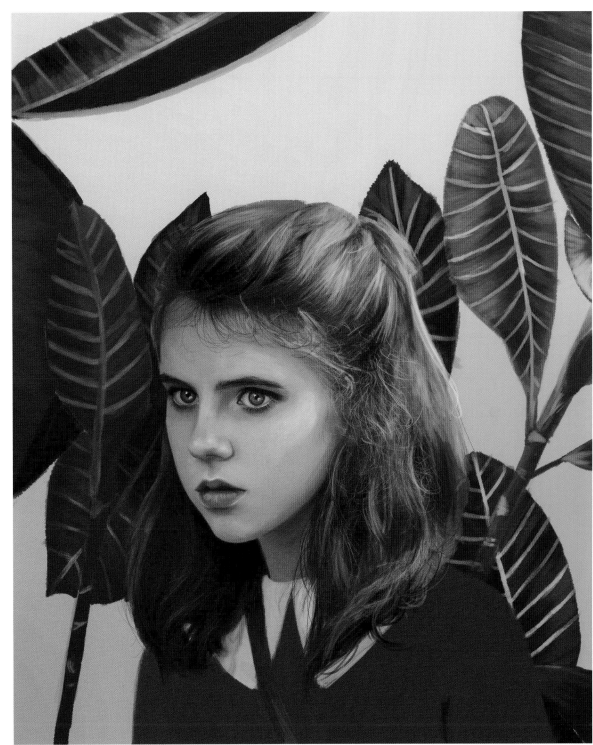

←

Tracie Ching
Moonrise Kingdom
Screen print
18 × 24"

→

Kemi Mai
Suzy
Fine art giclée print
19 × 19"

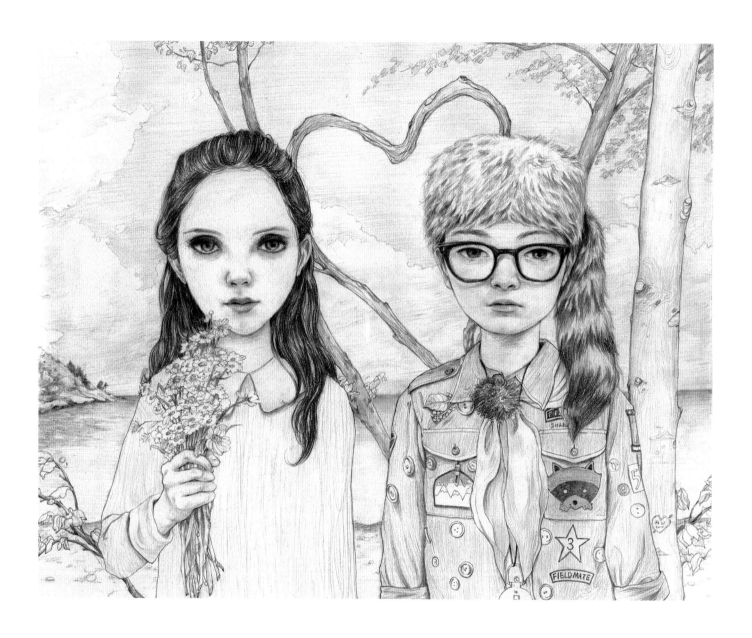

Helice Wen

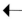

Le Temps de l'amour
Graphite on paper
29 × 25"

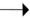

The Linden Tree
Mixed media on paper
12 × 15"

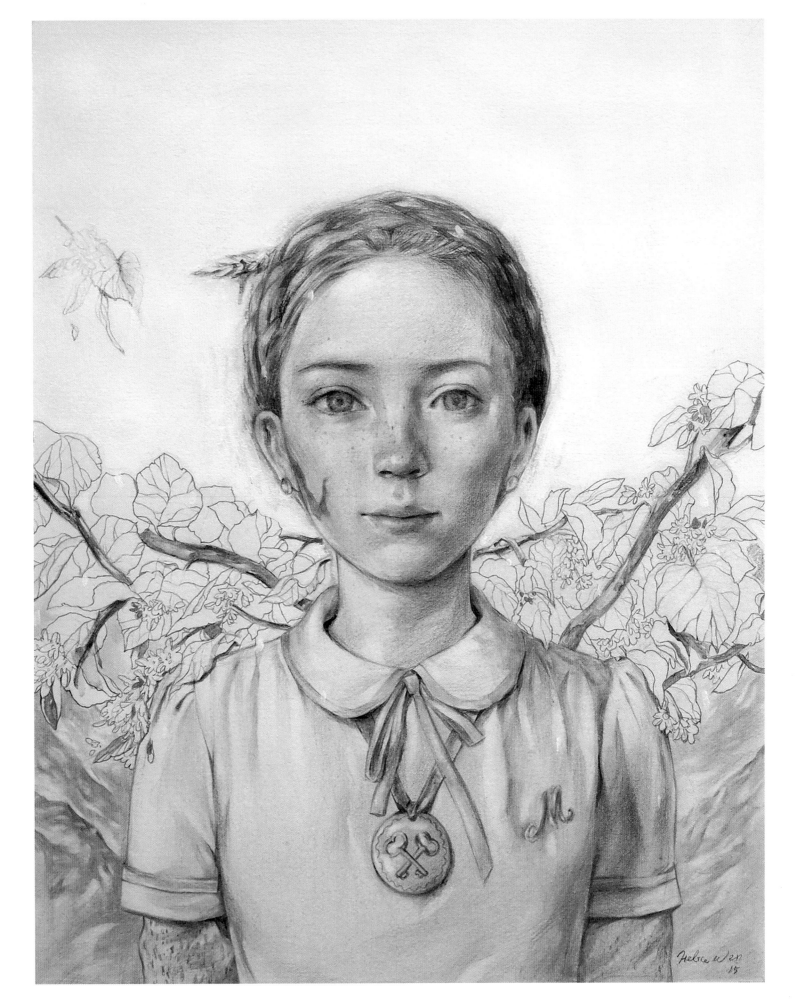

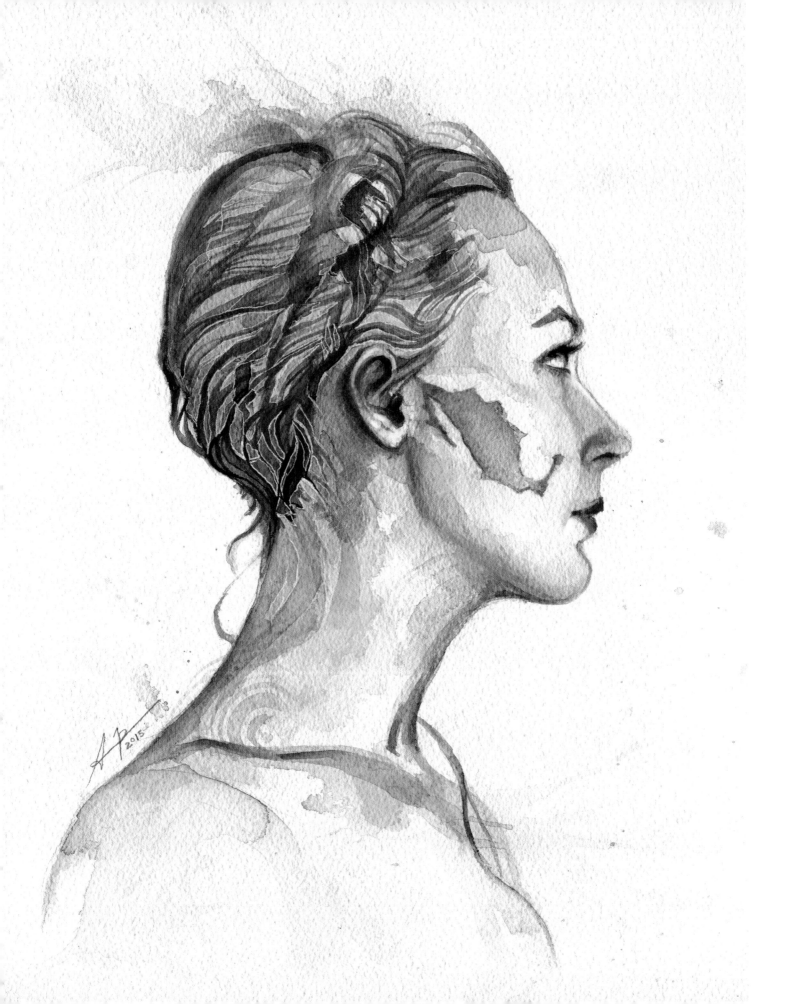

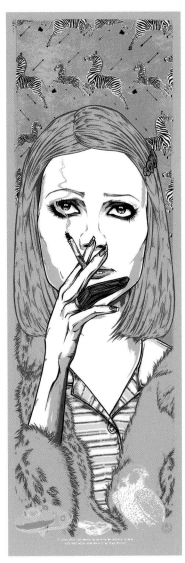
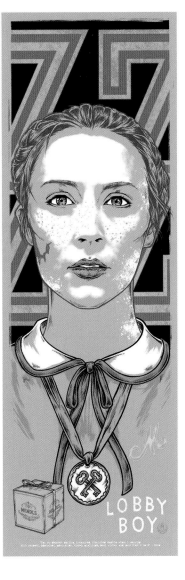

Alice X. Zhang
Always and Invariably
Lovely
Watercolor on paper
12 × 16"

→

Rhys Cooper
Felicity,
I'm a Raven,
Margot Helen Tenenbaum,
Agatha
Screen prints
12 × 36" (each)

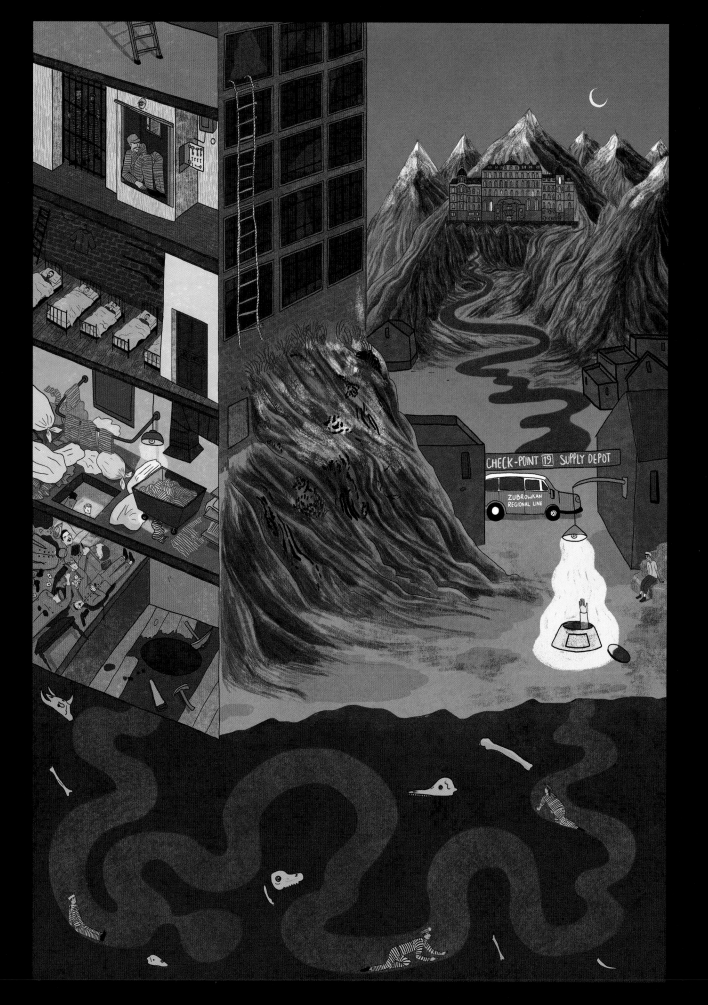

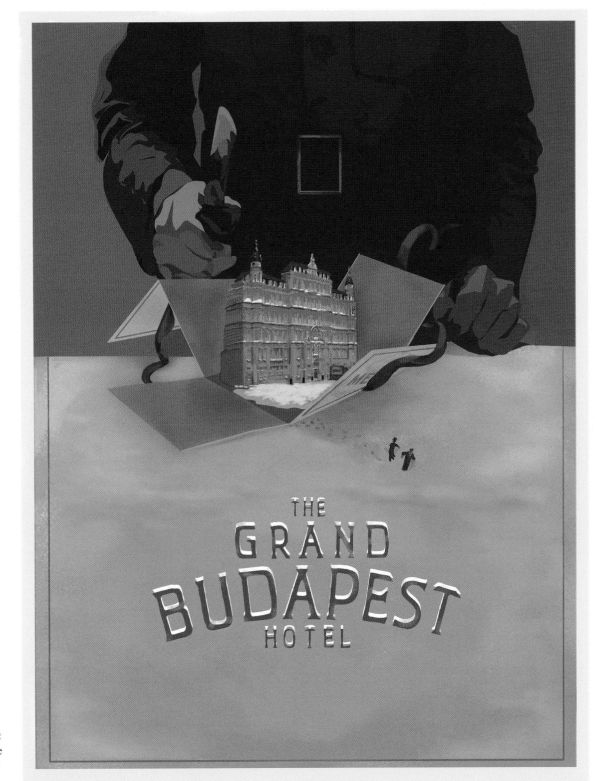

←
Lily Padula
Checkpoint 19
Fine art giclée print
13 × 19"

→
Fernando Reza
You See, There Are Still Faint Glimmers of Civilization Left in This Barbaric Slaughterhouse That Was Once Known as Humanity
Fine art giclée print
18 × 24"

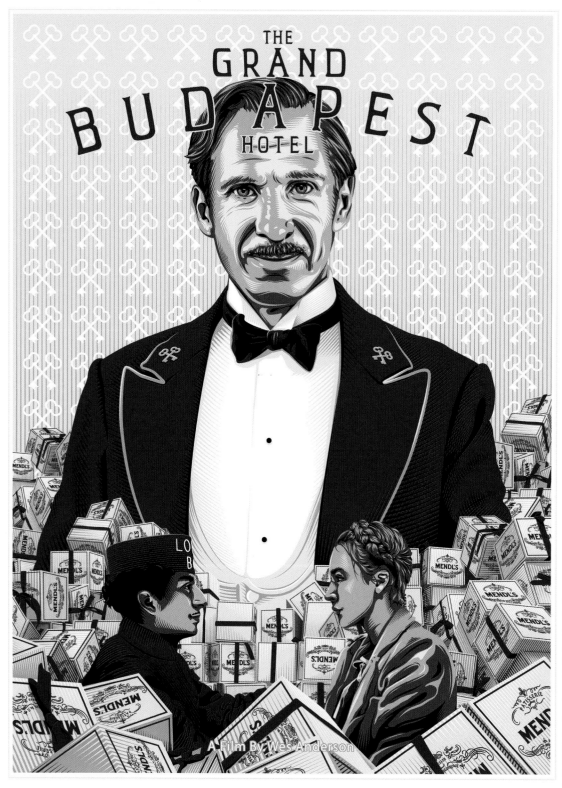

← **Tracie Ching**
*The Grand
Budapest Hotel*
Screen print
18 × 24"

→ **Alex R. Kirzhner**
*See the
Resemblance?*
Ink, marker, watercolor,
colored pencil, graphite,
gel ink, and ballpoint on
bristol board
12 × 16"

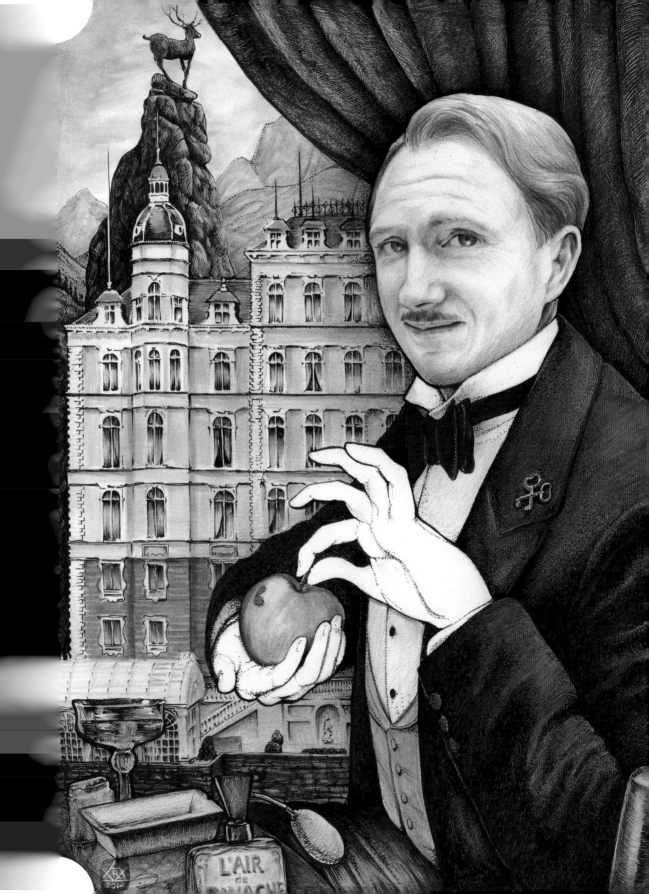

MENDLS

ULT-A-WHIRL RIDE ! WES ANDERSON THEME PARK

AT KIND OF BIRD ARE YOU?
WINGS WES ANDERSON THEME PARK

VOLTAIRE #6
La Petite Mort

GRAND BUDAPEST
DOWNHILL SKI
COASTER

ICE SKATING RINK

FEATHER CEREMONY RELIGIOUS SITE

MOONRISE KINGDOM

ETHELINE TENENBAUM'S
SITE OF ARCHAEOLOGICAL
SIGNIFICANCE

ROYAL'S
KARTS

YANKEE RACERS
HEADQUARTERS

VEHICLE TEST TRACK

ROYAL'S KARTS

FATHER DAUGHTER ICE CREAM PARLOUR

ZUBROWKA

DALMATION MICE

AGATHA'S CAROUSEL

HERMAN BLUME AQUATIC SHOW
SPONSORED BY BUDWEISER

ELI CASH'S WILD RIDE

MENDL'S SKY TILT-A-WHIRL

MARGOT TENENBAUM
PLAYHOUSE
NOW PLAYING MAX FISCHER'S
SERPICO

BOTTLEROCKET

RUSHMORE BIKE CRUSH DERBY

HINCKLEY
COLD STORAGE
4008 COMMERCE

MENDL'S BAKERY

HINCKLEY
HEIST EXPERIENCE

MAX FISCHER'S HEAVEN & HELL
SPECIAL EFFECTS SPECTACULAR

RALEIGH SINCLAIR
ADVENTURE RESERVE

SOCIETY OF THE CROSSED KEYS
DISGUISE SHOP

EAGLE ISLAND
B.B. GUN SHOOTING RANGE
TRAP & SKEET CLUB
HEADQUARTERS

CAMP IVANHOE CANOE RENTALS

DARJEELI

WES ANDERSON
SIC TRANS

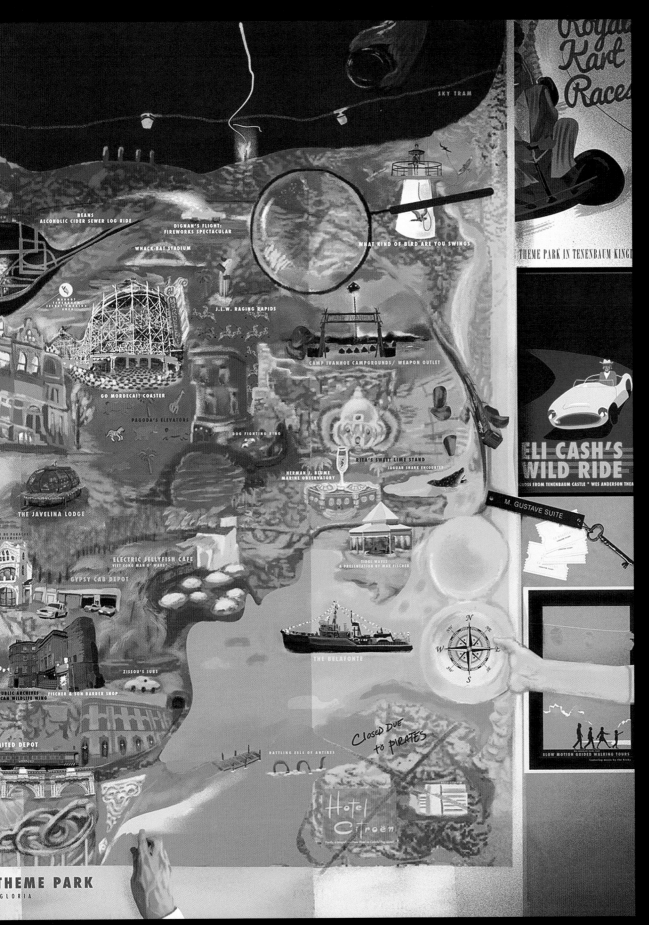

Fernando Reza
*Take This,
It's a Map,
and You
Might Need
a Magnifying
Glass to Read
It but It Tells
You Exactly
Where and
How to Find
"Boy with
Apple"*
Fine art giclée
print
36 × 24"

234

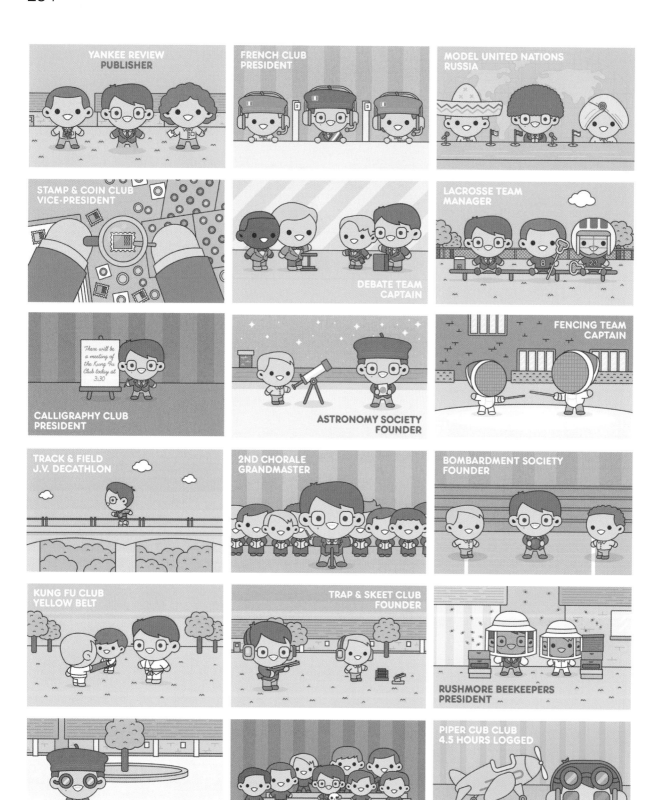

WES ANDERSON
FAMILY

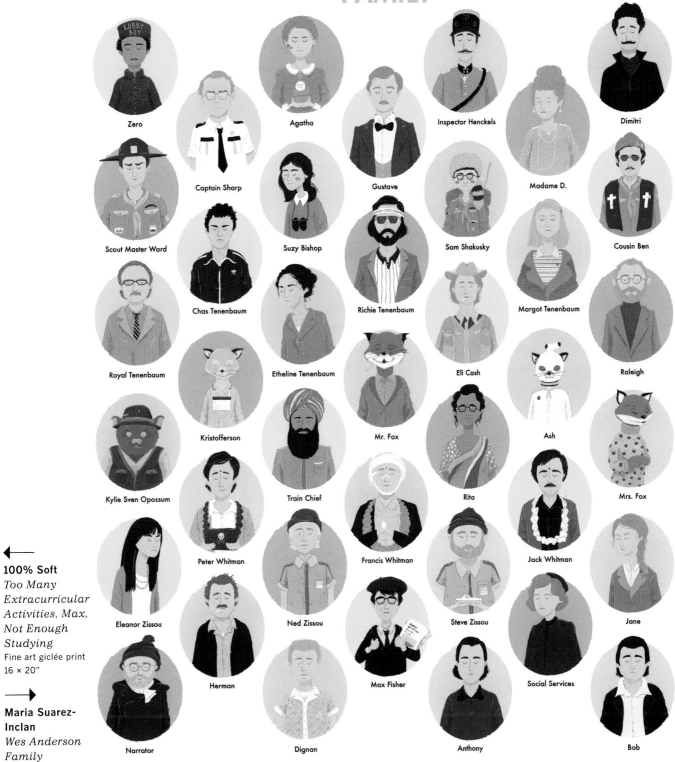

Zero

Captain Sharp

Agatha

Gustave

Inspector Henckels

Dimitri

Scout Master Ward

Suzy Bishop

Sam Shakusky

Madame D.

Cousin Ben

Chas Tenenbaum

Richie Tenenbaum

Margot Tenenbaum

Royal Tenenbaum

Etheline Tenenbaum

Eli Cash

Raleigh

Kristofferson

Mr. Fox

Ash

Kylie Sven Opossum

Train Chief

Rita

Mrs. Fox

Peter Whitman

Francis Whitman

Jack Whitman

Eleanor Zissou

Ned Zissou

Steve Zissou

Jane

Herman

Max Fisher

Social Services

Narrator

Dignan

Anthony

Bob

← **100% Soft**
*Too Many
Extracurricular
Activities, Max,
Not Enough
Studying*
Fine art giclée print
16 × 20"

→ **Maria Suarez-Inclan**
*Wes Anderson
Family*
Fine art giclée print
18 × 24"

Maria Suarez-Inclan
Wes Anderson Set
Fine art giclée print
24 × 18"

Bottle Rocket • Rushmore • The Royal Tenenbaums • The Life Aquatic • Hotel Chevalier

The Darjeeling Limited ● Fantastic Mr. Fox ● Moonrise Kingdom ● The Grand Budapest Hotel

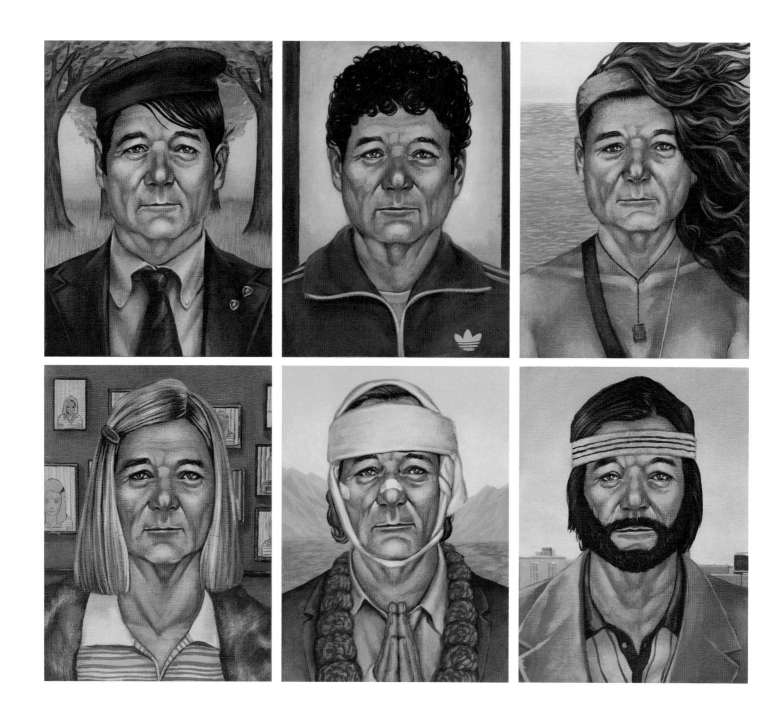

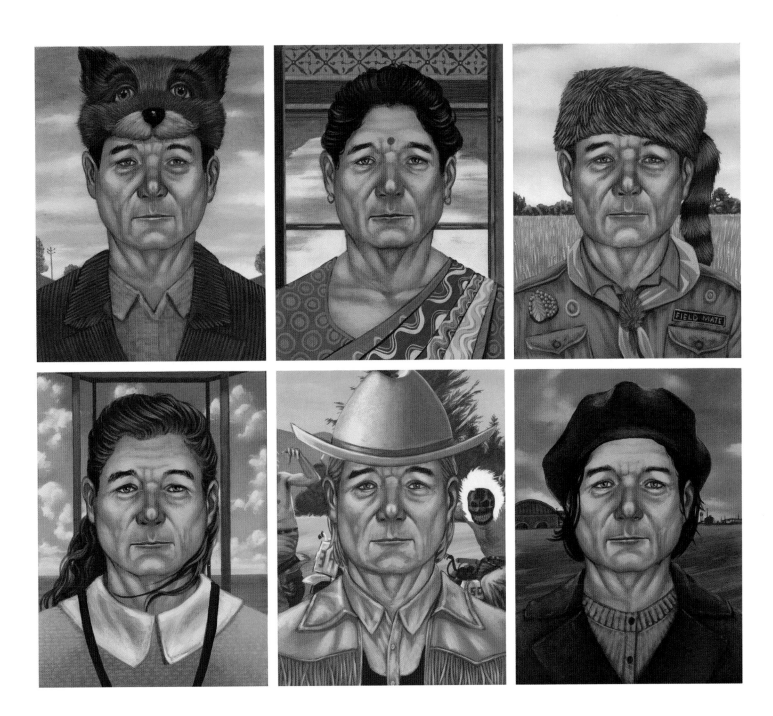

Casey Weldon

←

All as Murray

→

All as Murray II
Acrylic on panels
6 × 8" (each)

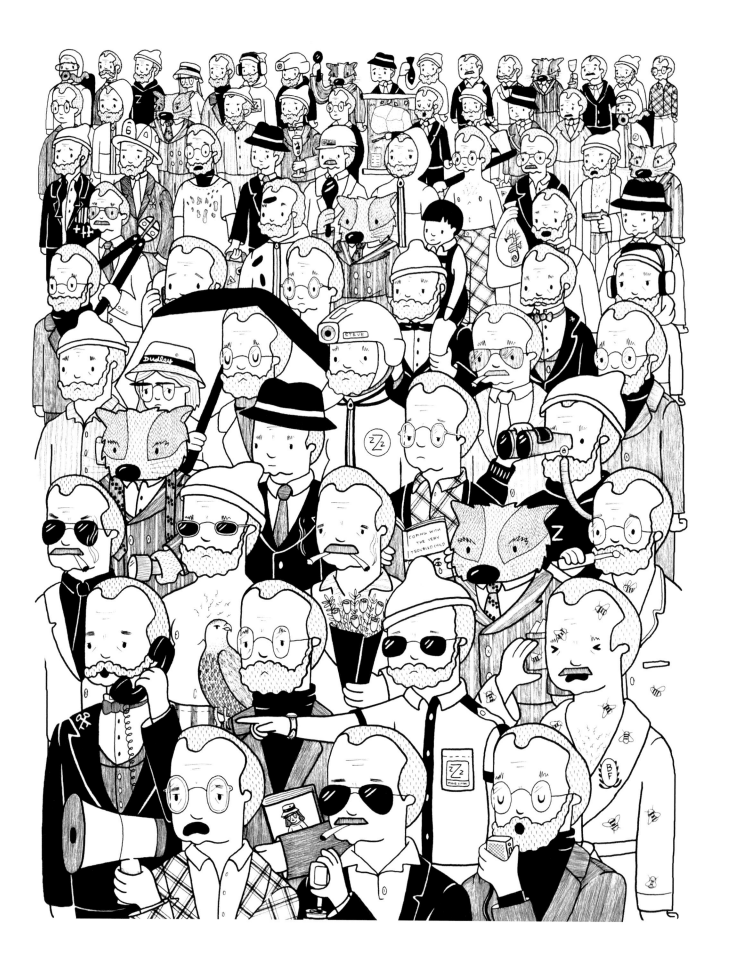

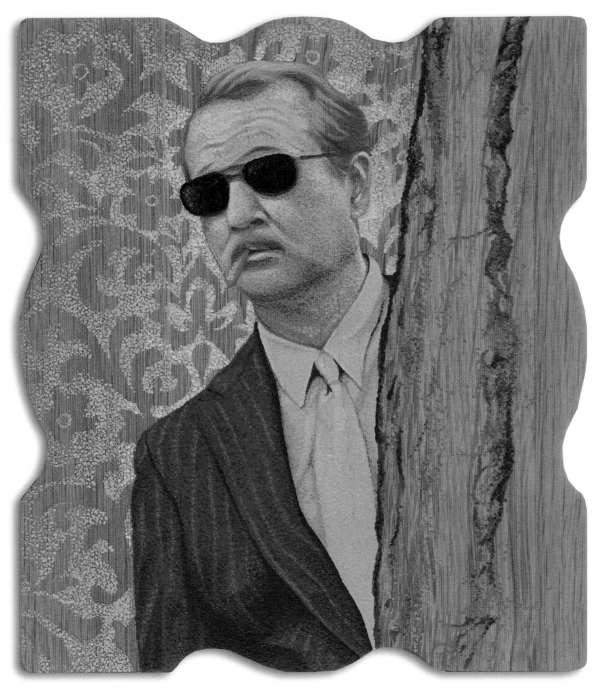

← **Jayde Fish**
So Many Murrays
Ink on paper
12 × 16"

→ **JoKa**
*Yeah, I'll Have One
of Those*
Acrylic on oak, painted
with toothpicks
6 × 6.5"

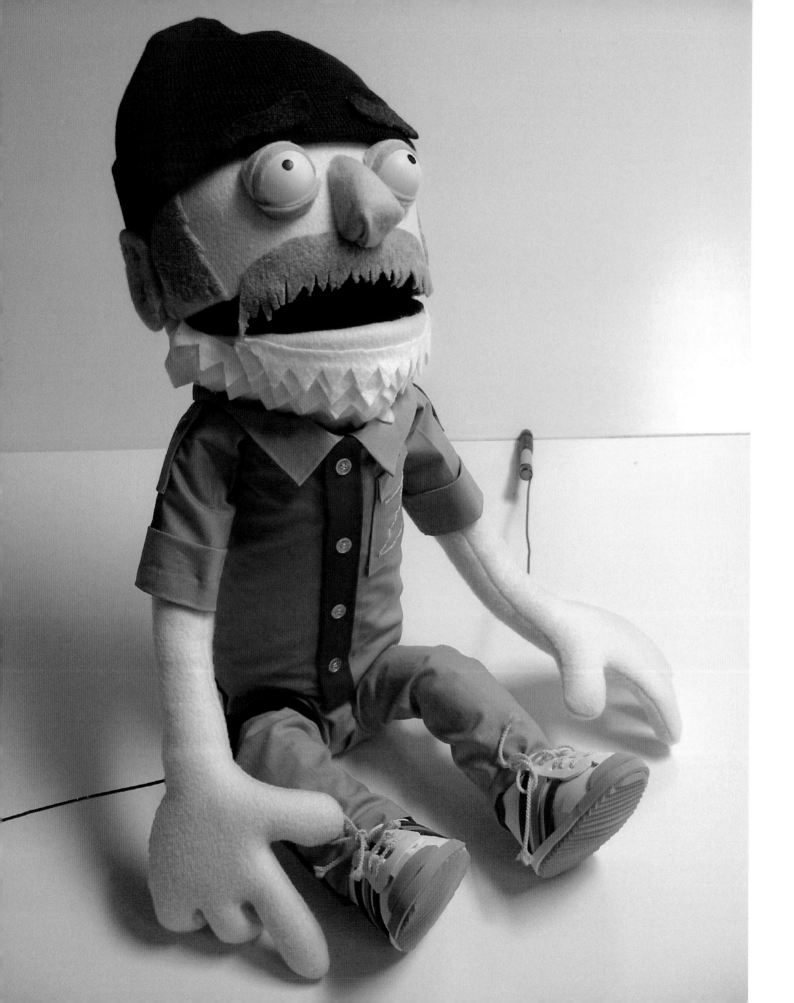

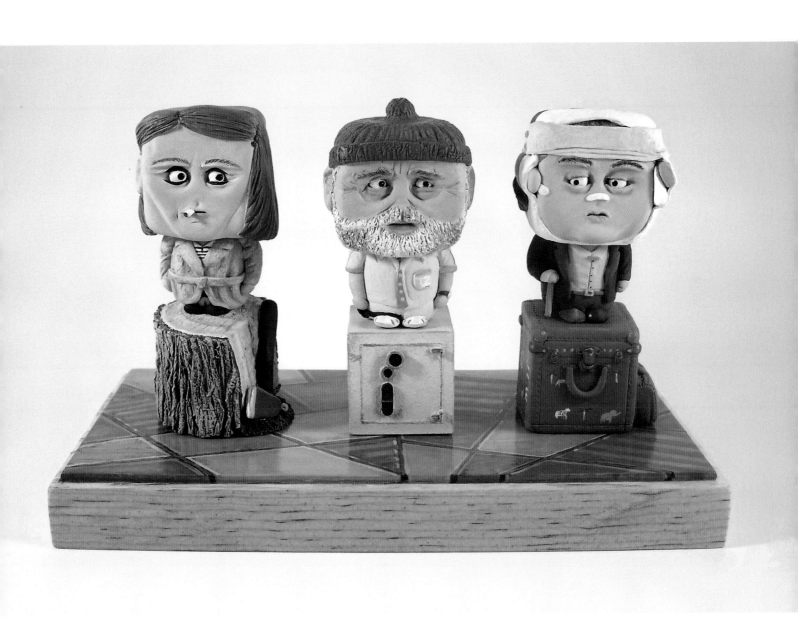

Tessa Yvonne Morrison
This Is an Adventure
Fiber art
9 × 23 × 7"

→

Brad Hill
No Relation
Mixed media
7 × 4.25 × 3"

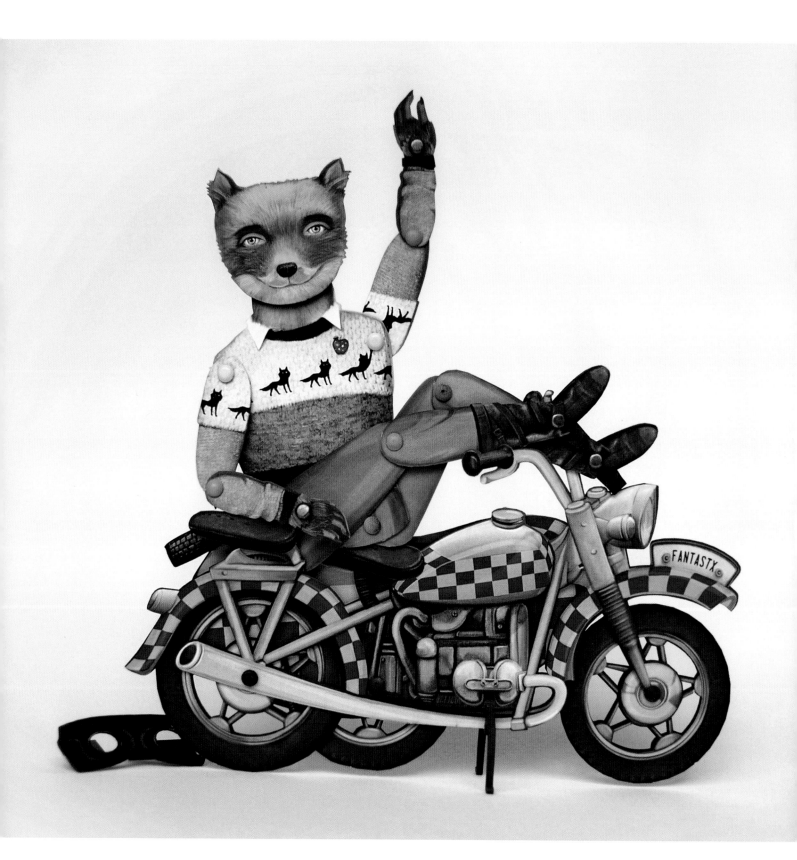

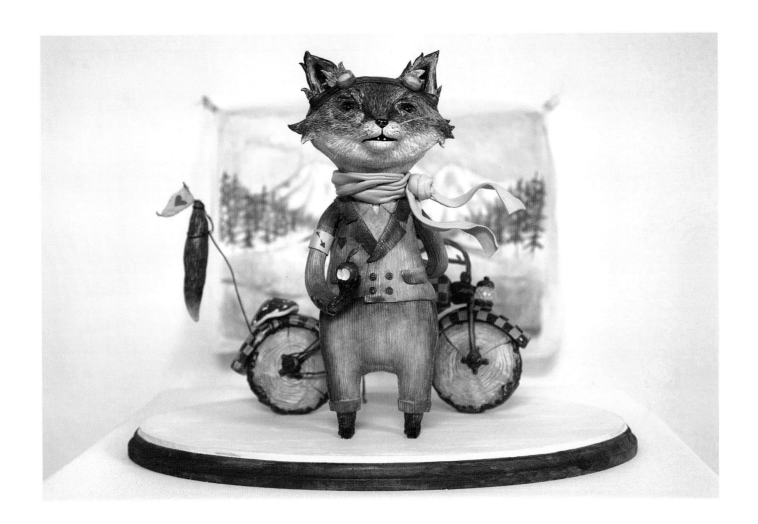

Crankbunny
Mr. Fox
Paper cutout toy
11 × 11 × 1"

Maryanna Hoggatt
Mr. Fox and His Bike
Wire, foil, clay, acrylic,
thread, wood, plastic bulb,
and fabric
12 × 9 × 9"

Rebecca Mason Adams graduated from Rhode Island School of Design in 2006 with a BFA in photography. She transitioned into painting soon after and has used her skills in lighting and interest in graphic stylized film to aid in her subject matter. Her work focuses on black-and-white photo-realistic portraits, using pattern, repetition, and reflection to create surreal imagery. It has been featured in *New American Paintings* and exhibited in cities across the country, including San Francisco, Philadelphia, and New York.

rebeccamadams.com
page 10

Anarkitty, aka Emma Geary, hails from Ballycarry, a small village in Northern Ireland. After graduating from Ulster University with a BA Hons degree in art and design, Emma moved to London as a web and graphic designer. The name Anarkitty was born there. As a sideline she started creating digital-based character illustrations, with work appearing in publications such as *Creative Review* and *Computer Arts*. She has also created work for the likes of MTV and the BBC.

Returning to Northern Ireland, Anarkitty started to move her characters onto canvas. Her artwork now appears in galleries and shows internationally.

"A prevalent theme running through my pieces stems from my fascination with cats! Inspired by their idiosyncratic ways, my 'ladies' have the same arcane attitude encased in a provocative and curious beauty. I want them to be comfortable within their own bodies; know their own minds; to have no feeling of restraint from surrounding judgments."

anarkitty.co.uk
pages 156, 157

Ana Bagayan's work is inspired by the metaphysical—ETs, aliens, spirits, ghosts, intergalactic space creatures, ethereal beings, anything that hints at the idea that we are just a small part of the unimaginably vast universe. She was born in Yerevan, Armenia, in 1983 and earned a BFA in illustration from the Art Center College of Design in Pasadena, California. Bagayan lives in the mountains of Southern California with her husband and their two dogs.

anabagayan.com
pages 158–159

Oliver Barrett is a guy who draws stuff and designs things. He isn't very comfortable writing about himself. *Insert accolades here*

ohbarrett.com
pages 152, 153, 155

Ryan Berkley is a self-taught illustrator best known for his detailed drawings of sophisticated animals in addition to his pop culture and comic book–influenced art. He splits his time between client work, gallery shows, and creating new art for his own line of prints and goods. When he's not drawing, you can find him having a dance party with his two young children. He lives and works among the trees of Portland, Oregon.

berkleyillustration.com
pages 78, 79

Isaac Bidwell is an illustrator from Syracuse, New York. He is influenced by cryptozoology, burlesque, and the sideshow. Over the past five years, his artwork has been seen at various galleries throughout the country. Currently, he's developing his company, Pickled Punks, for retail and wholesale.

isaacbidwell.com
page 120

Robert Bowen is a visual artist living and working in San Francisco. He has been exhibiting his artwork throughout the United States for more than fifteen years. Bowen got his start through graffiti and street art and went on to attend art school and obtain a classical education as a painter.

robertbowenart.com
pages 215, 216–217, 218-219

Christopher Brewer was born in Dayton, Ohio, in 1970. He works predominantly in the medium of acrylics on canvas but also creates digital art and graphic design. He is influenced by American pop art, including artists Chuck Close and Andy Warhol as well as Georgia O'Keeffe and Alan Streets.

He's had his paintings exhibited in notable group shows including *Robot Love v.2.0* in Melbourne, Florida; *Quentin vs. Coen* at Spoke Art in San Francisco; and *The Murray Affair: The Bill Murray Art Show* in Los Angeles.

His paintings have been published in notifications including *Brevard Live*, the *Beachside Resident*, and *Brevard Art News* in Central Florida. Christopher has paintings currently showing in Concord and Manchester, New Hampshire, with an upcoming solo exhibition in Manchester. He lives and works in New Hampshire.

pages 200–201

Joshua Budich is an independent illustrator working for numerous galleries, movie studios, and media outlets around the globe. Inspired by a love for the pop culture of his youth, his primary focus is on screen prints that celebrate popular movies (*Star Wars*, *Star Trek*, *The Big Lebowski*), television series (*Lost*, Marvel's *Agents of S.H.I.E.L.D.*), animated movies and shows (*The Simpsons*, *My Neighbor Totoro*, *Akira*), and more.

Budich graduated from the University of Maryland, Baltimore County with a BFA in imaging and digital arts in 2000. He enjoys cooking with his wife, drawing with his son, and reading to his little girl. He lives in the Baltimore/D.C. area with his wife and their two children.

joshuabudich.com
pages 90, 91, 149, 166, 167

Ivonna Buenrostro, aka Hearbeats Club, an artist based in Mexico. She makes drawings of elements that resonate with her after watching a movie.

heartbeatsclub.tumblr.com
page 148

Emma Butler is from New Zealand but currently lives in Canada, and only puts up with the cold winters because of the incredible summers she spends in the mountains. (The adrenaline rush that comes from not knowing whether there is a bear/cougar/rutting elk stalking you is something that just wasn't going to happen for her back home.) Emma currently works as art director for Kick Point, getting her hands dirty by developing brands, drawing illustrations, and creating motion graphics.

On the side, she designs and sells a series of "movie parts" posters, which basically means she spends a lot of time waiting in line at the post office.

Her favorite shape is the triangle.
emma-butler.com
page 179

Sandi Calistro is a tattoo artist and painter living and working in Denver, Colorado.

instagram.com/sandicalisto
page 221

THE ART ISTS

Julian Callos is an illustrator and gallery artist based in Los Angeles. Julian explores a wide variety of subjects in his work (which can range from lighthearted takes on popular culture to darker, symbolism-filled narratives), but is continuously fascinated by nature, folklore, death, and the allure of the unknown.

juliancallos.com
pages 35, 64, 206

Scott Campbell (Scott C.) is a maker of paintings, illustrations, comics, kids' books, and video games. He studied illustration at the Academy of Art in San Francisco, focusing on comic and children's book illustration. Soon after graduating, he began at Lucas Learning as a concept artist on children's video games. Four years later, he joined Double Fine Productions as art director on such games as the critically acclaimed *Psychonauts* and *Brütal Legend*. Alongside this career in games, he has published numerous comics and created paintings that have appeared in galleries and publications around the world. Some of his most notable projects include the Great Showdown series, Igloo Head and Tree Head series, Double Fine Action Comics, Hickee Comics, the children's books *Zombie in Love* and *East Dragon, West Dragon*, and *Psychonauts* and *The Art of Brütal Legend* with Double Fine Productions. The book *Amazing Everything: The Art of Scott C.* collects many of his paintings over the past few years. Scott lives in New York City.

pyramidcar.com
page 96

Mar Cerdà—the accent on the name is important! ;-)—is an illustrator who uses watercolor painting and paper as the base materials of her work, both in watercolor prints and in little dioramas made of cut papers.

Her training in cinema and audiovisual, and her specialization in art direction, are facts that have emphasized her fascination with scenography and the treatment of space—both displayed in many of her illustrations and, above all, in the dioramas. This sense of theater is one of the most present characteristics in her illustrations, where the space, the setting, and the use of frontal view frequently prevail. She firmly believes that a character can be defined by a space, even if it is not present at all.

She lives and works in Barcelona as a children's book illustrator for several publishing houses in Spain and has displayed her diorama pieces in galleries around the world (Barcelona, San Francisco, New York, Los Angeles, Romania . . .).

marillustrations.com
pages 28, 29, 30, 31, 32, 33

Matt Chase is a designer and artist living and working in Washington, D.C., for clients such as the *New York Times*, *GQ*, *Vanity Fair*, the *Atlantic*, *Esquire*, and the *New Yorker*. He watches *Star Wars* incessantly, and sometimes other films, too.

chasematt.com
pages 50, 51

Tracie Ching is an illustrator and graphic designer living in Washington, D.C. A self-taught digital artist, Tracie specializes in portraiture featuring complex, graphic line work with a limited palette—a tendency turned style after years of working in the medium of silk-screen prints.

While commissioned for a wide range of projects, including commercial athletic apparel, editorial illustration, and gallery work, Ching is best known for her alternative movie posters.

tracieching.com
pages 118, 119, 194, 195, 222, 230

Stanley Chow is an illustrator, artist, and graphic designer, in that order . . . from Manchester.

stanleychowillustration.com
pages 130–131

Dan Christofferson is an illustrator, painter, and designery dad from Salt Lake City, living in Brooklyn. Dan is the founder and sole member of three different secret societies.

beeteeth.com
page 116

Codeczombie was born and raised in Italy. After graduating from the art school in Ravenna (without studying that much), he took a three-year-long limited-admission course on comic drawings in Florence. While trying hard to avoid breaking any of his bones at skateboarding, but sadly failing at this specific task, he passed through graffiti (running away from police officers), and landed safely in computer-generated stuff, then went "back" to his original passion—sculpting on toy design—and mixes together all of his acquired knowledges (and, in fact, is still running sometimes, but just for fitness).

codeczombie.com
pages 36–37

For many years **Rhys Cooper** lived a double life, mild-mannered clothing and fashion designer by day and poster artist by night (and weekends). Graduating with honors from Swinburne University in his hometown of Melbourne, Australia, he discovered the world of gig posters thanks to his work with Beyond the Pale Posters in his final year of school. After the following six years in streetwear, a decision was made to focus on poster art, and he hasn't looked back since.

Rhys has proudly created work for bands such as Queens of the Stone Age, the Bronx, Misfits, Rage Against the Machine, Nine Inch Nails, Pearl Jam, Foo Fighters, and many others, as well as working with film studios, Alamo Drafthouse, Star Wars, and Marvel. Rhys's art prints can also be found in many pop culture galleries and shows around the world.

studioseppuku.bigcartel.com
pages 211, 227

Some things in life are slick, hip, polished, and blatantly obvious. But for Norma V. Toraya, who's known as **Crankbunny**, these are exactly the things she shies away from. Instead, Crankbunny is more inclined to explore storytelling through curiosity and timeless concepts while working as an animation director and paper artist.

crankbunny.com
pages 8, 174, 244

Michelle Romo is a self-taught illustrator who is fueled by cookies and naps. She has been designing under the name **Crowded Teeth** since 2004. Inspired by the need to make somebody's favorite something, Michelle is on an endless pursuit of drawing blobs with faces, cats in sweaters, and monsters who would really like to hug you.

crowdedteeth.com
pages 82–83, 84, 85

Kristin Tercek has been painting under the name **Cuddly Rigor Mortis** since 2009. Her family of CRM characters continues to come to life in the form of happy foods, charming botanicals, and animals both real and imagined. Her work has been shown in galleries and museums all over the world, from NYC to Los Angeles to Australia to the Disneyland Resort in California. She still can't believe it.

cuddlyrigormortis.com
pages 183, 207

Max Dalton is a graphic artist living in Buenos Aires by way of Barcelona, New York, and Paris. He has published a few books and illustrated some others, including the Abrams releases *The Wes Anderson Collection* (2013), *The Grand Budapest Hotel* (2015), and *Mad Men Carousel* (2015). Max started painting in 1977, and since 2008 he has been creating posters about music, movies, and pop culture. He has participated in many art shows, including *Bad Dads* since its inception, and his 2015 solo show, *On a Mission from God*, at Spoke Art.

max-dalton.com
pages 46, 47, 48, 49, 176–177

Matt Dangler has exhibited his artwork extensively throughout America and has also contributed to shows in other countries. His work resides in private collections around the world.

"The beauty of his surrealism is captivating. There's so much information and story behind Matt Dangler's characters. The environment, lighting, costume, composition, color, even down to the wrinkle on their faces, are all carefully and consciously planned. Each piece of his work is comparable to a book, where you could read the painting for hours yet there will be something new to discover. The mood of each piece inflicts a certain feeling, and it will definitely leave an impression once you leave." —Monzuki

mattdangler.com
pages 122–123

Vic DeLeon is a classically trained sculptor, miniaturist, and digital artist living in Seattle. His work spans multiple mediums yet frequently echoes the same gritty, morose, and outright absurd themes that wind through the hipster underbelly of the Pacific Northwest. With his miniature vignettes DeLeon gives viewers tiny artificial worlds to explore for themselves, much like tiny stage plays frozen in time. DeLeon is also known for sculpting digital environments for video games. His work can be seen in the popular Halo franchise, among others.

vicdeleon.tumblr.com
pages 20, 22

Scott Derby is an illustrator based in the Philly suburbs who loves the sound of his own voice and is nowhere near as funny as he thinks he is. . . .

scottderby.blogspot.com
page 27

Tim Doyle is an illustrator and printmaker working out of Austin. Growing up in the suburban sprawl of the Dallas area, he turned inward and sullen, only finding joy in comic books, television, and video games.

Moving to Austin in 1999 to fulfill a lifelong dream of not living in Dallas, Doyle began showing in galleries in 2001. Doyle held many nerd-friendly jobs, including running a chain of comic book stores, as well as art director/lead designer for Mondo from 2004 to 2009.

Doyle left "jobs" behind, launching his own company, Nakatomi, in January 2009. In the summer of 2009, he and Clint Wilson built their screen-printing studio, Nakatomi Print Labs, which they and other artists work out of.

Doyle works and lives in Austin with his wife and their two children and an indeterminate amount of cats. If you'd like a cat, swing on by, no questions asked.

mrdoyle.com
pages 92, 93, 94, 95, 214

Emily Dumas is an illustrator from north of Boston. She earned her BA in graphic design from Salem State University. Her career started in advertising, which eventually led her to break off on her own. Her passion for illustration and branding has led her to create products and illustrations for an array of clients. Her work has also been featured in galleries and publications in recent years.

Emily is fond of hip-hop, traveling, record shopping, and spinning. She is also owner and designer for Flowers in May paper and gifts.

flowersinmay.com
pages 146, 147

James R. Eads is a Los Angeles–based artist with a background in traditional printmaking and painting. He uses motion and color to create impressionistic, dreamlike paintings that sway between reality and fiction. Like a map to a new world, his pieces act as illustrations for something unknown. James takes this feeling of discovery and scatters it throughout his work, offering a glimpse of the underlying magic of everything.

jamesreads.com
pages 98–99

Artist **Josh Ellingson** creates unique designs and illustrations for brands, publications, and galleries worldwide. His artwork is often described as graphic and bold, drawing inspiration from the world of pop art, technology, and the absurd.

ellingson.cc
pages 168–169

Epyon5 is a full-time artist who resides in central Illinois. Although originally an oil painter trained in the fine art of Renaissance-style realism, he has shifted his focus to a more contemporary style of stencils and spray paint while combining elements of old-world design. E5 (the shorthand name he goes by) exhibits his work on a regular basis in cities such as Chicago, New York, San Francisco, and Los Angeles, as well as having contributed graphic design work seen in the film *Transformers: Dark of the Moon*. The influences that fuel his creativity are far and wide: everything from classic works by the Italian painter Caravaggio to comics, film, music, and Bill Murray. And lastly, he really loves cats, especially his fat cat named Butterchubs.

epyon5.tumblr.com
page 61

Jayde Fish is a San Francisco–based designer and illustrator. Her artwork, and her lifestyle, are inspired by old movies, fashion, vintage textiles, and a bit of humor. She is best known for her identifiable work illustrating stickers for Facebook, although her work can be found everywhere from magazines to clothing and children's books. She and her husband share an artists' paradise deep in the center of San Francisco's most magical neighborhood, North Beach. Jayde makes honest, thoughtful illustrations that reflect her style, personality, and gentle view of the world.

jaydefish.com
pages 141, 142, 143, 240

Veronica Fish is an illustrator, painter, and comic artist. Her clients include Lego, Condé Nast, and *Wired* magazine, among others. Comics include *Pirates of Mars*, *Archie* for Archie Comics, *Silk* and *Howard the Duck* for Marvel Entertainment, and several projects with Boom! Studios. She lives with her husband in Massachusetts and is seriously considering getting a chinchilla.

veronicafish.com
page 13

Steven Foundling makes artwork in various media, from paintings and puppets to immersive alternate-reality adventures and floating tree-house fortresses.

pages 16–17

Sam Gilbey's distinctive and contemporary illustrations and portraits are painted by hand (often digitally but not exclusively) and are inspired by a lifelong passion for popular culture.

Based north of London, Sam has been drawing for as long as he can remember, back when he was way too short to be a stormtrooper.

samgilbeyillustrates.com
pages 129, 190, 191, 192

James Gilleard is a freelance illustrator and animator living and working in Japan. He loves old cartoons, 1950s animation, film posters, pulp comics, past future predictions, birds, dinosaurs, robots, 1960s cars, and loads of other rubbish that he tries to include in his illustration when he can.

jamesgilleard.com
pages 132–133

Greg Gossel was born in 1982 in western Wisconsin. With a background in design, he creates work that is an expressive interplay of many diverse words, images, and gestures. Gossel's multilayered work illustrates a visual history of change and process that simultaneously features and condemns popular culture. His work has been exhibited throughout the United States and abroad, including San Francisco, New York, Los Angeles, Copenhagen, and London. His commercial clients include Levi's, Burton Snowboards, Stüssy, *Vice* magazine, and Interscope Records, while his work has been published in the *San Francisco Chronicle*, *Juxtapoz Art & Culture Magazine*, *ArtSlant*, and *ROJO* magazine. Greg currently resides in Minneapolis.

greggossel.com
page 134

Lauren Gregg is an illustrator who lives in Athens, Georgia. She makes paintings by herself and animations with her best friend (called Kangaroo Alliance). She has made things for Nickelodeon, Disney Television, *Yo Gabba Gabba!*, and even commercials about tampons and homeless pets. Her paintings have hung in galleries in various cities across the United States since 2003. She can be found either taking a nap, petting a dog, eating a pizza, or looking at things!

laurengregg.com
pages 106, 144, 145

Dan Grissom is an artist and musician from Austin. In college, he studied graphic design, painting, and printmaking, and he continues to explore those things and all the ways that they can overlap. By day, he is more behind the scenes in the poster world, working as a screen printer at Nakatomi, Inc., where he has printed posters and art prints for artists such as Tim Doyle, Joshua Budich, Tracie Ching, Godmachine, Nicolas Delort, and many more. He also started a small print shop in his garage called Biscuit Press where he does screen printing and letterpress printing of his own works as well as for other artists.

dangrissomartanddesign.com
page 170

Nicole Gustafsson works as a full-time illustrator, specializing in traditional media paintings featuring everything from woodland characters and environments to pop culture–based projects for galleries around the country. She enjoys incorporating themes of adventure and exploration in her artwork. Nicole currently lives in the Pacific Northwest with her husband and pet kids.

nimasprout.com
pages 23, 74–75

Hari & Deepti are a husband-and-wife art duo based in Denver/Mumbai and known for their unique, intricate paper art that combines paper and light. They are explorers and collect stories along their travels. Stories have many shades and depth in them, and they believe paper as a medium has the exact qualities to reflect and interpret them. They seek inspiration from nature, as it makes them humble and understand where they stand in the grand scheme of things.

They have hosted various solo shows in Denver, and have recently exhibited their work in Oslo, Norway. They have also shown at art fairs such as Art Basel, Scope Miami/NY, and the Context Art Fair in Miami.

They are inspired by the works of Hayao Miyazaki and Wes Anderson.

harianddeepti.com
page 18

Brad Hill is a mixed-media artist based in Michigan. He began sculpting in 2010 as a way to pass the time and instantly fell in love with the craft. Soon, he began exhibiting sculptures in galleries spanning the United States. Brad was named one of Hero Complex Gallery's Distinguished Artists of 2015, and he will be having his first solo show in 2016 at Gallery 1988.

sircreate.com
page 243

Maryanna Hoggatt is a painter, sculptor, and illustrator who works out of gloomy Portland. She is best known for her Animal Battle series, and her first children's book will be out in the wild in 2016.

maryannahoggatt.com
pages 104, 105, 245

Christine Aria Hostetler is an artist based in San Francisco. Her artwork ranges from life-size watercolor portraits to commercial print illustration. She focuses primarily on the human form, and works in watercolor and pen and ink. Christine is enraptured by the expression and depth of emotion and the possibility of story that's found in the furrow of someone's brow, the wrinkle in their clothing, their stance, the things they carry.

christinearia.com
pages 38–39, 188, 189

Alec Huxley (born in 1980) is a painter based in San Francisco. His work is anchored by haunting cityscapes definitively of the American West Coast, which are frequently populated by wild beasts and well-dressed figures in space helmets.

alechuxley.com
pages 164–165

Maria Suarez-Inclan is a freelance illustrator and graphic designer born and raised in Madrid. She graduated with a degree in graphic design from the Complutense University of Madrid. She's highly inspired by the worlds of cinema, Franco-Belgian comic books, and advertising. Her work has been shown in different American and Spanish art galleries. Sometimes she goes by msinclan.

msinclan.com
pages 235, 236–237

Ruben Ireland is a graphic artist and illustrator based in London. Using a fusion of traditional techniques and digital processing, he creates thoughtful, dreamlike images that carry emotional weight as well as a relevance to daily life. His tools include ink, acrylic, dirty water, foods, and weathered paper, as well as Photoshop and a Wacom tablet.

rubenireland.co.uk
page 154

Aaron Jasinski's paintings have shown across the United States and internationally. He also illustrates children's books and album covers and creates electronic music. His paintings feature nostalgic themes peppered with social commentary and whimsical creatures utilizing a Technicolor palette. He resides near Seattle with his wife and their four children.

aaronjasinski.com
pages 72–73, 171

While you are enveloped in sleep, **JoKa** is toiling into the night, stippling acrylic paint to blank facades, using images of styles and faces of yore. JoKa's penchant for meticulous and detailed work led him to his method of hyperpointillism, wherein he uses only toothpicks to apply his tiny dots of color. Although his images may be skewed from direct interpretation, the meanings behind his work are usually dark in tone and lean toward a devious nature. Currently residing in Philadelphia, he has exhibited from coast to coast as well as lands afar.

dotjoka.com
page 241

Tim Jordan is a graphic designer living in Eugene, Oregon. Born in Syracuse, New York, Tim moved to Eugene in 1981. He has lived and worked there ever since. He attended Pratt Institute's School of Art and Design in Brooklyn, the University of Oregon, and Oregon State University. He has been a graphic designer at the University of Oregon since 2003 and has also run a freelance design business, Tim Jordan Designs, since 1996. His design work has won numerous awards and has been published in *American Corporate Identity* 9 and 10.

Since 2011, Tim has worked with Matt Dye at Blunt Graffix, designing and hand-pulling screen-printed posters, participating in group shows, and showing in galleries around the country. Tim lives with his wife, their two children, a dog, and two cats.

facebook.com/timjordandesign
pages 86, 87, 137

Andy Kehoe was born and raised in Pittsburgh and lives there today with his wife, Ash, and three cat children. Kehoe explored a number of different art schools before finishing up at Parsons School of Design in New York City with a degree in illustration. After dabbling in commercial illustration for a short time, Andy began showing his work at galleries and never looked back. Kehoe's work has shown the world over including with such prestigious galleries as Jonathan LeVine Gallery (New York), Thinkspace Gallery (Culver City, California), Roq La Rue (Seattle), and Copro Nason Gallery (Santa Monica), and he has taken part in Scope Miami Beach during Art Basel in Miami.

andykehoe.net
page 103

Jaesun Kim is an artist, sculptor, and illustrator who lives in Suwon, South Korea. She studied illustration at the Art Center College of Design in Pasadena, California. She loves riding her bike on the beach and playing with her lovely dog, Byul.

cargocollective.com/jkjaesunkim
pages 126–127

With strong roots in folklore, mysticism, and myth, **Alex R. Kirzhner** crafts his images with a desire for extravagant detail. His artwork is informed as much by art history as it is by popular culture.

Alex is also a designer and photographer, and has received multiple acknowledgments; most notably two consecutive Grammy nominations as an art director/designer, an Art Directors Club Young Guns award, and an award for outstanding package design from NARM.

Alex is a graduate of the School of Visual Arts, and currently lives and works in New York City.

newshadeofblack.com
page 231

Having grown up in California, **Caia Koopman** is considerably drawn to the surf, skate, and tattoo cultures; these lowbrow influences, combined with her love of nature, result in a visually striking style, full of eccentric illustrative touches. The female subjects that grace her paintings are forceful in their feminist gaze yet remain fluid and organic akin to the nature that surrounds them. Surreal and whimsical all at once, Caia's females are intentionally situated in colorful, dreamlike worlds of their own making.

A staunch devotee to environmentalism and a second-generation conservationist, loving the environment and acutely aware that humanity is dangling our planet over a dangerous flame of pollution, Caia often weaves nature into the haunting fabric of her images. Birds, flowers, plants, butterflies, animals, and mythical creatures are interlaced with iconic symbols of love, mystery, soul-searching, and timeless values. Lurking throughout these visual fantasies are *Día de los Muertos* skulls, cute yet macabre reminders of the interlocking yin and yang of life and death.

caiakoopman.com
pages 58, 108, 109

Bartosz Kosowski is a freelance illustrator born in 1979 in a small town in the Polish Masurian Lake District. His work, which is executed both traditionally and digitally, is characterized by the limited color palette and the detailed line work that shows his love of etching developed during his studies at the Strzemiński Academy of Art in Lodz.

He has received three gold medals from the Society of Illustrators, and his published work includes portraits, illustrations, and posters for *Legendary*, the *New Yorker*, the *New Republic*, the *Hollywood Reporter*, *Newsweek*, *Orange*, ING, and others.

His illustrations have been awarded by Graphis, 3×3, New York Festivals, American Illustration, the Society of Illustrators, and European Design Awards. They have also been featured in Taschen's *Illustration Now!* and Lürzer's Archive's *200 Best Illustrators Worldwide*. For the last two years Kosowski has been an Adobe Design Achievement Awards mentor.

bartoszkosowski.com
pages 88, 89

Tara Krebs is a Toronto-based artist who paints surreal worlds and curious creatures that seem ripped from the pages of a storybook. While the majority of her artwork deals with this subject matter, she is also a huge nerd and pop culture junkie who enjoys playing outside her usual style now and then to create tributes to beloved movies and general nostalgia.

tarakrebs.com
page 45

Conor Langton is an Irish artist and illustrator. He has received awards from the Society of Illustrators, *American Illustration*, and *Communication Arts*, and his clients include the *New Yorker*, *Rolling Stone*, and Jemaine Clement (*Flight of the Conchords*).

conorlangton.com
pages 54, 55

Doug LaRocca is an illustrator and designer currently residing in Philadelphia. He designs party-supply packaging by day and paints robots and dinosaurs by night (and sometimes weekends). Doug has been a part of many geeky group shows in places such as Gallery 1988 (Los Angeles), Bottleneck Gallery (Brooklyn), and Spoke Art (San Francisco).

douglarocca.com
page 43

Scott Listfield (born in Boston in 1976) is known for his paintings featuring a lone exploratory astronaut lost in a landscape cluttered with pop culture icons, corporate logos, and tongue-in-cheek science fiction references. Scott studied art at Dartmouth College, for which his parents have finally forgiven him. After some time spent abroad, Scott returned to America where, a little bit before the year 2001, he began painting astronauts and, sometimes, dinosaurs.

Scott has been profiled in *Wired* magazine, the *Boston Globe*, *Juxtapoz*, *New American Paintings*, and on WBZ-TV Boston. He has exhibited his work in Los Angeles, Chicago, London, New York, San Francisco, Miami, Boston, and many other nice places.

society6.com/scottlistfield
pages 212–213

The Little Friends of Printmaking are the husband-and-wife team JW and Melissa Buchanan, who first made a name for themselves by designing and printing silk-screen concert posters but soon branched out into further fields, designing fancy junk for whoever would pay them money. In addition to their work as illustrators and designers, they continue their fine art pursuits through exhibitions, lectures, and artists' residencies worldwide, spreading the gospel of silk screen to anyone inclined to listen. The Little Friends currently live in Los Angeles with too many animals.

Their awards include honors from the Art Directors Club, *American Illustration*, and *Communication Arts*. Their work has been featured in books including *New Masters of Poster Design* (Rockport) and *Handmade Nation* (Princeton Architectural Press) and has appeared in magazines including *Bloomberg Businessweek*, *Wired*, and *Sierra*.

thelittlefriendsofprintmaking.com
page 178

Kathryn Macnaughton is an artist from Toronto who pulls inspiration from the grit of her risqué keepsakes and translates them into her own modern interpretations. Her work provokes an intense arousal and romance—whether the abstract paintings she methodically toils over or the bodacious illustrations she creates. Her work can be seen as remakes of popular novel covers for Penguin books or in publications like *Fashion* magazine and *The Walrus*.

kathrynmacnaughton.com
page 140

Kemi Mai is a self-taught artist based in the United Kingdom. Armed with tools of the digital medium, Mai often sets her subjects against minimal backgrounds, incorporating abstract or surreal elements and vivid experiments in color.

kemimai.com
page 223

Born in Chicago in 1965, **Craig "Tapecat" McCudden** has lived his life creating art, working in every medium one can think of. For the last fifteen years, his work—in pen and ink and scratchboard—has been primarily focused on the beauty of nature and its oddities. His work has been shown in galleries nationally many times, and it is in private collections around the globe.

instagram.com/craigtapecatmccudden
page 34

Paige Jiyoung Moon was born in Seoul, South Korea. She studied illustration at the Art Center College of Design, and currently works and lives in Pasadena, California.

paigemoon.com
pages 150–151

Currently residing in Austin, multidisciplinary artist **Tessa Yvonne Morrison** hails from the Mountain State, where she received her BA in visual arts from Marshall University.

As a self-taught puppet maker and fiber artist, she employs sewing, knitting, crocheting, needle felting, and wet felting to produce original and pop culture–inspired soft sculptures, intricate puppets, and costumes.

Her work has been exhibited in Austin, Los Angeles, San Francisco, Honolulu, and New York, through Guzu Gallery, Gallery 1988, Spoke Art, Hero Complex Gallery, Bottleneck Gallery, Bold Hype Gallery, POW! WOW! Hawaii, PangeaSeed, SOMArts, Beyond Eden Art Fair, and Design Matters.

Along with gallery exhibits, she strives to do more commissions and film-based work with her pieces. Hobbies include aerial arts, cosplay, writing, video games, horror and sci-fi movies, and snuggling kitties.

tessamorrison.com
page 242

Joseph Murdach grew up in a great environment for art. His parents had renditions of masterworks around their home, and at an early age he was encouraged to pursue any creative impulse he had. His earliest influences were his father and brother, who introduced him to animation, movies, and fine art.

Murdach studied art at Chabot College in Hayward, California, and at CCAC in Oakland and San Francisco. He graduated in 2002 with a BFA in painting and drawing and has worked in the areas of graphic design, silk-screen printing, printmaking, drawing, and painting. All of these processes come into play as he creates his art. He finds himself using bold lines, overlaying colors, and mixing up image content, while trying to create an interesting and compelling composition. Whether he is working on an abstract painting or trying to capture the likeness of a portrait, he is always using his experiences as a guide to create new pieces of art. Hidden in the layers of Joseph's work, you will find some nods to anatomy, figurative representations, some pop art, and maybe a little politics or social commentary.

joemur.com
pages 186–187

Danielle Murray is a painter, illustrator, and surface designer. She grew up in New Jersey and studied illustration at the University of the Arts in Philadelphia. She has worked in-house as a product designer for a division of Bed Bath & Beyond and has been freelancing and licensing her artwork on her own since 2013. She is inspired by past times, past places, and the sea.

danielle-murray.com
page 97

Matt Needle (born in 1987) was firmly enamored of the world of art, comics, TV, and movies from a young age. He was always sketching all manner of things, redrawing his favorite scenes from films (in wax crayon nonetheless!!!).

Fast-forward through the boring and awkward years, and he graduated top of his class at university with first-class honors in 2009, and after already working freelance for a year or so, he took on a few different jobs at studios/magazines while also setting himself up as a freelancer on a more permanent basis.

Over the years that followed, Matt was fortunate enough to exhibit worldwide and work with great clients of all sizes from all over the globe. Most recently and notably, he's worked with/for: 20th Century Fox, *Time Out New York*, Enterprise Rent-A-Car, *Wired*, and CNN.

mattneedle.co.uk
page 203

Chelsea O'Byrne is an illustrator living and working in Vancouver. Her work is inspired by vintage illustration, picture books, and all of the interwoven stories that make up our world. She studied illustration at Emily Carr University, where she spent a lot of time sketching, drinking tea, and looking at ducks. When she's not drawing, she can usually be found sewing, embroidering, printmaking, writing, or reading.

chelseaobyrne.com
pages 52–53

Johannah O'Donnell, a Florida native, grew up in Sarasota, where she graduated from Ringling College of Art and Design with a degree in fine art. She is currently a full-time painter/art instructor, and has exhibited work in numerous shows around the country, including a solo show at Bold Hype Gallery in New York City.

Influenced by the American pop art movement, Spanish surrealism, and sci-fi/fantasy art, O'Donnell's paintings use natural and figurative symbolism to comment on the ever-evolving human condition.

johannahodonnell.com
pages 161, 220

Truck Torrence is a Los Angeles–based illustrator who makes kawaii pop art under the moniker **100% Soft**. His influences are pizza, coffee, the movie *Hausu*, and his kitty, Admiral Whiskers.

100percentsoft.com
page 234

Lily Padula is an illustrator born and raised in a beach town outside of New York City. She graduated from the School of Visual Arts. Lily lives and works in Brooklyn with her tuxedo cat.

Lily is a prolific illustrator, who, when not creating commissioned work, likes to make zines, comics, and gouache paintings. Her work has been honored by *American Illustration*, the Society of Illustrators, *Communication Arts*, and *Creative Quarterly*, and she was named one of Tumblr's Illustrators to Watch in 2014.

lilypadula.com
page 228

Ruel Pascual has been an artist for more than twenty years. He has spent the last thirteen years working in the animation industry. Currently he's a senior animator at Disney Publishing Worldwide. His love of painting is what he holds most dear. He takes a personal approach to his work. The idea is to achieve beauty through narratives by painting familiar landscapes and characters that portray simple life experiences. Ruel fosters his art as if it were a living, breathing extension of who he is and the life journey we all share.

ruelpascualart.bigcartel.com
pages 100–101

Rich Pellegrino is an artist and illustrator with a BFA from the Rhode Island School of Design. His work is internationally exhibited and he has illustrated seven picture books. Pellegrino's work was displayed on Blue Moon beer labels in summer 2015. In 2014, he was commissioned by Wes Anderson to create a painting featured in the film *The Grand Budapest Hotel*. Clients include *The Big Bang Theory*, Eric Clapton's Crossroads Guitar Festival 2010, *Tomb Raider*, Lucasfilm, *RISD XYZ*, Picture Window Books, and White Wolf Publishing. He is recognized by *Spectrum 22*, Richmond Illustrators Club (2012), and *CMYK #37*. Rich currently resides in Boston with his wife, Kristina, and their cat, Ernie.

richpellegrino.bigcartel.com
pages 196, 197, 198, 199

Dave Perillo has done work for prestigious clients such as Disney, Target, Warner Bros., and CBS. He has had his work showcased in many galleries around the globe.

He draws inspiration for his work from many of the following sources: 1950s sci-fi movies, Charles Schulz, Jim Flora, Ray Harryhausen, Roy Lichtenstein, Jim Henson, Hanna-Barbera, *The Twilight Zone*,

Alfred Hitchcock, and character advertising icons. Dave currently resides in the burbs of Philly, and he believes that bowling is the sport of kings and that a bag of Swedish Fish is a seafood dinner.

montygog.blogspot.com

pages 180–181, 182

Joel Daniel Phillips lives and works in the San Francisco Bay Area. His artwork focuses on the tenets of classical draftsmanship employed in monumental formats. Inspired by the depth and breadth of human experience, he strives to tell the stories etched in the faces of those around him.

Born in 1989 in Kirkland, Washington, Phillips received his BA in 2011 from Westmont College, where he graduated with honors. Phillips has exhibited across the United States and Europe, most notably at institutions such as the Fort Wayne Museum of Art and the National Portrait Gallery at the Smithsonian. He is currently represented by Hashimoto Contemporary in San Francisco.

joeldanielphillips.com

pages 56, 68–69, 112

Audrey Pongracz was born and raised in Detroit. She is a self-taught painter whose work focuses along the figurative and surreal.

audreypongracz.com

page 59

Michael Ramstead is an oil painter and digital illustrator. In 2010, he earned his degree in studio art from UC Davis.

michaelramstead.com

pages 110, 128, 162–163

Allison Reimold was born and raised in Los Angeles, and currently works as an illustrator designing movie posters. Her favorite things are dogs, taxidermy, and Bill Murray.

thereimoldeffect.blogspot.com

pages 135, 193

Fernando Reza was born in the winter. He has a clean criminal record and loves making art. He also has a mysterious scar above his right eye.

frodesignco.com

pages 42, 63, 229, 232–233

Jesse Riggle is a painter, illustrator, and creator of odd images. He has been an active participant in the pop-surrealism world for many years, showing in various galleries across the United States. He also recently illustrated his first book.

jesseriggle.com

pages 66, 67

Matt Ritchie is a Bay Area artist who enjoys cats, Mexican food, pop culture, skateboarding, roller skating, and making tiny objects out of wood and paint. He splits his days between a career as an artist and a career as a park ranger. Matt uses a variety of mediums to create his artworks, such as pencil, ballpoint pens, paint, and wood. When not working on art or in a park, Matt is obsessed with his cat and Instagram. And cats on Instagram.

matt136.deviantart.com

page 173

Danielle Rizzolo received her BFA in illustration with honors from the University of the Arts in May 2006. Her paintings have been exhibited in Philadelphia, Los Angeles, San Francisco, and New York. She has received recognition from *Creative Quarterly* and *CMYK Magazine* and some of her clients include Urban Outfitters, *Seattle Weekly*, the *Progressive*, and *Tu Ciudad Magazine*. When she is not making oil paintings, she enjoys hanging out with friends and family, singing love songs to Zoe-Boe, driving her old cars. and frequenting flea markets.

danieller.com

page 26

Ridge Rooms is an illustrator and consumer product designer who combines her film school background and love of mid-century design and advertising to create movie- and TV-themed artwork with a retro flair. Previously an in-house designer for Peanuts, Barnes & Noble, and Pepsi, Ridge relocated from New York City to a sleepy little Victorian tourist town in the Midwest where she owns a pop-art boutique called The Mascot Syndicate.

ridgerooms.tumblr.com

page 205

From the mean streets of western Kentucky, **Darin Shock** has always found the strength to focus on his four passions: art, pop culture, man thongs, and toaster strudels. His focus on art, however, allowed him to resist the temptations of NASCAR, double negatives, and Larry the Cable Guy quotes that took down so many of his southern companions. Now residing in the "Greater" Cincinnati area, Mr. Shock predominantly produces gig posters, pop art, and people. The first two can be found at his website. Determined to be the greatest artist ever to emerge from Kentucky who doesn't paint horses and has a verb for a last name, Darin Shock will continue his quest to change the world . . . via pencil, paper, and Macintosh. He told me so.

stateofshockstudios.com

page 62

Bennett Slater's work draws inspiration from the relationship the future shares with the past; new from old, life from death. Utilizing traditional oil methods on wood, Bennett plays with a mixture of traditional Flemish and Dutch disciplines, with bold geometric forms linked to the contemporary avant-garde school of design. This dichotomy of contrasting artistic disciplines and influences lends itself to the underlying dualities observed in his work.

bennettslater.com

page 117

Operating out of a converted garage studio on the outskirts of Austin, Texas, artist **Todd Slater** is as prolific as he is piercingly inventive. Since graduating from art school in 2003, he has created hundreds of dazzling posters featuring the music industry's hottest acts, including the Black Keys, Jack White, the Avett Brothers, and Muse, to mention just a few. Todd draws his inspiration directly from each artist's music, translating the sounds into gut instincts for graphics, and he has an acute sense for the vibes that drive color selection and design schemes.

toddslater.net

page 65

Cuyler Smith was born and raised in Texas, where his passion for art began at an early age. Inspired by animation and film, Cuyler moved to Southern California, where he obtained his BFA in animation from Laguna College of Art and Design and his MFA in illustration from California State University, Fullerton. He currently resides in Irvine, California, with his beautiful wife and their two children.

Cuyler's pop culture–inspired illustrations can be seen in several galleries across the United States, including Gallery 1988, Spoke Art Gallery, Hero Complex Gallery, and Bottleneck Gallery. He continues to enhance and adapt his passion and technique as a visual communicator while being an art instructor and freelance illustrator.

cuylersmith.com

pages 124, 125, 210

Andrew Spear is a full-time illustrator/mural artist. Some of his high-profile clients include MTV, Adidas, the NFL, Red Bull, Jameson Whiskey, and Live Nation. A Boston native currently residing in Orlando, Spear can't get you free tickets into theme parks, even though people who visit ask him on a regular basis.

spearlife.com

page 70

Daniel Speight, aka The Soft City, is a London-based artist who captures architectural features of buildings through his intricate style of elevation drawing and his unique approach to printmaking onto three-dimensional objects or reclaimed surfaces. A graduate from the University of the Arts London, he explores the distinction between illustration and fine art to make work that challenges the material possibilities of printmaking.

Capturing the detail of decorative facades, architectural eras, and broken-down walls, Dan creates a micro-experience of city streets for interior spaces. Like a digital flaneur, Dan can wander cities online to re-create his own versions of these spaces through this innovative method of screen printing.

Dan has exhibited in London, New York, Miami, and San Francisco, and is represented by Debut Arts, London.

thesoftcity.co.uk

Chuck Sperry lives in the Haight-Ashbury district of San Francisco, where he's made his particular style of rock poster designs for more than twenty years. He operates Hangar 18, a silk-screen print studio, located in Oakland.

His artwork has been exhibited at leading San Francisco art institutions including the San Francisco Museum of Modern Art and the Yerba Buena Center for the Arts; his prints have been archived by the Achenbach Graphic Arts Council, the Oakland Museum of California, the San Francisco Public Library (main branch), the US Library of Congress, and the Rock and Roll Hall of Fame.

Chuck Sperry has honed the craft of designing and hand screen printing to become recognized throughout the world as one of the foremost rock poster artists and printmakers. Elevating the craft to fine art, Sperry creates sociopolitical artwork beyond rock. He adheres to the ideal that beauty strengthens his message.

chucksperry.net

A multidisciplinary artist, **Beau Stanton** works in paintings, murals, large-scale installations, stained glass, and multimedia animations. Focusing on meticulous technique and craft, Stanton's work is heavily informed by historic ornamentation, religious iconography, and classical painting. A keen interest in iconic visual symbols and Jungian archetypes often provides the foundation for his images.

Stanton is originally from California, where he studied illustration at Laguna College of Art and Design. After graduating in 2008, he relocated to New York, where he continues to live and work in Red Hook, Brooklyn, constantly drawing inspiration from local nautical history. His work has recently been shown in a twelfth-century crypt, on the Berlin Wall, on a Fiat 500, and in galleries worldwide.

beaustanton.com

Meghan Stratman is a paper-collage artist who lives and works in Lincoln, Nebraska.

bunnypirates.com

Before becoming a freelance illustrator/graphic artist, **Steve Thomas** worked for newspapers, creating graphics and illustrations for fourteen years. He did work for every section of the paper, from Life and Entertainment to News and Sports. It was during this time that he developed his style.

Now, Thomas tries to come up with new and interesting ideas for illustrations. His love for vintage poster, propaganda, and product art from the early twentieth century and an interest in retrofuturistic art from the mid-twentieth has led him to create some cool (he thinks) poster art. Who doesn't want to travel the solar system or join the fight against the villains of 1980s arcade games?

stevethomasart.com

Los Angeles–based artist Tenderloin Television **(TLtv)**, aka Benjamin Clarke, creates "low-brow, psychedelic art" that reflects his sense of humor and religious satire with a unique style.

fearache.tumblr.com

Geoff Trapp graduated from the Mason Gross School of the Arts in 2005 and began his career as a professional model painter with NECA Toys in 2006. His work has been featured at Spoke Art, Gallery 1988, and Bottleneck Gallery, among others. Geoff continues to work from his studio in Jersey City, New Jersey.

facebook.com/Geoff-Trapp-Did-It
-314413307837

Philip Tseng is an illustrator based out of San Diego. Phil's work can best be described as lighthearted and often includes his favorite subject: food.

minicubby.com

Mandy Tsung was born in Banff, Canada, but spent her formative years in Calgary and Hong Kong. After completing a BFA in sculpture at the Alberta College of Art and Design in 2007, she moved to Vancouver, where she now paints full-time. She has exhibited in numerous galleries in North America, Germany, Japan, and Australia, and has completed many private commissions.

choplogik.org/mandytsung

Justin Van Genderen has been working as a graphic artist in some form or another for fifteen years. About two years ago he started his own ad agency, 2046 Design. While his work leans more toward photorealism and manipulation, he has recently begun to experiment with poster design and screen printing. Most of Van Genderen's recent work is influenced by old art deco prints, propaganda posters, and pop culture.

2046design.com

Van Orton Design are twin brothers from Turin, Italy. Their art is influenced by pop culture and a design inspired by stained-glass windows of churches. They started reinterpreting iconic cult movies of the '80s, which allowed them to quickly get a lot of visibility on the web and to be contacted by major brands, including ESPN, Marvel, Sky, and *Rolling Stone*. They are currently exhibiting for several American galleries between Los Angeles and San Francisco.

vanortondesign.com

Originally from Southern California, **Casey Weldon** attended the Art Center College of Design in Pasadena. After living in Las Vegas, he relocated to Brooklyn and finally Seattle, where he now lives and works as an illustrator and fine artist.

"Weldon's signature style utilizes a bright, vibrating hyperchromatic palette often portraying strange and dreamlike circumstances between people and the natural world. His carefully constructed layers of neon glazes create a supernatural glow, almost as though the painting is illuminated from within. The result is an astonishingly cinematic narrative that draws us into the story, where we have entered into the scene at a moment just before or after some unknown climactic event." —Sharon Arnold, Roq La Rue

caseyweldon.bigcartel.com

Helice Wen was born in Shenzhen, China. She now lives and works in San Francisco.

helicewen.com

Bruce White is a painter and tattoo artist based in North Carolina. Bruce feels that painting on velvet gives his work a degree of visual contrast that cannot be replicated on any other surface. He has chosen this medium to channel his admiration for many of pop culture's most iconic characters. Among his many possessions, you will find an unhealthy number of action figures, as well as a BFA from UNC–Chapel Hill.

velvetgeek.com

Robert Wilson IV is a comic artist and illustrator currently living in Dallas with his wife, daughter, and dog. He is the co-creator and artist of *Heartthrob* at Oni Press with writer Christopher Sebela. He also co-created *Knuckleheads* at IDW/Monkeybrain with Brian Winkeler and *Like a Virus* with Ken Lowery. Additionally, he was the artist for *Bitch Planet* #3, as well as cover artist for comics such as *Bloodshot* and *Archer & Armstrong* for Valiant Entertainment and *Star Trek: Starfleet Academy* for IDW.

He is also active in the poster community, making tour and concert posters for bands such as the Mountain Goats, Ray LaMontagne, and the Sword, among others.

robertwilsoniv.com
page 202

Bec Winnel enjoys creating beautiful and detailed portraits of imaginary women in imaginary worlds. His "girls" are often accompanied by elements of nature, fantasy, and items from bygone eras. Winnel's color palette is mostly soft, subdued pastels, and his mediums include pencil, pastel, watercolor, and acrylic. To further enhance the mystery, his girls are often fading into or out of the background, as if they are nearly there, speaking to you from a distant place.

becwinnel.com
page 160

Jasper Wong is an artist, illustrator, and curator. He is a man who wears many hats and is best known for art that is a unique clash of Asian-influenced pop culture on paper. Wong has exhibited worldwide, in places such as Japan, California, France, London, Mexico, New York, Hong Kong, Chicago, and Australia, and he has been selected on multiple occasions by *Archive Magazine* as one of the 200 Best Illustrators Worldwide.

Wong is also the creator and lead director of POW! WOW! Hawaii, which is a nonprofit organization of contemporary artists committed to community enrichment through the creation of art outreach programs, educational programs, and engaging the community in the creation and appreciation of art.

radness.jasperwong.net
page 139

Steve Yamane is a third-generation Japanese American born in Gilroy, California. He lives in San Francisco and studied film at San Francisco State University. Steve makes short experimental film collages using stop-motion animation, optical printing, miniatures, and original music. His films reveal the absurdity of life in black and white and have shown in festivals in the United States and abroad.

In 2013, he painted a fourteen-by-twenty-foot scale model of Alcatraz that is on permanent display at Pier 33 in San Francisco. In 2015, Steve had a solo show, *miniature/APErture*, at San Francisco's Right Window Gallery featuring recent sculpture, and photography based on cinema and simian.

His work has appeared in Spoke Art's *Bad Dads 4* and the Stanley Kubrick tribute show.

He works as a projectionist, film crew member, and an archivist at Skywalker Ranch. Steve also grows lots of strawberries.

page 21

Alice X. Zhang is an illustrator with an enduring interest in cinema, comics, and pop culture.

alicexz.com
page 226

Zoltron is an enigma. A self-proclaimed '80s teen idol, Zoltron had a wave hairdo and unique California accent that epitomized a certain level of cool, which inevitably paved the way to his modest success as a visual artist and graphic designer.

In the late '90s, Zoltron would create his self-named design company and work with major label clients like Interscope Records, Geffen, A&E, and Universal, as well as music festivals such as Bonnaroo, Outside Lands, New Orleans Jazz Fest, and the BottleRock festival.

In early 2002, he founded the (now world-renowned) sticker printing company Sticker Robot, where he is currently listed as co-owner and creative director.

His true identity unrevealed, Zoltron is best known for his poster art, street art, and the co-creation of his two children.

Zoltron's unique creations have been spotted from California to Poland, Kamchatka to Irkutsk, Thailand to Tennessee. His artwork has been shown in galleries throughout the country, archived by the U.S. Print & Photographs Division of the Library of Congress, and published in lots of rad books and magazines.

Because he hasn't been able to reach Yanni's cell phone, Zoltron currently works with bands like Primus, the Black Keys, Foo Fighters, Soundgarden, Devo, Alice in Chains, the Residents, Die Antwoord, Faith No More, the Melvins, and most important, Neil Hamburger, among many others.

His work was once overheard to be called "pretty heavy" . . . by a guy who was urinating on a Dumpster as Zoltron walked by.

zzz.zoltron.com
page 60

ACKNOWL EDGMENTS

The author wishes to thank, first and foremost, the many fans and collectors who have supported the gallery and annual *Bad Dads* exhibitions since its inception in 2010. Your unbridled passion for Wes Anderson's films has kept this exhibition alive and we love seeing you year after year!

I am forever indebted to our amazing staff, past and present: Peter Adamyan, Sarah Erickson, Megan Cerminaro, Jess Suttner, Becca Knight, Ryan Whelan, and Kate Kuaimoku. A very special thank-you to Jessica Ross for spearheading this project. You rock and are my rock.

Our exhibition, let alone this book, would not have been possible without the efforts of the many artists who have contributed over the years. While we weren't able to fit everyone into this book, no omission was made lightheartedly. This show isn't possible without you—thank you.

For Molly Cooper and Ben Adler, thank you so much for your support. Eric Klopfer and the amazing staff at Abrams, thank you for sharing our works with the world and allowing this dream to become a reality.

Lastly, thank you to Wes Anderson and all the casts and crews from his films for the last twenty years of inspiration—we look forward to another twenty more years to come.

—Ken Harman

Editor: Eric Klopfer
Managing Editor: Sally Knapp
Design: Martin Venezky's Appetite Engineers
Production Manager: Denise LaCongo
Cover and endpaper illustrations: Max Dalton
Cover design: Martin Venezky's Appetite Engineers

Library of Congress Control Number: 2015955654

ISBN: 978-1-4197-2047-5

Printed and bound in the United States
10 9 8 7 6 5 4 3 2 1

Abrams books are available at special discounts when purchased in quantity for premiums and promotions as well as fundraising or educational use. Special editions can also be created to specification. For details, contact specialsales@abramsbooks.com or the address below.

ABRAMS The Art of Books
115 West 18th Street, New York, NY 10011
abramsbooks.com

JOKER

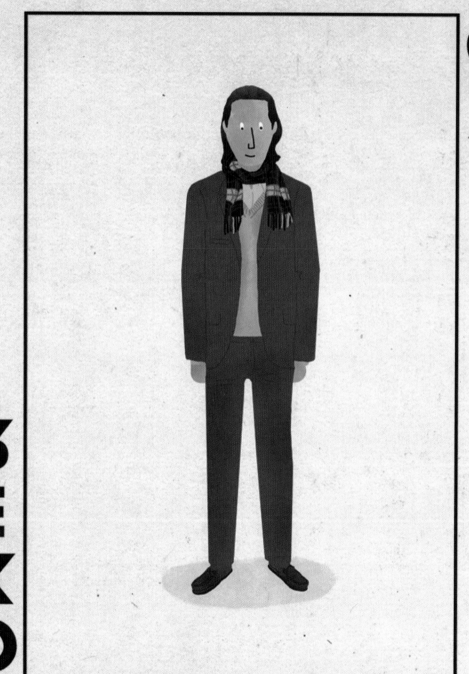

JOKER